FASHION & GRAPHICS

LAURENCE KING

Published in 2004 by Laurence King Publishing
71 Great Russell Street
London WC1B 3BP
Tel: +44 020 7430 8850
Fax: +44 020 7430 8880
email: enquiries@laurenceking.co.uk
www.laurenceking.co.uk

A catalogue record for this book is available
from the British Library

ISBN 1 85669 338 4

Designed by Frost Design, London
www.frostdesign.co.uk

Printed in China

FASHION & GRAPHICS
TAMSIN BLANCHARD

FASHION

Antoni & Alison **12** A-POC **22** Armani **30** Bally **36** Hussein Chalayan **44** Comme des Garçons **50** Dolce & Gabbana **60** John Galliano **70** Donna Karan **76** Calvin Klein **82** Alexander McQueen **90** Martin Margiela **98** Wim Neels **106** Jurgi Persoons **112** Jil Sander **120** Paul Smith **128** Anna Sui **140** Walter Van Beirendonck **146** Viktor & Rolf **154** Vivienne Westwood **162** Bernhard Willhelm **168** Yohji Yamamoto **174** You Must Create **186**

GRAPHICS

Åbäke **98** Aboud Sodano **128** Marc Ascoli **120, 174** Baron & Baron **82** Boris Bencic & Scott Fellows **36** Paul Boudens **106, 112, 146** Ronnie Cooke Newhouse & Stephen Wolstenholme **50** Carmen Freudenthal & Elle Verhagen **168** Graphic Thought Facility **12** Trey Laird **76** Dean Landry **140** M/M (Paris) **82, 174** Mevis & Van Deursen **154** Fraser Moss & Jimmy Collins **186** Michael Nash Associates **70, 90** Pascal Roulin **22** Peter Saville **120, 174** Milan Vukmirovic **120** Work in Progress **44**

INTRODUCTION
TAMSIN BLANCHARD

Fashion & Graphics

It is just a tiny rectangle of fabric, sewn into the back of a jacket. But what power it holds. Tied up in that little label is money, aspiration, sex appeal and status. Unpick it, and the jacket might as well be worthless. The label has become its own form of currency. It is the maker's mark: the reason the garment was sold in the first place. In the fashion industry, it is all about labels, branding and identity. A simple label can mean the difference between a plain, white T-shirt selling for £5.99 or £59.99.

Increasingly, fashion brands rely on packaging and presentation rather than the product itself. The brand image defines a particular aspiration or set of references that attract the consumer to choose one polo shirt, one pair of jeans or a particular pair of trainers over another. There comes a point when designer clothing is not about cut and cloth, but about graphic design, packaging and communication, whether it is a rubber band sewn into collar and stamped with John Galliano in Gothic script, or a catalogue for Yohji Yamamoto, photographed by Inez van Lamsweerde and Vinoodh Matadin and art directed by M/M (Paris), a collector's item in its own right, but seen only by a chosen few within the fashion industry. Not surprisingly, the graphic designer responsible for the look of a label or the art direction of the ad campaign has taken on a status and power within the fashion industry that was unheard of in the early 1980s.

Fashion companies have become mini publishing empires, often employing their own graphic-design teams, and producing not just invitations to fashion shows, but 'look books', catalogues, press mail-outs, magazines, advertising and even Christmas cards. But this is all a relatively new phenomenon. And much of the material, although highly sophisticated, expensive to produce, exquisitely designed and highly influential, is totally ephemeral, and thrown away without another thought.

British maverick Peter Saville was one of the pioneers who paved the way for the current generation of fashion graphics. 'Be careful what you wish for' is his motto; he intends to blow it up large in neon, and hang it on his Clerkenwell studio wall. As a young graduate in post-punk, bombed-out Manchester, he wished for a time when the world would be a better place because of the way it was designed.

It would look better; it would work better. Twenty-five years later, the landscape not just of Manchester, but of the whole consumer universe has changed beyond recognition. It has been designed. In Saville's opinion, it has gone too far. It has been over-designed, given a lick of gloss just for the sake of it. Things don't necessarily look better. They certainly don't necessarily work any better. But one thing is for sure: they have been designed.

In the mid-1980s, when Saville began collaborating with photographer Nick Knight and creative director Marc Ascoli on the advertising and imagery for Yohji Yamamoto, the concept of a graphic designer working on a fashion brand — creating layouts of images for brochures to be sent to press and buyers, deciding on the size and position of a logo, or simply editing a set of pictures — was something quite new. When Nick Knight requested that Saville work on the Yamamoto project with him, the idea was met with some degree of mystification. Nobody was quite sure what exactly a graphic designer would do. But the collaboration between Knight and Saville was to prove groundbreaking. 'When the Yohji catalogues appeared on the scene in autumn/winter 1986, they had a really profound effect,' remembers Saville. 'They became collected immediately because they were different. When you look back at them now, they are actually a little bit naive by contemporary graphic standards.'

The fashion industry is one of the most overcrowded and competitive industries. What makes one designer's white shirt stand out from another's is not necessarily the design. An architect might be attracted to a shirt by Comme des Garçons because of the message it is communicating to him or her. The way that message is communicated is carefully coded in language he will understand, through the advertising, the label, the packaging, the store design — it's a matter of presentation rather than fashion. Likewise, a businessman might buy his shirt from Hugo Boss because the logo speaks to him. It is confident, direct and has a very clear, corporate message. However similar the shirts may be, their customers live in totally different worlds.

Graphics have become an integral part of any fashion house; in some cases, the graphic designer or art director is also the fashion designer. For Giorgio Armani, he is the all-seeing eye: both art director and fashion director. 'A designer label is his or her business card,' he says. 'It not only reflects the spirit and integrity of each collection; it also expresses the philosophy and character of the line to the customer. The final product is the most important part of the package, but a label and logo secures a recognizable identity. The graphic identity is a natural extension to what my products are trying to express and reflect.'

In many cases, the graphic designer takes on a role as important – if not more important – than the fashion designer themself. As creative director of Burberry, Fabien Baron was closely involved in many aspects of the British brand's relaunch at the end of the 1990s. Working alongside managing director Rose Marie Bravo, he signalled the new direction of the brand by not only modernizing the logo (losing the confusing apostrophe in the process), but by creating an advertising campaign before there was any new product to advertise. His first ads for the brand, working with the photographer Mario Testino and promoting a certain English eccentricity and humour, were to set the tone for the rest of the highly successful turnaround from purveyor of old-fashioned raincoats to dynamic, high-fashion, luxury label.

The Belgian designer Walter Van Beirendonck has always incorporated graphics into his fashion, both for his own labels and for the streetwear brand, W<, with the help of Paul Boudens, the Antwerp-based graphic artist who has worked with many of the new wave of Belgian designers since the late 1980s. Van Beirendonck sees graphics and fashion as so inseparable as to include graphics as part of the fashion degree for students at the prestigious Antwerp Academy of Fine Art. 'It is an important "first presentation" to the real world,' he says. 'A graphic communication identity is important because it is the impression and language between designer and public.'

When Stella McCartney launched her own label under the Gucci umbrella in 2002, she worked with Wink Media – the multi-disciplinary creative agency set up in London by Tyler Brulé in 1998 – to define

her identity as a graphic logo. Her debut show was held in March 2002, at the Ecole des Beaux Arts in Paris. It was as though she were starting with a blank canvas; the catwalk was bright white and her new logo, her name apparently punched out as a series of dots, was emblazoned across it in silver. Although the assembled press and buyers were very familiar with Stella McCartney's name, this was the first time they would see a fully-fledged collection bearing it.

Erik Torstensson is one of a team of art directors at Wink Media. Wink offers a wide range of creative services, including advertising, brand development and corporate identity. But Stella McCartney was a unique project. 'We were creating a new brand for a very well-known designer, so it was already loaded with values and perceptions, which made it very interesting but also much more demanding, as the expectations on Stella launching her own label were very high.' His job was to create a brand image for a designer who already had a very strong brand image of her own. Everybody knew who Stella McCartney was, but nobody knew what her fashion label looked like. The process was a collaboration between Torstensson, McCartney and typeface designer Richard Hart. 'We worked very closely with Stella to explore different directions based on her personal style and professional requirements,' says Torstensson. 'We would often visit Stella's studio to study the fabrics and the designs so we could get a very clear idea of the collection – and of course the designer behind it.' The initial brief was to create a logotype for the launch of her own-name brand. 'The logo had not only to convey a sense of luxury but also the freshness, quality, charm and edge that are embodied in the spirit of Stella McCartney's designs.' It was also important that the logo would have longevity, versatility and accessibility to different markets.' McCartney might be based in London, but Gucci is an international luxury-goods group and the new label had to have the same appeal in Dubai as New York, Sydney or Tokyo.

A brand's graphic identity is how it expresses itself, shows what it wants to belong to and talks to its customer with its chosen visual language. The graphic identity will be applied to everything that the brand uses so it is vital to find an expression that suits its values. If your brand has a well-produced and managed graphic identity

or design strategy, it will pay off tenfold. A badly managed and implemented corporate identity can prove to be very expensive and damaging. The responsibility, therefore, is on the designer to get it right. An identity for a brand like Stella McCartney must be as confident and sure of itself as the woman herself.

For any fashion house, a well-designed, universally recognized logo is the key to commercial success. The logo becomes its own currency, whether printed on a T-shirt, embossed on a wallet, packaged around a face cream or, of course, sewn into an item of clothing. No one has proved this better than Yves Saint Laurent, who has one of the most famous and enduring logos in fashion history. He was one of the first to turn to a graphic artist for help in translating the abstract idea of a new fashion house into a logo. Yves Saint Laurent had met A.M. Cassandre through his previous employer, Christian Dior, and he approached the old master (who was already well known for his stylish, graphic posters for Dubonnet and the *Normandie* ocean liner) in the late 1950s to create his own logo. It is said to have taken just a few minutes for Cassandre to sketch the three letters Y, S and L into their elegant, interlocking shape. Those three letters, beautifully and timelessly drawn, were to form the basis of one of the most prestigious and lucrative fashion houses ever. Even people who have never owned a Saint Laurent handkerchief, let alone a piece of *haute couture*, could draw the logo from memory.

Alice Rawsthorn, director of the Design Museum in London and author of *Yves Saint Laurent – A Biography*, says the YSL logo is successful because it is a beautiful piece of lettering. 'It is exquisitely drawn in an instantly recognizable but distinctive style. Also, its central characteristics – elegance and a sleek sensuality – fuse perfectly with those of the brand and it has been reproduced more or less consistently over the years. Those are the generic characteristics of any classic logo and the YSL symbol encapsulates them perfectly.' The logo is so strong, that when the Gucci Group took control of the brand in 2000, it was one of the few things that was not updated. 'Even a visual obsessive like Tom Ford has restrained himself to making just a few tiny tweaks since the Gucci Group took control of YSL,' says Rawsthorn. 'Everything else about the company has changed – but not the logo.'

Fabien Baron is not surprised that Tom Ford didn't change the logo: 'I would not have changed it either. Cassandre was one of the best graphic designers in the world. He was an artist. That logo can stay forever. It's beautiful. It's the lettering, the intricacy of the logo, the way the letters are stacked up. It's very elegant and very French with a sense of history. Why change it if it works? It would be like going to Egypt and changing the pyramids.'

It was in the 1980s, however, that fashion houses began to take graphic design and art direction seriously. Yohji Yamamoto's creative director, Marc Ascoli, was persuaded into hiring Peter Saville by Nick Knight, a photographer who had come to his attention after a series of 100 portraits of the 1980s for *i-D* magazine. Saville's work with the Manchester band Joy Division impressed Ascoli. 'Marc had the confidence in the mid-1980s to break new ground and break new photographers,' says Saville. 'Nick had never shot fashion before, his portraits for *i-D* were as close as he'd come to the style magazine world. But Marc would take a sports photographer if he wanted to because he knows he could put the clothes in front of the photographer and say just take the picture. That's how he started with Nick – he did a men's shoot. As I understand it, during the shoot, Nick asked who would be doing the graphics. Apparently Marc said, 'I don't know. What is the graphics?' He didn't really know what Nick meant. There was not a close relationship of any sort between graphic designer and fashion.'

The graphic designer was, however, already well-established in the music business. Stephanie Nash and Anthony Michael, who formed the design agency Michael Nash after they graduated from St Martins in the early 1980s, had made a name for themselves in the music industry long before they began their work with designers such as John Galliano, Alexander McQueen and Marc Jacobs. 'I think we started off doing music – including work for Neneh Cherry and Massive Attack – because in the early Eighties, there wasn't any fashion to be done,' says Nash. 'If somebody makes music and they have made a record then you have a respect for that music. You have got to be their graphic designer in the same way that if you've made a frock, you've got to graphically represent that brand and that frock. You have got to do the same for the musician.

I suppose we were doing it in a fashion, corporate identity kind of way and I think music sits in the middle and you do all these photo sessions and get heavily involved with the hairstyling and makeup.' Despite the fact that they were at St Martin's School of Art around the same time as John Galliano, and remember him playing with Letraset for his logo in the college library, fashion and graphics students were not encouraged to work together. Nowadays it seems impossible to have one without the other. 'It would have been a great experience doing the final show material for one of the students' shows.' It was not until almost twenty years later that their paths crossed once more and Michael Nash Associates was commissioned to work on a new brand identity and packaging for Galliano, to coincide with the opening of the designer's first store.

Michaël Amzalag and Mathias Augustyniak, the French designers who formed the creative partnership M/M (Paris) in 1991, also work with both music and fashion. It is possible to trace the evolution between their 2001 cover for Björk's 'Hidden Place' single and their two short but impactful seasons' worth of advertising images for Calvin Klein. The two clients could not be further apart – one is fairly specialist, artistic and independent and the other mass-market and corporate – but their markets are surprisingly similar. Fashion houses, no matter how mainstream, need to keep a step ahead if they are to maintain their credibility. M/M (Paris), with their playful, hands-on techniques, including drawing over images and scratching into photographs, have been incredibly influential in the late 1990s and into the new millennium. Their approach is the antithesis to that of Baron & Baron, who has had a long-standing, close, working relationship with Calvin Klein. Baron's work for the company has always been clean, slick and utterly consistent. But M/M (Paris) had a completely different approach.

'The whole set-up needed a shake-up,' says Amzalag. They like to work in bold statements rather than subtle nuances. Their way of making people sit up and take notice of the brand again – of injecting it with some credibility and freshness – was to take the Calvin Klein logo, the very core of the fashion empire, and rip it up and start again. They re-drew it, as a schoolkid might make a doodle in his exercise book. They felt the Calvin Klein brand had become

schizophrenic and needed to have a single stamp to bring all the strands back together again. 'The character of Calvin Klein had become like a ghost,' they say. They wanted the logo to look as though someone had redrawn it from memory. The ads were no longer about the clothes. They were about rebranding a brand that had become so familiar it was almost invisible.

Previously, M/M (Paris) had worked for Yohji Yamamoto. In 1994 they were asked to design ads for the Y's diffusion range for which Peter Saville had drawn the logo. They were, of course, aware of Saville's previous work for the label, and their own work became an evolution of that. 'Peter Saville was one of the first modern art directors,' they say. 'He understood that graphic design is about ideas. He is fed by different fields of creativity.'

At their best, graphic designers have brought to the fashion industry another set of eyes, a fresh perspective and an uncompromising vision. At worst, they are simply another marketing tool, a way for the designer to create a visual peg on which to hang sales of perfumes, face creams, scarves and T-shirts. In the early 1990s, when Saville's contract with Yohji Yamamoto came to an end, he thought there was nowhere else to go in the fashion industry, that it had become a dead end. 'As we got to the end of the Eighties it all seemed really stupid and unnecessary, and there was a recession and it was nonsense really,' says Saville. 'At the time, I said, fashion clients are never going to pay a grand a day. I wrote the fashion business off as a new business area for graphic design. I just couldn't see it happening.' But of course, the domino effect had only just begun. A whole new generation of graphic designers – and fashion designers – had been studiously collecting those Yohji Yamamoto catalogues, as well as *Six*, the ground-breaking magazine published by Comme des Garçons which was one of the defining moments of the fusion between fashion and graphics. 'By the time we got to the mid-1990s, I looked back and reconvened with fashion to see that, oh!, they've embraced the graphic element big time,' says Saville. Fashion designers themselves – the ones who were just starting out and still couldn't afford to pay a graphic designer – were even having a go. 'I looked at the scene in the mid-1990s and fashion had really embraced graphics,' he says. But perhaps it has gone too far. The

design has overtaken the content. Although he says it is what he wished for, Saville confesses that he didn't really want it to turn out like this. 'Design is the new advertising. It's the insidious influence. It was better when it was a form of rebellion, when you had to fight with business. Now it's the other way round. It's entirely superficial. The result of it all is that design loses its credibility, its truth. Rather than design communicating a certain integrity, it begins to be the opposite. If it looks good, don't trust it.'

The whole process has certainly speeded up, and graphic designers are treated much the same as photographers are: with a certain awe and reverence, but also often with the same short shelf-life of a few seasons only. As the fashion industry grows and grows, each company fighting for its slice of the action, what they are saying becomes less important than how they are saying it. There is a conflict of power between fashion and graphics designer. 'What is more powerful,' asks Mathias Augustyniak of M/M (Paris), 'the image or the object?' Presentation is in danger of becoming everything.

Nevertheless, what is remarkable is that fashion graphics have become a genre all their own, often existing in their own private universe occupied by the fashion industry and rarely seeing the light of day beyond that. 'Many times, there are images that could have several lives,' agrees Michael Amzalag. 'In fashion, once you've seen it, it's dead, which I think is stupid because it's not dead. If you are a fashion addict, the idea is to have several cupboards and then you store your old clothing, and then do some kind of rotation – you wait ten years or five years, and pull it out again. It's just a matter of shifting things. Of course you don't wear it with the same shoes.'

So in the spirit of the true fashion addict, this book is dedicated to airing some of the fashion graphics that deserve a life longer than a single season, and telling the stories behind some of fashion's most famous labels.

Although not trained as graphic designers, one of Antoni & Alison's first priorities when they set up in business was packaging and presentation – as important to them as the product itself. Their innovative idea was to vacuum-pack their T-shirts like meat in a supermarket. They have also collaborated on special projects with the design agency Graphic Thought Facility.

ANTONI & ALISON
ANTONI BURAKOWSKI ALISON ROBERTS WITH GRAPHIC THOUGHT FACILITY

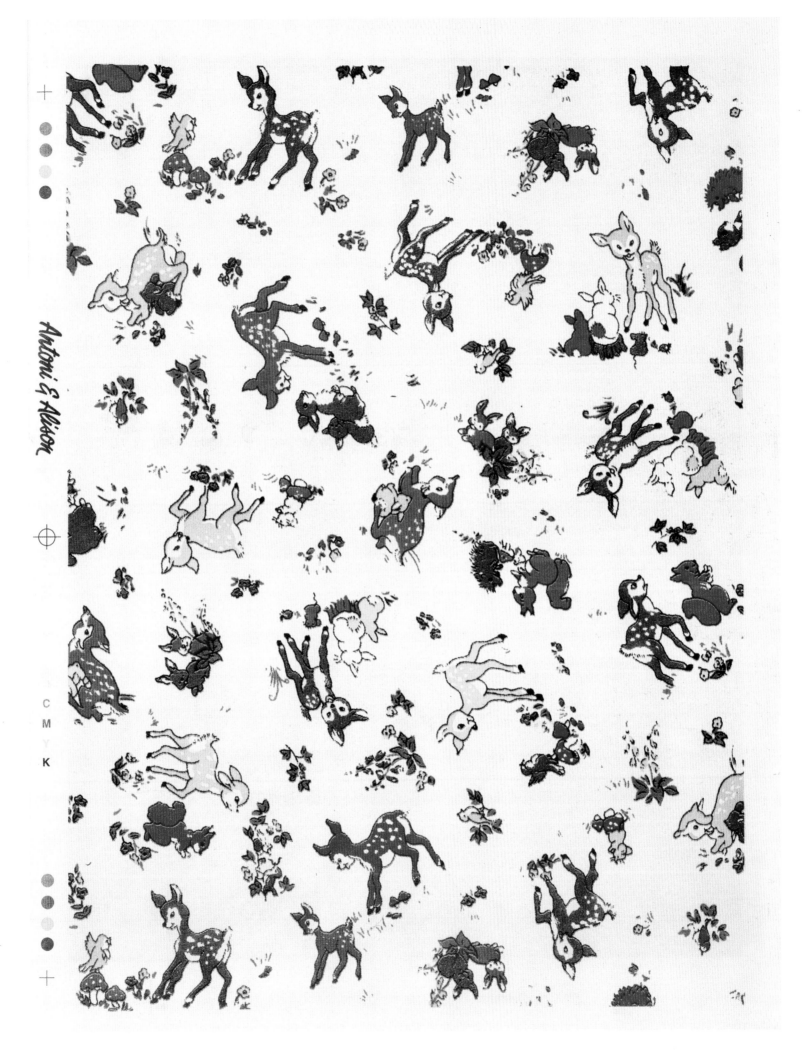

Antoni & Alison

C
M
Y
K

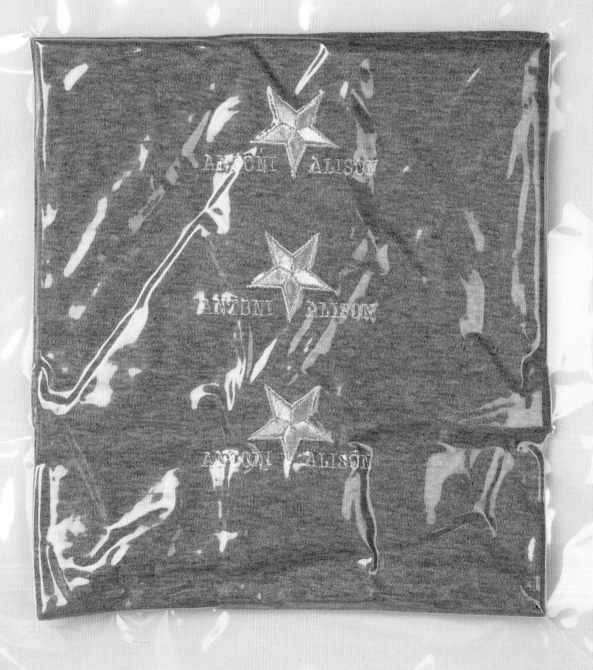

London-based designers Antoni & Alison have a thriving fashion business, with a loyal and enthusiastic following from Los Angeles to Tokyo. Their particular, unique brand of fashion has always relied heavily on their use of graphics, from the logo T-shirts that launched their careers in 1988 to their recent free broadsheet mail-order catalogues, completed with a little help from design agency Graphic Thought Facility (GTF).

'We were never trained in graphics,' says Antoni. 'We just did it. The first thing we always did was write things down.' Alison agrees: 'It was our common ground.' Right from the beginning, their ideas on presentation were as strong as what was inside the package. They invested in a vacuum-packing machine, having been inspired by the packaging of meat and other produce at the supermarket. From the outset, they created a product that looked as good unwrapped as it did wrapped and hanging on the wall as an object in its own right. Their T-shirts were vacuum-packed to keep them fresh, an idea that has been imitated many times ever since.

The designers met at St Martins School of Art in the 1980s. Antoni studied fashion and Alison studied fine art. Their approach has never been trend-led. They didn't so much want to create fashion as a product. 'We thought you needed to have packaging to make a product', says Alison. And a big part of that was graphics and typography. 'We thought what we could write down was better than what we could make.' To communicate their messages, they referred to their bible, the now-defunct Letraset catalogue. They still have the book, 'borrowed' from a friend, and their original logo was simply photocopied from it, because they couldn't afford to buy the actual sheets of type.

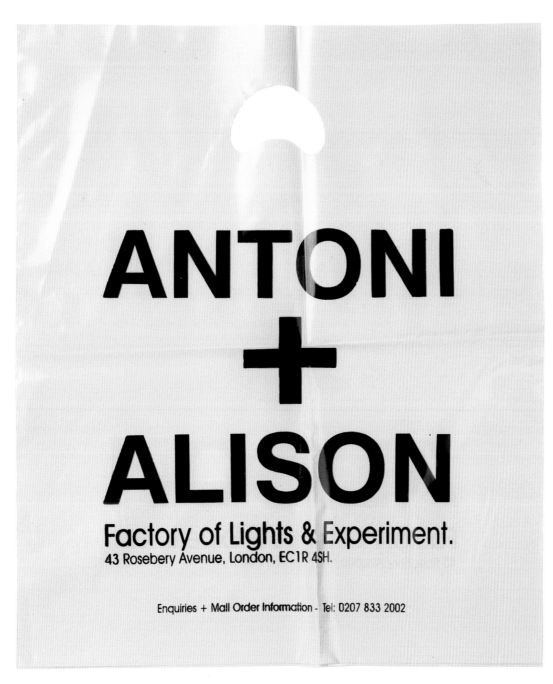

ANTONI
+
ALISON

Factory of Lights & Experiment.
43 Rosebery Avenue, London, EC1R 4SH.

Enquiries + Mail Order Information - Tel: 0207 833 2002

Previous page
Cover of Antoni & Alison's 1998 mail-order news sheet.

Opposite
Antoni & Alison's vacuum-packed T-shirts have been highly influential. Their logo is purposefully inconsistent in terms of typeface and design.

Left
The design duo's carrier bag is a basic affair, printed simply in black on cream. It is a utility item.

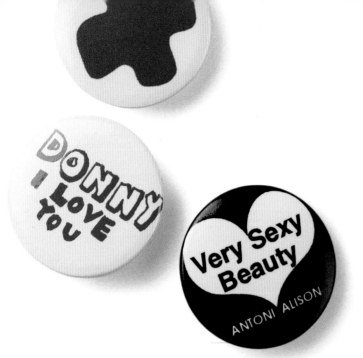

For their collection for spring/summer 2003, they explored different logos, putting several on a single item of clothing at the same time. As well as printing them, they use woven labels, and use their graphics woven into the actual fabric as a repeat pattern. They never take it too seriously, putting their names upside down, or making comical caricatures of themselves. Their drawings are themselves pared down and simple, inspired perhaps by the sheets of people and images from the old days of Letraset.

Their typefaces are always plain, sans serif and very simple. Arial black is a favourite, or Antique Olive Compacta. They have about four or five they usually choose from. 'The word is more important than the font,' they say. 'Take the word "swanky",' explains Antoni. 'It doesn't need much mucking about with. It needs something quite basic. We hate being too design-y. We pare it down to an absolute minimum.'

NOBODY UNDERSTANDS ME
Antoni And Alison

Bird And Spider
ANTONI AND ALISON

ART NOUVEAU ANARCHIST
Antoni And Alison

Opposite above
Antoni & Alison like to
spread their message
on simple metal badges.

Opposite below
The designers' woven
logos take on a life of
their own.

Left
Their attention to detail,
here on a series of clothing
labels, is unlimited.

Below
For the invites to their
spring/summer 2001 show,
'13', the designers combined
humorous self-portraits
with simple graphics.

ANTONI

ALISON

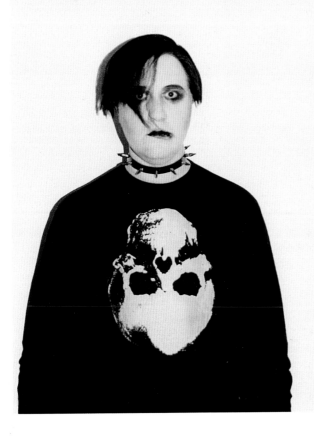

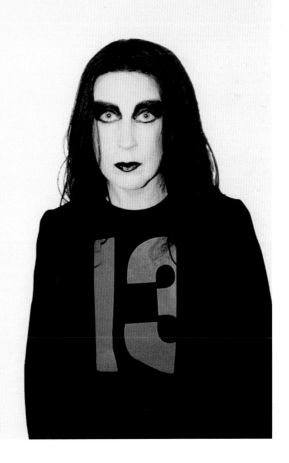

Right
Antoni & Alison cannot resist
using words and graphics.
The word 'modern', used as
a logo on a T-shirt, is scrawled
in capitals by hand. Their
collections often begin this
way, as words on paper.

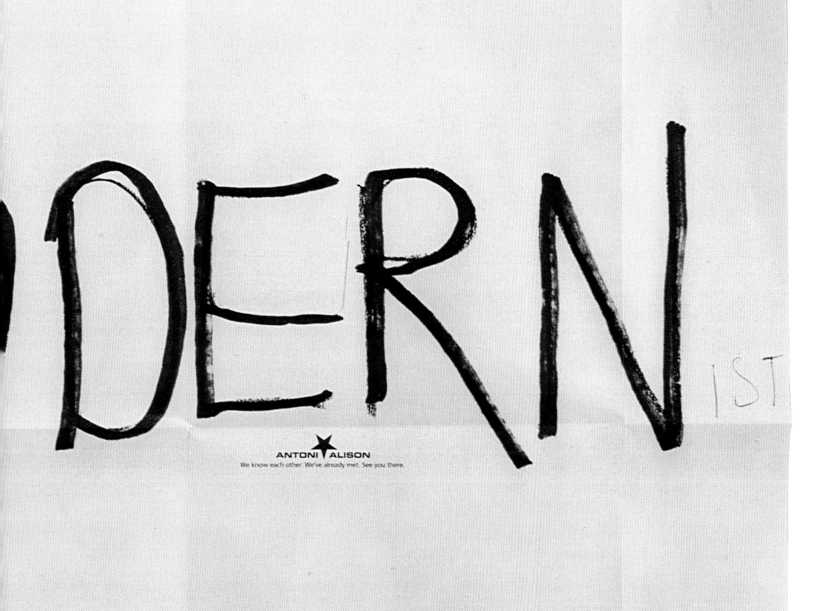

ANTONI ★ ALISON

We know each other. We've already met. See you there.

Their business has developed to cover a wider range of clothing, from knitwear to bags, hats, purses, dresses and skirts. Their graphics are usually present in one form or another, be it in the form of a word or a slogan ('All men are pigs', say) or as a print. They use a lot of their own photography, transferring unlikely images – like a banana photographed to imitate a Nike tick – onto their clothing. Or they will use a print as a symbol; instead of making a skirt with pleats and ruffles, they will print a simplified, naive *trompe l'oeil* pattern instead. The graphics in their work usually serve to inject an element of humour or wit. 'The way we design is very flat and one-dimensional,' says Alison. 'Instead of actually sewing on buttons, we print them; instead of making ruffles, we draw them. Our clothes are like paper cut-outs. We are flat designers.' Everything they do is worked out on paper first. Much of their collection begins as words on paper and part of their task as designers is to communicate those words to the wearer or the consumer. For them, graphics and fashion

are all part of the same package. For their shows, they also make films – very arty and experimental – as well as using their abstract photography to sell their collections. Their recent mail-order catalogues, printed on newsprint like free newspaper handouts, exploits their graphic skills fully. For technical advice and further input, they worked with the graphics company, Graphic Thought Facility (GTF). It was an ideal opportunity for them to produce something totally graphics-led. They saw it not as promotional material but as an intrinsic part of their work.

This page and opposite Antoni & Alison's mail-order catalogue shown here from 1998 (this page, top right and bottom left) and 2000 (this page, bottom right and opposite), are as important to them as their collection. They worked with Graphic Thought Facility to create a 'free-sheet' style newspaper, printed on presses used by local papers.

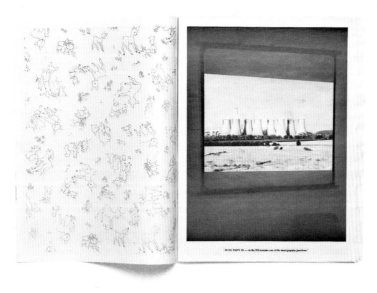

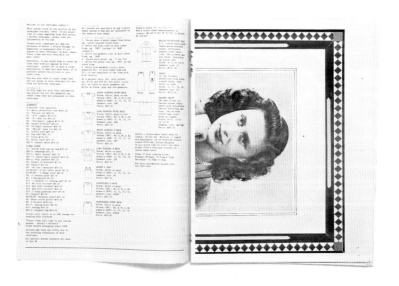

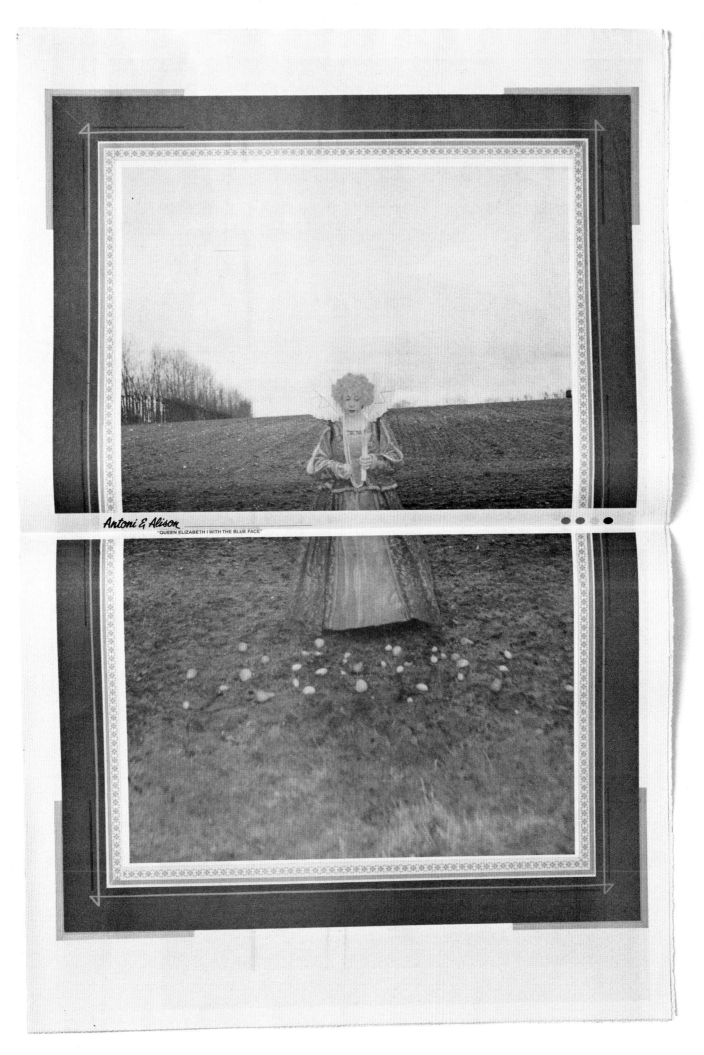

Antoni & Alison
"QUEEN ELIZABETH I WITH THE BLUE FACE"

In 1998 Issey Miyake launched a new label. It was called
A-POC (literally, A Piece of Cloth) and was a whole new
way of looking at, making and wearing clothes. Since then,
the brand has developed its own graphic language, with
a little help from the Paris-based commercial film director
and computer graphics specialist, Pascal Roulin, whose
involvement began with a series of short animated films.
Born in Belgium in 1958, he has worked with companies
such as TDK, Evian and Panasonic DVD.

A-POC
ISSEY MIYAKE INC.
PASCAL ROULIN

Issey Miyake has a very graphic approach to his work. His highly innovative clothes have been photographed over the years by Irving Penn as bold, abstract shapes and can be viewed flat as well as on the body, when they take on their own three-dimensional shape. In 1998, he launched a new concept in clothing: A-POC. Together with his design associate, Dai Fujiwara, he developed a way of manufacturing clothes that used a new computerized, industrial technique. The clothes were literally knitted in a single tube and rolled off the production line as a single piece of cloth. In the first collection, it was up to the wearer to finish off the process and cut around the dotted lines to reveal an entire capsule wardrobe, including dress, top, shoes, socks, hat and bag. A new process of making clothes needed a new way of communicating how to wear it to the consumer.

For a retrospective exhibition, 'Issey Miyake Making Things', at the Fondation Cartier pour l'Art Contemporain in Paris, the company commissioned the photographer Marcus Tomlinson and the Paris-based film-maker Pascal Roulin to make some films, with computer animations to explain the manufacturing process of the A-POC. 'They were looking for an entertaining way to present in animation several process developed by Issey Miyake in a section of the exhibition called "Laboratory",' explains Roulin. 'We made six films projected in a loop on the floor, at the foot of the garments worn by mannequins and flat materials hung on the walls.' Roulin worked in collaboration with Issey Miyake's director of communications, Midori Kitamura, and their relationship – although long distance – has been a fruitful one.

A-POC 1|1999

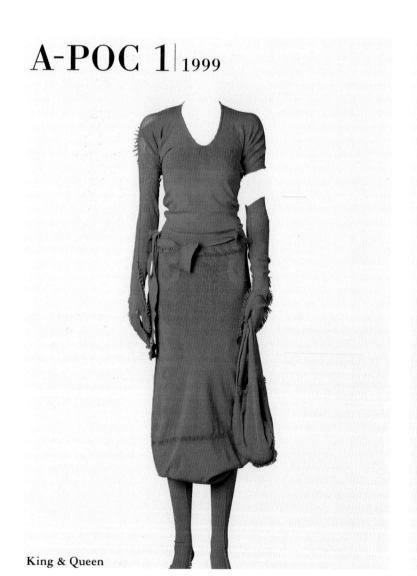

King & Queen

King & Queen

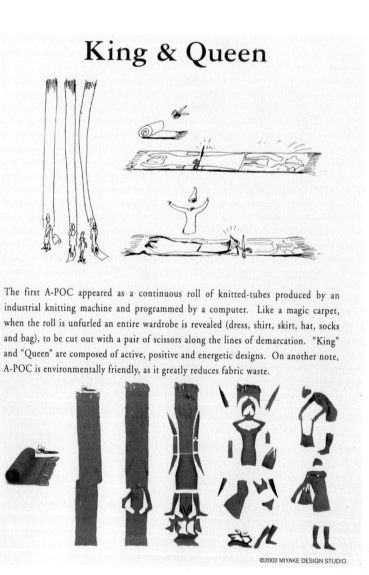

The first A-POC appeared as a continuous roll of knitted-tubes produced by an industrial knitting machine and programmed by a computer. Like a magic carpet, when the roll is unfurled an entire wardrobe is revealed (dress, shirt, skirt, hat, socks and bag), to be cut out with a pair of scissors along the lines of demarcation. "King" and "Queen" are composed of active, positive and energetic designs. On another note, A-POC is environmentally friendly, as it greatly reduces fabric waste.

'From the beginning Issey-san told me, "I'm concentrating on making clothes; for the image part, you work with Midori." Usually the brief is very technical: showing me the new prototypes, telling me the planning of an event or of a publication, the tight schedule, and from that I propose a solution, and see her reactions. Midori is driving the image side like a chef, my part is modest. She uses graphics or animations the way it suits their needs.' The graphic images have been used extensively by the company as publicity stills to communicate the interactive process of the making and wearing of the collection.

Previous page
The carrier bag for the A-POC is as futuristic as the concept of the clothing itself.

Opposite and below
The Miyake design studio produced this series of instruction cards in 2001, demonstrating the evolution of the A-POC using computer-generated images.

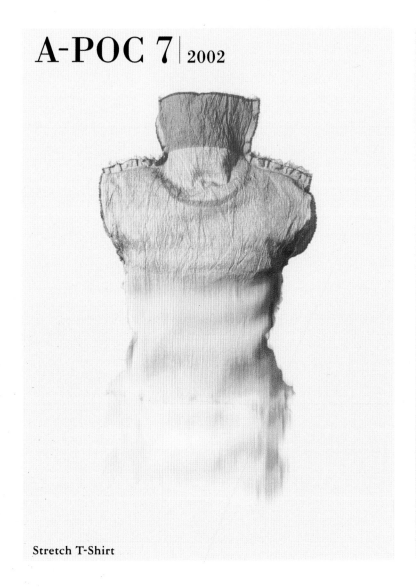

A-POC 7 | 2002

Stretch T-Shirt

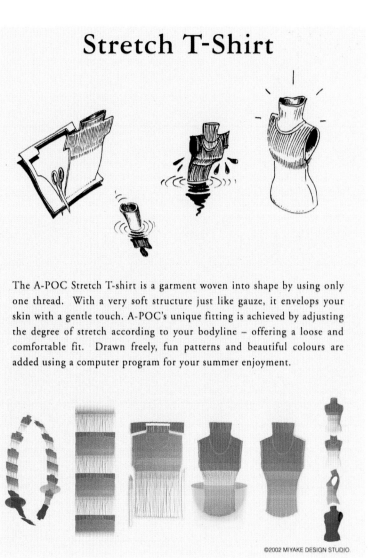

Stretch T-Shirt

The A-POC Stretch T-shirt is a garment woven into shape by using only one thread. With a very soft structure just like gauze, it envelops your skin with a gentle touch. A-POC's unique fitting is achieved by adjusting the degree of stretch according to your bodyline – offering a loose and comfortable fit. Drawn freely, fun patterns and beautiful colours are added using a computer program for your summer enjoyment.

©2002 MIYAKE DESIGN STUDIO

Below and opposite
Issey Miyake commissioned
Marcus Tomlinson to make
a series of short films to be
shown in gallery situations.

As well as brand identity, it was
important to communicate
how the A-POC is worn.
Tomlinson's series of images
demonstrated this perfectly.

Although not a graphic designer, Roulin's ideas and sketches have become the visual language of A-POC. The logo began life as a simple sketch for a presentation idea: 'I wanted to make a jumping animation in a loop, symbolizing the spirit of A-POC.' It caught Miyake's eye. 'When the animation was done, they asked me to use it for the logo.' It just seemed to fit, partly – says Roulin – because it looked like nothing else before it. 'It's a fresh and fun adventure,' he says of the project. He has tried to project the spirit of Miyake's co-designer, Dai Fujiwara. 'He is like a boy showing his toys.

The clothes are fun to cut and wear – the same mood that we tried to express through the animations. Clever design can transform into many things. The logo expresses the beginning of the A-POC adventure, though it's now growing into many directions. But the essence of "clever design", surprising and fun, is still there.' Roulin regards A-POC as industrial design rather than fashion, but understands that a logo must have a strong impact. 'It's what we recognize from afar. It can tell you a lot of information in one split second. If it's well made, and if the brand is good, it can last.'

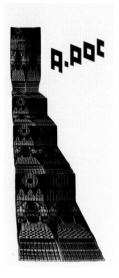

BERLIN DISTRICT

Just like biscuits made using a mold, A-POC "Framework" proposes a multitude of choices in colour and material within the same form. Straight dresses are tapered towards the hem in a stretch fabric, complemented by a hat. The fabric has a woven pattern consisting of black warp threads and 6 different weft threads evocative of the streets of Berlin. A city that is constantly evolving as is A-POC.

BERLIN DISTRICT

Comme des biscuits faits à partir d'un seul moule,"FRAME WORK" propose une multitude de variations à partir d'une même forme dans différentes matières et couleurs. Des robes droites resserrées dans le bas par un tissu élastique s'agrémentent d'un chapeau. Ce tissu écossais réalisé à partir de la chaîne noire et de la trame de six couleurs évoque l'image des rues berlinoises. Une ville en perpétuelle changement tout comme A-POC.

ベルリン ディストリクト

クッキー型のように型の枠組みを決め、素材や色で変化させる「フレームワーク」から、またすてきなバリエーションから、裾に向かってストレッチ性を強めたスレンダーなワンピース+帽子。黒の経糸の緯糸に6色の糸を織り上げる様子は、ベルリンの街並みをイメージしました。ダイナミックに進化する都市に、A-POCの未来を重ねて。

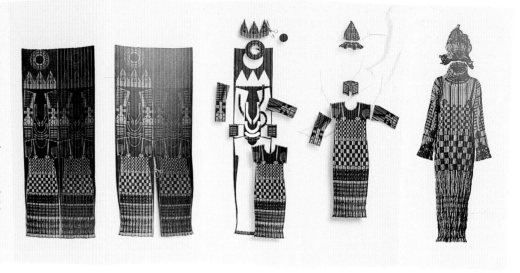

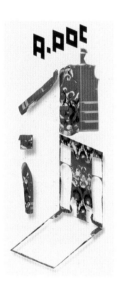

CHOIR COTTON

For the forthcoming autumn and winter, A-POC has become warmer, more comfortable and stylish. The latest A-POC introduces a new jacket series "Framework" in which the textures of the weave as well as the colours can be changed at will, using the computer. You can wear these jackets over "Baguette" or "One Piece" since these jackets are both roomy and lightweight. "Choir Cotton" represents the fine line that A-POC has achieved three-dimensionally within the very process of its creation. Ever-evolving, A-POC has endless potential much like a seed growing into a tree, that fast becomes an entire grove of trees in a forest.

CHŒUR DE COTON

Pour l'automne et l'hiver à venir, A-POC devient plus chaud, plus confortable et aussi plus élégant. Et suivant sur la combinaison encore plus libre, la méthode de "Framework" se diversifie en revêtant l'idée de "patron" selon la philosophie d'A-POC, le vêtement conçu comme un corps se compose ou s'assemble corps à corps spécifiques. La géométrie d'A-POC passe de l'espace plat euclidien au relief tridimensionnel pour une série de vestes inédites aux formes surprenantes. Comme la graine qui germe devient arbre et donne naissance à la forêt, A-POC se développe suivant la logique du vivant, en perpétuelle mutation.

クワイア コットン

秋から冬へ。A-POCがもっと暖かく、着心地よく、スタイリッシュになりました。コンピュータ操作で自由に織りや色を変えられるフレームワークの最新作……ジャケットシリーズの登場です。バゲットやワンピースの上に、ゆったり軽く重ねてくれます。フラットな2次元から今回初めて立体的な3次元の新たなヘ。一粒の種が木になり森になるように、進化を続けるA-POCのバリエーションは無限です。

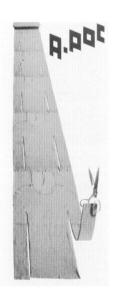

BAGUETTE

Just like the French bread, cut it wherever you like. A marvelous stretch-knit series. Four items, born from one shirt, depending upon where the lines of demarcation are cut. No matter where you cut, it will not unravel. Shorten a sleeve, or cut a slit on the side, it is totally up to you. You are the designer. All you need is a pair of scissors.

BAGUETTE

Tout comme la baguette que le monde entier envie à la France pour sa saveur et sa simplicité, A-POC "BAGUETTE" peut se couper où vous le désirez. Et répondre à vos envies de changements ou aux caprices de votre fantaisie sans s'effilocher. Participez aux joies de la création à l'aide d'une simple paire de ciseaux!

バゲット

フランスパンのバゲットのように、お好きな形に切って着るふしぎなストレッチニットのシリーズです。案内線に沿ってカットすると1つのシャツが4つのバリエーションが生まれます。案内線以外で切ってもほつれません。袖を短くしたり、スリットを入れたり、ほぼひとつで、あなたがデザイナー。パンツ&スカートもある、フルアイテムで、ご自分だけの形を作り出してください。

 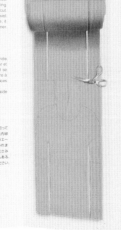

Most of the early A-POC presentations used computer graphics. It seemed the most logical way of showing the futuristic clothes, and could also demonstrate the interactive element between the wearer and their wardrobe. In 2002, for a touring A-POC presentation, Miyake introduced a more human element, with hand-drawn illustrations demonstrating how the clothes can be worn. 'Drawings make the A-POC more accessible,' he said. Like the original logo, they are all sketches by Roulin, rough ideas and storyboards for animations. 'Sometimes, they asked me to draw "like you do for your sketches" some specific items, like for the floor map of the Tokyo exhibition, and for the catalogue. I take it as a joke, it's very quick for me to draw like that. But I agree with them that the balance of rough drawings, and highly sophisticated computer-designed frameworks, makes a special blend by contrast.'

Opposite and below
The A-POC lends itself well to two-dimensional graphic renderings showing how the costumes come to life from a flat tube of fabric. The logo was designed by Pascal Roulin.

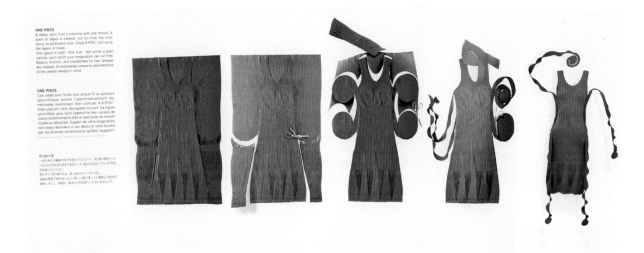

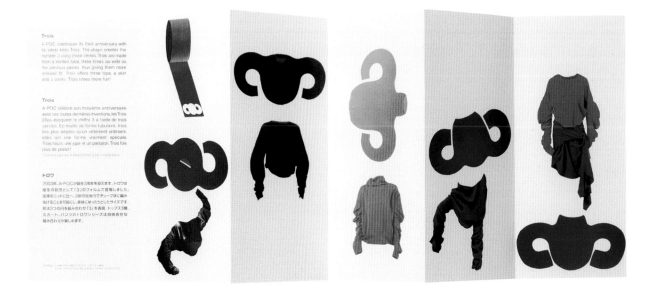

Working with his in-house graphics team, Giorgio Armani oversees the graphic presentation and identity of his fashion house. Every logo, T-shirt label, fragrance bottle and carrier bag is created under his direction. For the launch of his cosmetics collection in 2000, slickly presented in chic matt black, he worked with Fabien Baron. The Armani logo itself has undergone subtle changes since it was created in the 1970s.

ARMANI
GIORGIO ARMANI

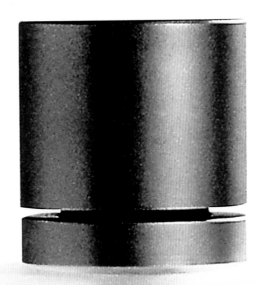

ACQUA DI GIÒ

GIORGIO ARMANI

POUR HOMME

With the entire Giorgio Armani brand, all direction comes from the designer himself. This includes the graphic identity, which has gently and gradually evolved over the years under his watchful eye. 'When my business partner, Sergio Galeotti, and I founded the Giorgio Armani Company, we had a very specific idea in mind for our logo,' says Armani. 'We wanted it to be simple, elegant, strong and easily identifiable – almost as if the characters were engraved in stone.' Together with a logo consultant, they created their own typeface which has been consistent throughout the label's history. 'In the Seventies, the original Giorgio Armani logo had the "G" and the "A" slightly bigger than the rest of the letters. In the Eighties, we decided to make all of the letters the same size, keeping the original width and typeprint. But then in the Nineties, I decided to downsize the actual letters and make the logo slimmer, lighter and, ultimately, more elegant.'

For Armani, consistency is everything, both in the product itself and the way the product is communicated to the consumer. His fashion philosophy is 'evolution, not revolution'. 'Customers identify the style, an image and a sense of security with a label. As with fashion, if one continually changes elements, style and identity just to follow a trend or fad, consumers become confused and lose faith in your product.' So the Armani label sends out a very specific message, one that is impossible to confuse. 'A designer label is his or her business card,' he says. 'It not only reflects the spirit and integrity of each collection; it also expresses the philosophy and character of the line to the customer. The final product is the most important part of the package, but a label and logo secures a recognizable identity.'

GIORGIO ARMANI

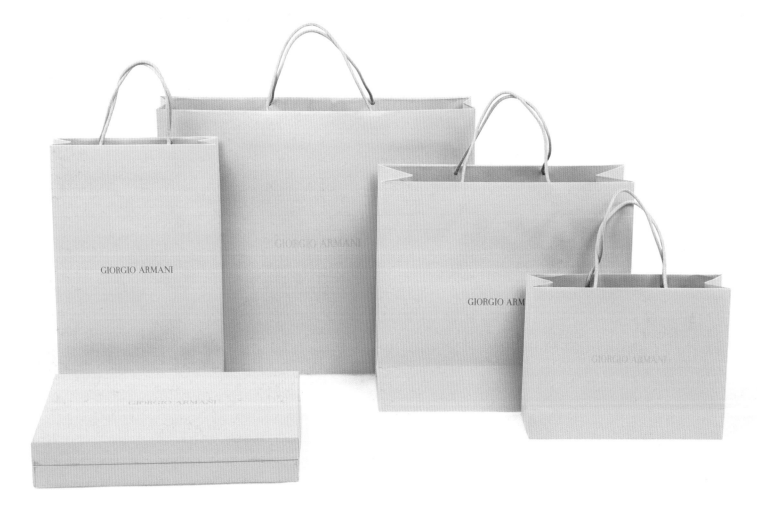

Even in 1975, when Armani first launched his label, he knew the power of branding and of creating a strong signature logo. He employed a graphics team in-house, to ensure that the graphic image remained as important as the clothes themselves. 'I think it is essential to present a coherent point of view. It is a natural extension to what my products are trying to express and reflect. Rather than look at these two elements (graphics and fashion) separately, they need to be complementary and continuous, as this is what gives a brand its identity.' The in-house team works on all of the visual layouts of the Armani logos as well as the art direction of the advertising campaigns and catalogues. 'I work very closely with a small group of designers,' he says. 'However, at the end of the day, I am the one who makes the final decision.'

Previous page
A men's fragrance bottle is stamped with the Armani signature.

Opposite
The packaging for Giorgio Armani is classic and uniform throughout. The logo was designed to be simple, elegant and easily identifiable, as if the characters are engraved in stone.

Below
Armani Jeans packaging is just as focused and strongly identifiable, although the plastic packaging gives it a more functional feel.

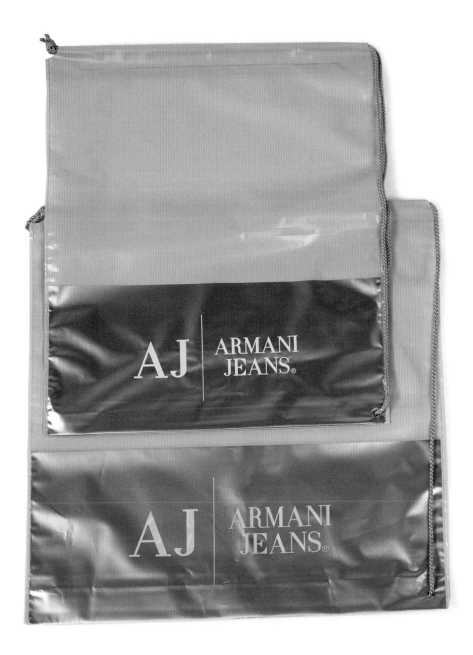

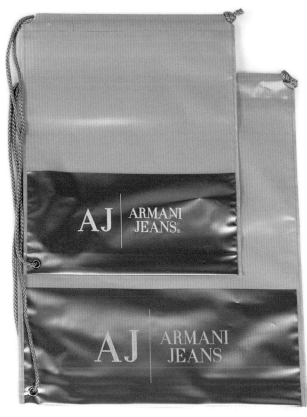

The Armani logo has become part of the landscape of Milan itself, with its own special place on the side of a building in the centre of the city, where larger-than-life adverts are changed each season; his Emporio Armani logo is so powerful, it is the first thing you see when you land at Milan's Linate Airport, high and mighty above an aircraft hanger. 'Emporio Armani was launched in the early Eighties, and again, we had a very clear idea of what we wanted as a logo.' Working with a graphic consultant, they created the eagle symbol, separating the words Emporio and Armani, giving the logo its own identity separate to the Giorgio Armani logo. However, the eagle soon became a victim of its own success. 'By the end of the Eighties, this line had become very successful so we ran into the problem of counterfeit products. The bigger logo was extremely easy to copy, and with the growing problem of fake Emporio Armani items,

we downsized this eagle logo. It changed again in the Nineties, when the logo became slimmer and more refined, and the eagle a smaller element within it.' The eagle was used again for the launch of Armani Jeans, but in the 1990s, it was removed to avoid confusion with the Emporio Armani collection. By the late 1990s, the Armani Jeans logo was refined again, to 'AJ/Armani Jeans' to make it more strongly identifiable.

EMPORIO ARMANI

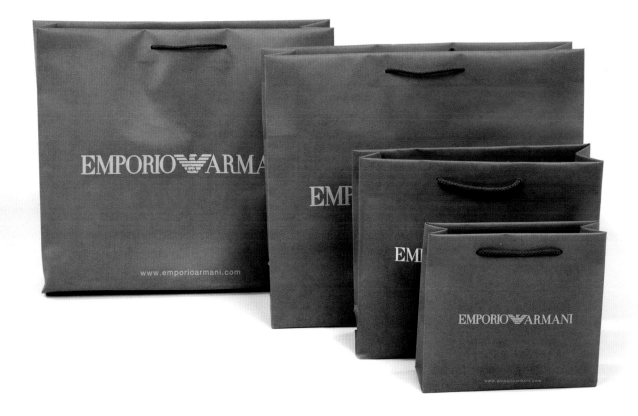

Left
The Emporio Armani eagle has become a recognizable logo in its own right. The eagle had to be downsized in the 1990s, however, as it had become too much of a target for counterfeiters.

Opposite
Fabien Baron consulted on Armani's cosmetics packaging.

For the launch of his cosmetics line in 2000, Armani worked with Fabien Baron, who consulted on the packaging as well as the advertising. 'I have known Fabien Baron for many years,' he says, 'through his success with the various publications such as American *Harper's Bazaar* and *Arena Homme Plus*. When working on the launch of Armani Cosmetics, I wanted to portray this line as a luxurious, rich, elegant collection of colour palettes and beautiful textures. Something special, something individual, something understated, yet something very identifiable. The packaging needed to reflect this philosophy – hence the idea for the sleek, opaque, black minimalist packaging. Fabien instantly understood what I wanted to do ... his talents and capabilities seem to beautifully mirror the idea that I wanted to portray.'

Part of Giorgio Armani's phenomenal success over the years has been his grasp of graphics and the importance of applying them directly and consistently. Every aspect of the brand has his signature on it. While other designers might have wanted a redesign after more than twenty-five years, Armani knows that his logo is his brand – solid, reliable and well beyond the vagaries of fashion.

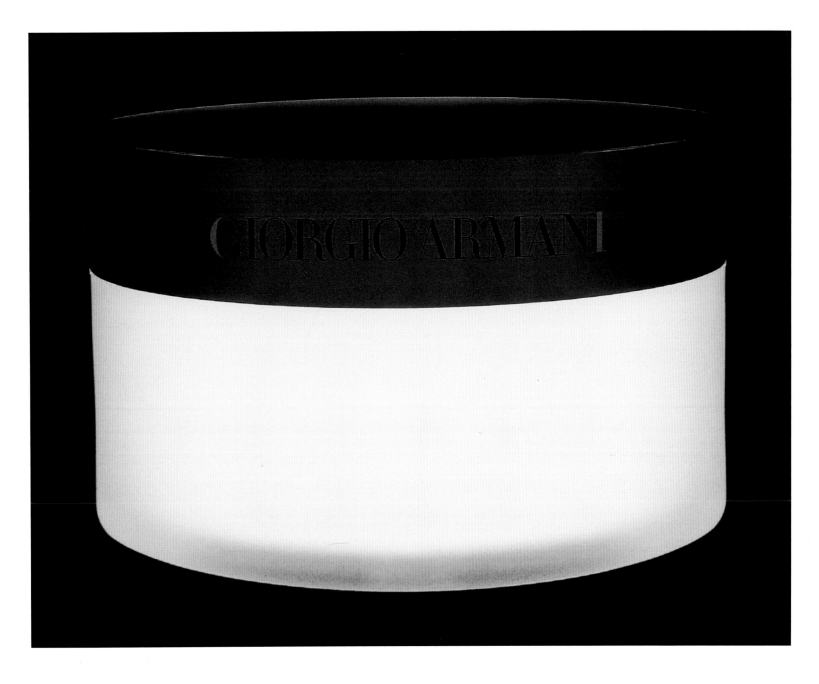

Boris Bencic was a magazine designer and art director before he was hired by Bally to create a new graphic identity for the ailing Swiss shoe brand. He has worked on magazines such as *The Face*, *Arena Homme Plus* and *Frank*. Together with creative director Scott Fellows, Bencic has refreshed the image of Bally, revitalizing it for a sharp and competitive new market and a new millennium.

BALLY
BORIS BENCIC
SCOTT FELLOWS

By the late 1990s, the classic Swiss shoe and bag company, Bally, was looking tired and out of synch with the times. The company was founded in 1851 by Carl Franz Bally in the little hamlet of Schoenwerd. But in 1999, it was bought by the Texas Pacific Group, an American company that believed Bally was underachieving. Scott Fellows, a 37-year-old American with an MBA from Harvard, a stint at New York's Fashion Institute of Technology and head of marketing at Salvatore Ferragamo, the luxury Italian shoe company, was enlisted to head the brand's creative direction.

'Bally is one of the biggest brand turnarounds in history, possibly bigger than Gucci', says Fellows. 'Bally had been in decline for almost twenty years. It is like changing the engine of a plane mid-flight.' It wasn't just the product, but the advertising, the store design and, above all, the brand image. One of Fellows's first moves was

to employ graphic designer Boris Bencic to build a new corporate image for the brand. Bally was to rid itself of its conservative, fuddy-duddy reputation and find a younger, more dynamic and altogether cooler look.

Fellows had met Bencic when he was art director on the short-lived British fashion magazine, *Frank*. Previously, the designer had worked as art director at *The Face* and *Arena Homme Plus*. His outlook has always been very European. He was born in the former Yugoslavia and brought up in Sweden, although he is now based in New York. He was a magazine man through and through; creating a corporate brand was new territory for him. But between them, art director and creative director had a strong working relationship. What appealed to Bencic was that this job would not involve boardrooms and committees in suits. 'I work a lot on instinct,' he says, 'Scott

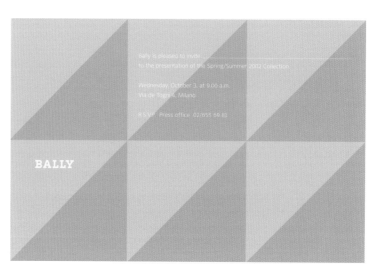

inspires me as much as I inspire him.' Because of his own initials, Bencic had been doodling 'Bs' all his life. Now he was being paid to do it, and his 'B' has made the transition from sketchbook to bags, jackets and shoes. 'The original Bally logo was very classic,' he says. 'The previous team had completely got rid of it and made it into a thin black box with Gill Sans type. It didn't look luxurious. I preferred the old logo. A luxury brand is old; there's a heritage.' He commissioned typographer Hubert Jochan to work on the old logo and he fixed the typography. It was a subtle but distinctive change; he made it wider and more spaced out. Bencic then used the logo very small.

Previous page
The Bally 'Busy B' logo is made into a bag. Graphics become the product.

Opposite above
Bally invitation for womenswear spring/summer 2002 show. Designer Boris Bencic and Scott Fellows. Invitations are inspired by details and colours from the collection. Bencic describes these ones as a little bit of Art Deco combined with the paintings of Ellsworth Kelly.

Opposite below
Bally invitation for menswear spring/summer 2002 show. Designer Boris Bencic and Scott Fellows.

Below
Bally invitation for menswear autumn/winter 2001 show. Designer Boris Bencic and Scott Fellows. The graphics here reflected the idea of a military-inspired collection. Bencic and Fellows considered the idea of camouflage to be over-exploited, so the result is an abstract and geometric interpretation.

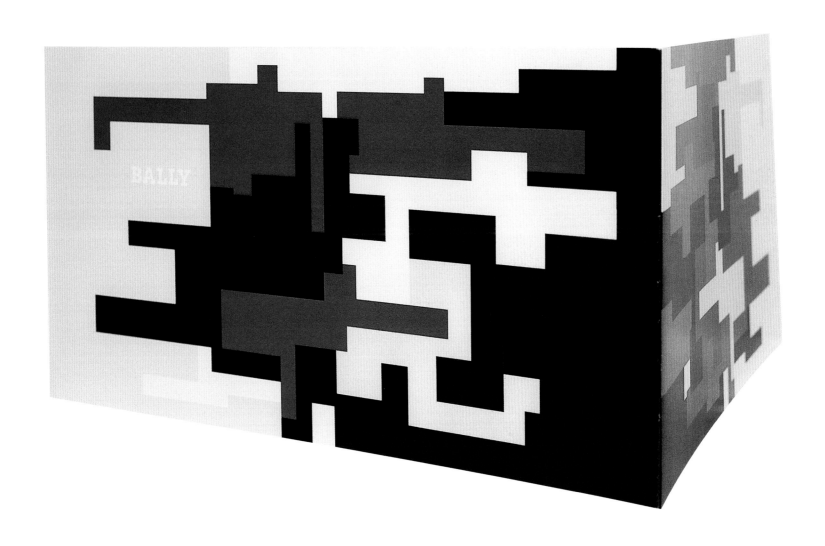

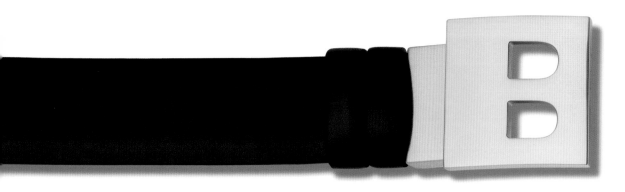

Above
'B' belt from spring/summer 2001. Bally's variation on the logo belt.

Below
'B' keyring from spring/summer 2001.

Right
'Busy B' wallet from spring/summer 2002. The 'Busy B' pattern was created as Bally's 'signature print'. The idea was to make a large print in bold colours with Scandinavian echoes from the 1970s. Each season uses a new colourway, playing off both clothes and other accessories.

Opposite
Bally advertising campaign autumn/winter 2001/2002. Photographer: Sølve Sundsbø. This campaign reflects an important idea at Bally, that 'nature is a true part of modern living'. Having shot on location in previous campaigns they opted to separate the two elements this time; nature in its purity and essence, fashion in a calm and clean manner in a studio. All the landscapes were shot by Sundsbø on location between Lugano and St Moritz in Switzerland.

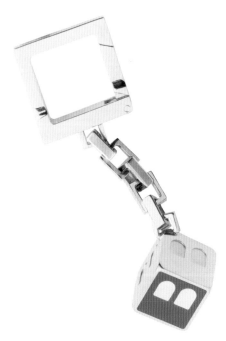

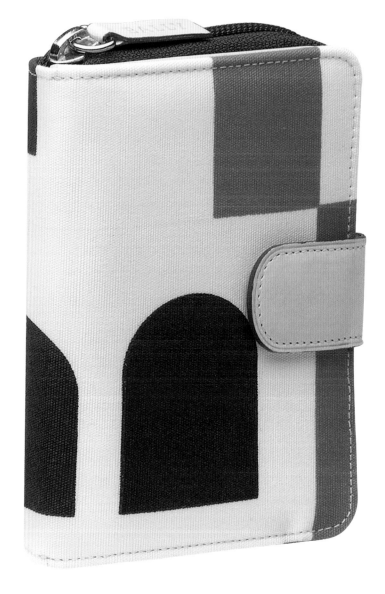

Every brand must have a mark – the 'G' for Gucci or the double 'Cs' of Chanel – and so Bencic set about creating a mark using the letter B. He was doodling in front of the TV when he came up with it: a negative of the Bally B, with a Swiss cross giving it some geometry. He did it in red and white, the colours of the Swiss cross. It was the mark. It took six weeks to complete. 'There are two rules that no one is allowed to break,' says Bencic. 'The Bally logo can never be black – it cheapens it a bit. And the mark can never be printed. It is either embossed into leather, or enamelled onto accessories like a padlock.

The distinctive colours of the packaging were just as instinctive. 'Afterwards, when we intellectualized it, there was camel, the colour of skin, leather; white, the colour of snow; brown is wood – some say chocolate – and it's the Swiss red. But it is also blood. It's all nature. Nature is the true point of modern living. It's where nature and modernity meet.'

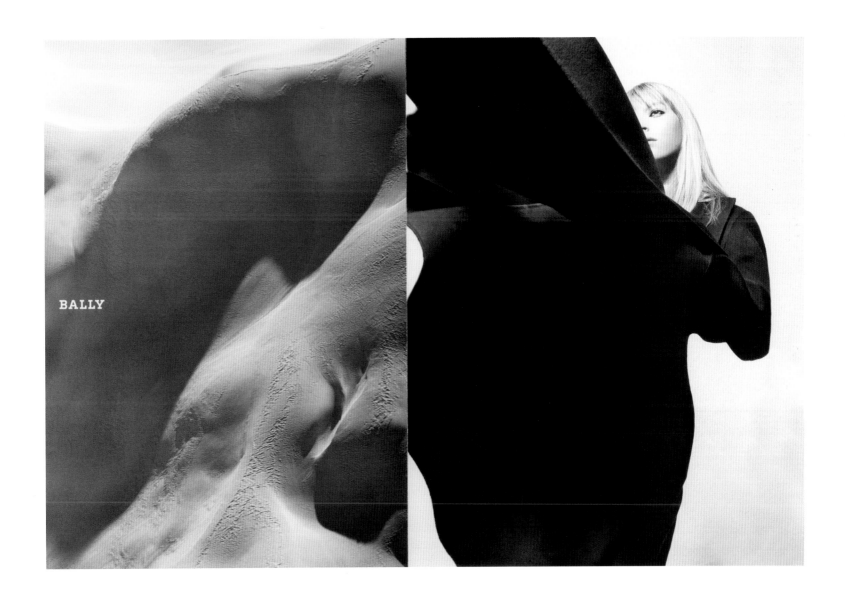

BALLY

Below
Bally advertising campaign
spring/summer 2002.
Photographer: Sølve
Sundsbø. For this campaign
the idea was of dryness
and an abundance of light.
Again Sundsbø travelled
across ungodly terrrain; from
Las Vegas to Death Valley,
to capture landscapes
reflecting this mood. The
fashion was shot against
the sky engulfed by the
sunlight to create a vast
and light feel.

Opposite above
Bally keyring autumn/winter
2001/2002. This is the
original 'mark' for Bally made
into a keyring. The mark was
always meant to be physical
(in products) and not graphic
(printed on paper). The
keyring is a perennial item
and is produced in different
colourways each season.

Opposite below
Bally advertising campaign
spring/summer 2002.
Photographer: Sølve Sundsbø.

Bencic's contract was for three years, and it ended in 2002. During that time, he lived and breathed Bally. 'I was so involved, I didn't need to be briefed before a campaign. I was utterly focused on it and couldn't have done anything else in that time.' He went to every design meeting with the product teams and watched the product develop and grow. He was responsible for the windows, the watches, the silk products and even the music in the stores. Bencic and Fellows had a unique way of working for such a big corporation. Each season, they would gather together the design team and ask everyone to bring something to the meeting. 'We all did it together. It was very democratic. We were trying to tap into what was beyond what was going on at that particular moment.'

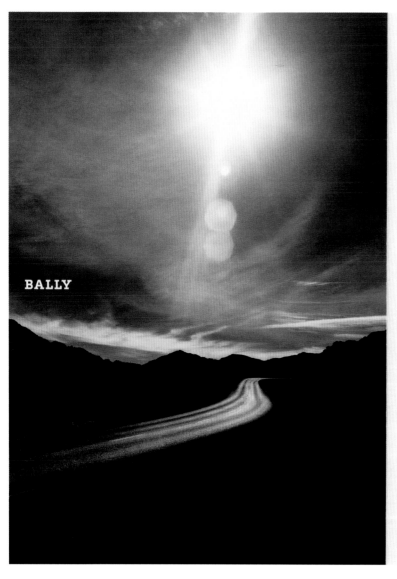

'At the beginning, we went on common sense of what a brand is. It was at a time when everything was being designed just for the sake of it – the wine-bar design ethic. For Bally, the approach wasn't change for change's sake, but a process of modernization. It's a bourgeois brand,' says Bencic. 'So we thought, "Let's do the new bourgeois." Bally's strength was quality in the past, not design. It was important not to lose that sense of quality and history.' Bencic's corporate identity for Bally is utterly consistent and focused. He has still managed to retain some of the old values of the brand, but has reinforced them with a fresher, more contemporary approach that runs from the swing tags through to the embossed leather soles of the shoes.

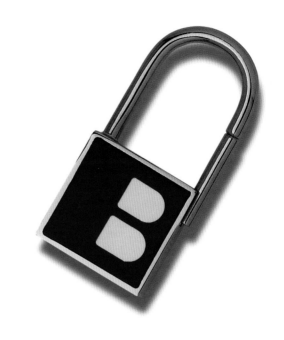

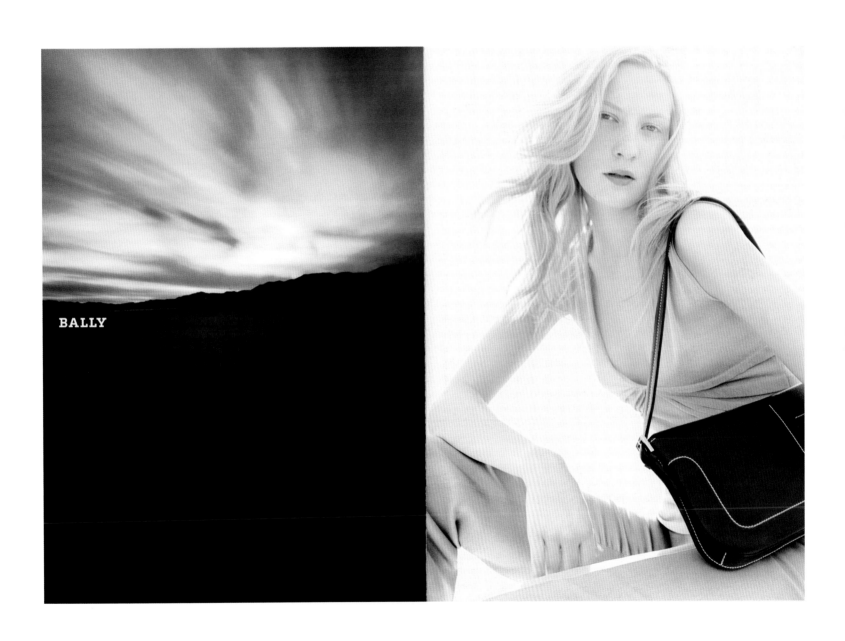

BALLY

Work in Progress has offices in Paris and New York, working on consultancies for brands, visual identities, packaging and advertising. It was founded in 1993 by Ezra Petronio and Suzanne Keller, and has recently worked on the rebranding of Cacharel and on the creation of an identity for the Italian manufacturer Gibo's new range, designed by Julie Verhoeven. The design company also publishes the magazine *Self Service*.

HUSSEIN CHALAYAN WORK IN PROGRESS

hussein chalayan

ambimorphous

fall/winter 2002
friday march 8th at 8pm
cité de la musique
rue musicale
221 avenue jean jaurès
porte de pantin
75019 paris

name: _____ seat: _____

press enquiries: karla otto, paris. tel: 33 1 42 61 34 36. fax: 33 1 42 61 58 91 - buyer enquiries: cvdc, paris. tel: 331 4261 9980. fax: 331 4260 1270
l.a. distributione, milan. tel: 39 02 336 14721. fax: 39 02 336 14754 - usa - onward kashiyama, new york. tel: 1 212 629 6100. fax: 1 212 629 7370

London-based designer Hussein Chalayan has always had strong graphic elements in his work, be it the prints on the clothes, the presentation of the shows themselves, or special projects like the Airmail Dress, a paper dress that was designed to be folded into its own airmail envelope and posted to its wearer. The line of his clothing is strong and pure. He is a designer who considers everything – no element of a dress or jacket is there by chance. For him, the concept and the process is as important as the finished product. Although he launched his label after leaving Central Saint Martins College of Art & Design in 1993, it was not until 2001 that Chalayan really put his own graphic identity under serious scrutiny.

Ezra Petronio and Suzanne Koller founded the multi-disciplinary design company, Work in Progress, in Paris in 1993. In 2000, they opened a New York office with partner Patrick Li, each sharing projects which range from visual identity, packaging, advertising and branding to image consultation. They also publish and design the fashion insider's biannual magazine, *Self Service*, creating links between the worlds of fashion, publishing, advertising, graphic design and promotion. The magazine provides them with an easy entry into the fashion world, a place where they can exchange views, start trends and nurture relationships. Their relationship with Hussein Chalayan began at *Self Service*, which was also a vehicle for his first advertising campaign, shot by David Sims and styled by Jane How, but directed by Work in Progress. The magazine offers young designers free advertising space – an opportunity for them to project their own image in print, something they would not normally be able to afford until they were much more established. They see their role as collaborator rather than client.

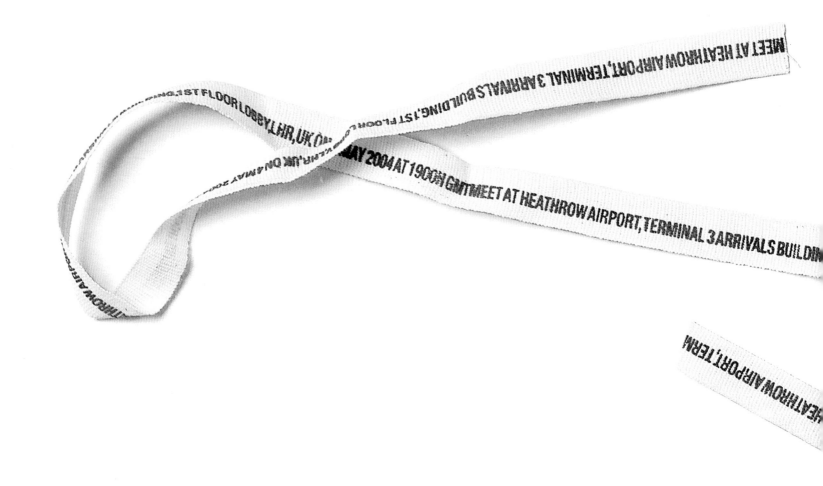

PLACE / NON-PLACE
HUSSEIN CHALAYAN AUTUMN/WINTER 2003-2004
MADE IN ITALY

A PLACE CAN BE DEFINED BY MONUMENTS IN A SPACE OR BY
BUILDINGS WHICH MARK SOCIAL, TECHNOLOGICAL, ECONOMIC AND
POLITICAL HISTORY; PRESCRIBING NATIONAL IDENTITY AND
NORMATIVE VALUES, ALTERNATIVELY AN EVENT CAN TEMPORARILY
TRANSFORM A SPACE INTO A PLACE.

SIMILARLY, AN ANONYMOUS INDUSTRIALLY PRODUCED GARMENT
CAN, OVER TIME, ACQUIRE LAYERS OF MEMORY THROUGH USE AND
OCCASION. THIS GARMENT ACTS AS A CATALYST FOR AN EVENT
WHERE PEOPLE CAN EXCHANGE EXPERIENCES RELATING TO THE
GARMENT THROUGH TEXT OR PHOTOGRAPHS, CULMINATING IN AN
INTERPLAY BETWEEN SPACE, PLACE AND MEMORY.

CREATED BY _____

DATE/TIME _____ / _____

MEET AT HEATHROW AIRPORT, TERMINAL 3 ARRIVALS BUILDING,
1ST FLOOR LOBBY, LHR, UK, ON 4 MAY 2004 AT 1900H GMT.

Previous page
Invitation to the show
for autumn/winter 2002,
designed by Work in Progress.

Left and below
Graphics are often used as
an integral part of Hussein
Chalayan's clothing. For
autumn/winter 2003/2004,
printed tape is sewn into the
inside seams of the menswear
collection. The label and tape
were designed in-house.

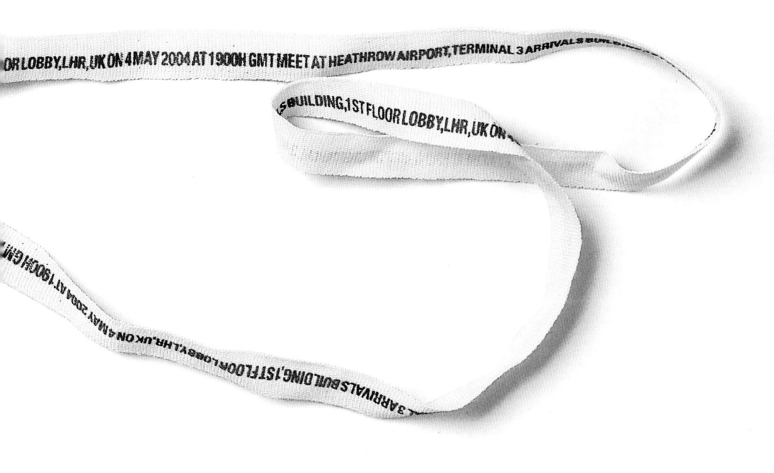

'I spent a lot of time talking about Hussein's philosophy behind his clothing,' says Petronio. 'He has a lot of interest in architecture and industrial design and technicalities. He likes the fact that there is a process in everything, and he likes instructions.' It took three months of 'craziness' to get to the final logo. Petronio has a strong typography background and Work in Progress likes to use type and words as the basis for much of its design. But Chalayan also has a very strong and extremely precise graphic eye, and every minute stage of the process had to meet with his approval – or disapproval. Chalayan has a broad knowledge and understanding of graphics and typography, and Petronio found himself having the sort of discussions he had not had since leaving Parsons School of Art in New York.

'We wanted something very pure', says Petronio. The final logo is pure Helvetica with a few touches of Futura, altering the stems and the heights of the letters. 'It's not obvious at first', says Petronio. In keeping with Chalayan's own approach to his work, Petronio developed a graphic system for the designer, a system that would convey his fascination with architecture, grids and instructions.

'It needed to encapsulate a slight twist and an offbeat subtlety that might not be immediately apparent.' For the invitation cards, the title of the collection takes on the same graphic methodology as the title of a painting hanging in an art gallery, more of an explanation than a statement. 'Every level of information (logo and supporting type) is in lower case and the same font size, and left aligned to give a technical feel. For the logo's typography, a mixture of typefaces was combined to give the result that Chalayan desired: something very precise and formal, while also being slightly disconcerting.' The invitations have developed a certain style and consistency in the space of three seasons. They are printed on heavyweight card and are not cut in a perfect rectangle. 'The angles are forced,' says Petronio, 'conveying an unexpected perspective.'

hussein chalayan
medea, 1866
612 x 456 mm, oil on canvas
af sandys

spring/summer 2002
friday october 5th at 8pm
couvent des cordeliers
15 rue de l'école de medecine
75006 paris

name: seat:

TEXTILE IN TURKEY **turquality** FROM TURKEY
press enquiries: annika mcveigh. tel: 44 207 216 6497. fax: 44 207 216 6498
buyer enquiries: cvdc, paris. tel: 331 4261 9980. fax: 331 4260 1270
l.a. distributione, milan tel: 39 02 336 14721. fax: 39 02 336 14754
usa - onward kashiyama, new york. tel: 1 212 629 6100. fax: 1 212 629 7370

This page and opposite
Show invitations designed
by Work in Progress. All are
slightly asymmetric, and use
a system of instructions,
similar to those used in
galleries to describe works of
art. Spring/summer invitation
2003, below: photography by
Marcus Tomlinson.

hussein chalayan
manifest destiny

spring/summer 2003
friday october 4th at 8pm
salle gaveau
45, rue de la boetie
75008 paris

photography by marcus tomlinson

PARIS • FASHION WEEK

New York • London • Paris • Milan • São Paolo

Fondation
Musée d'Art Moderne
Grand-Duc Jean
Luxembourg

name: seat:
press enquiries: karla otto, paris. tel: 33 1 42 61 34 36. fax: 33 1 42 61 58 91 - buyer enquiries: cvdc, paris. tel: 331 4261 9980. fax: 331 4260 1270
i.a. distributione, milan. tel: 39 02 336 14721. fax: 39 02 336 14754 - usa - onward kashiyama, new york. tel: 1 212 997 3600. fax: 1 212 997 5515.
on stage 2000, munich. tel: 49 89 480 6010. fax: 49 89 480 6014 0.

Ronnie Cooke Newhouse runs her creative consultancy studio with Stephen Wolstenholme from London, working for clients such as Arcadia, Shiseido and Topshop. She began working with Rei Kawakubo of Comme des Garçons in 1997, concentrating on the thought-provoking advertising campaigns for Comme des Garçons SHIRT, as well as collaborating on direct mailers and acting as creative director for Comme des Garçons Parfums. The relationship is one of close collaboration.

COMME DES GARÇONS
RONNIE COOKE NEWHOUSE STEPHEN WOLSTENHOLME

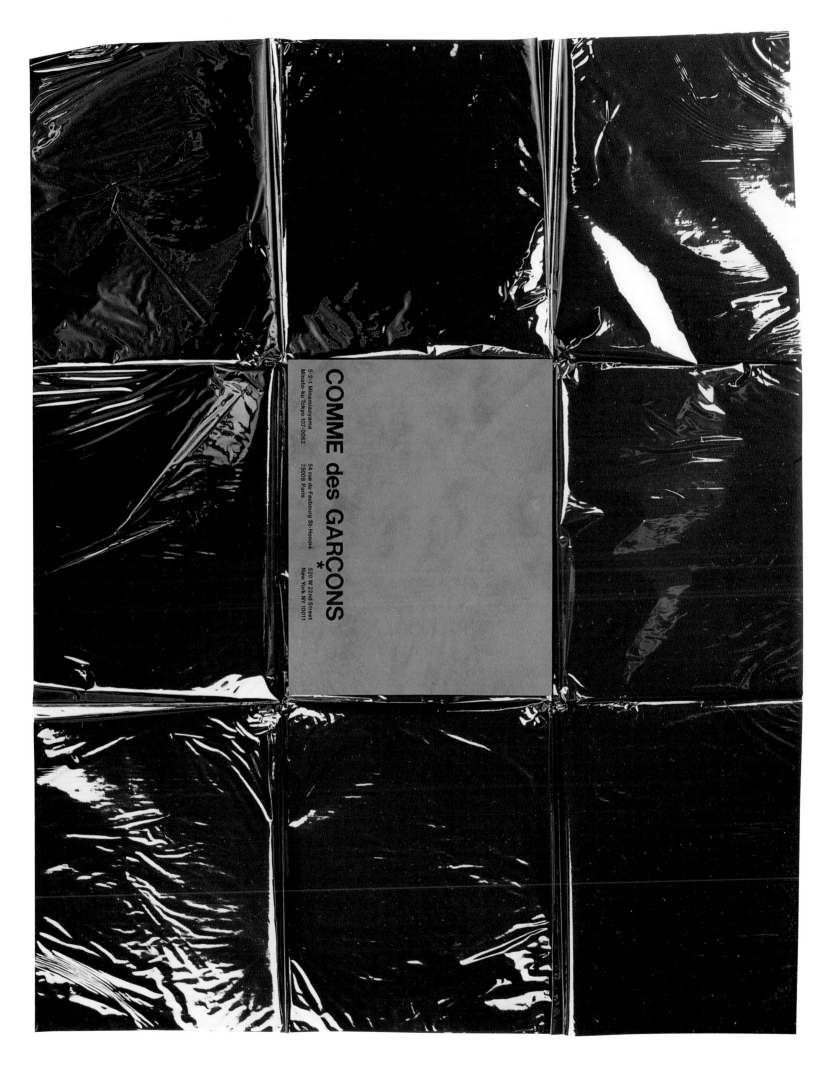

COMME des GARÇONS
*

5-2-1 Minamiaoyama
Minato-ku Tokyo 107-0062

54 rue du Faubourg St-Honoré
75008 Paris

520 W 22nd Street
New York NY 10011

'When you work with a designer, the viewpoint is idiosyncratic to that designer. You have to define a process of communication and working to realize the final goal.' Ronnie Cooke Newhouse, the American creative director and co-founder of Details, and former creative director of Barneys and Calvin Klein in-house agencies, is based in London. Stephen Wolstenholme, an English art director, met her in New York at Calvin Klein. They formed a studio, and for the past five years have been working with Rei Kawakubo and Adrian Joffe of the Tokyo-based fashion house, Comme des Garçons.

When Rei Kawakubo launched Comme des Garçons in 1969, she had already thought about her logo. It was designed by the late graphic artist, Toji Murata, in 1968 and has remained unchanged since then. It is very simple, very pure, and has become one of the most recognizable in the industry. Her clothes are often complicated and difficult to understand, and her methods of communicating to the consumer are obscure, to say the least. But her customers have a highly developed visual and cultural awareness – they are artists, architects, designers – creative types. For Newhouse, the challenge has been to create a language that communicates the brand.

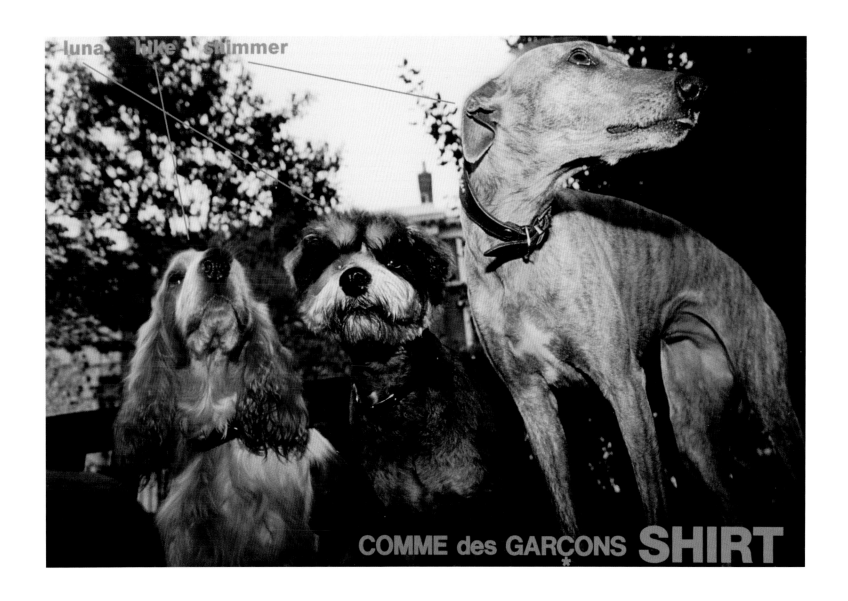

Newhouse's main work is with the advertising campaigns for SHIRT. She is also creative director for CDG Parfums, and works with Kawakubo on 'a number of different things'. 'Rei did not want to show the product in the campaigns for Comme des Garçons SHIRT,' she says. 'Somehow it will have relevance to the clothes but not a very obvious link. You might show her different ideas and she takes something very minor out of it and eliminates the unnecessary bits. Rei will shake it in the right way and it lands on its side.' Since she began working for Comme des Garçons in 1997, the SHIRT campaigns have featured early cave paintings; American trucks photographed by specialist truck photographers; portraits of dogs (including Newhouse's own pet) by the art photographer Jeff Mermelstein.

There has been poetry; underground comic art; Lynn Davies's photographs of icebergs; vintage badges from the early 1970s; and graffiti tags in New York. The artwork for a season will often be a reaction to the previous one. 'It ties into a cultural *Zeitgeist*,' says Newhouse. 'It has to be real. If we use poets, we have to find eight or nine really great poets. It has to be right. It has to be the real thing.' Her reference points are wide-ranging and have no boundaries. They are not usually from the world of fashion. 'I read a lot,' she says. 'I read about different things.'

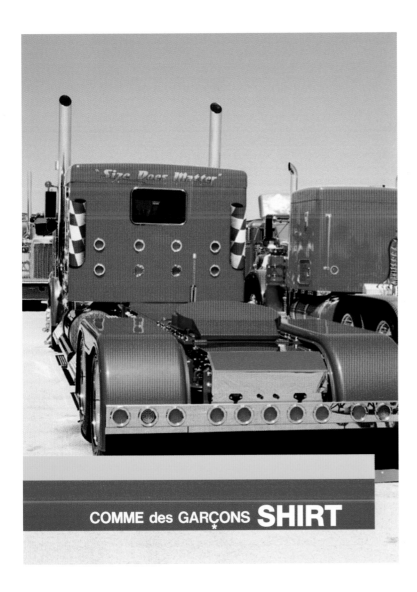

Previous page
A direct mailer for Comme des Garçons – simple but effective.

Opposite
Dogs advertisement, Autumn 2002. Photography by Jeff Mermelstein.

Left
Truck advertisement, Spring 2002. Photography by David A. Bontrager.

COMME des GARÇONS **SHIRT**

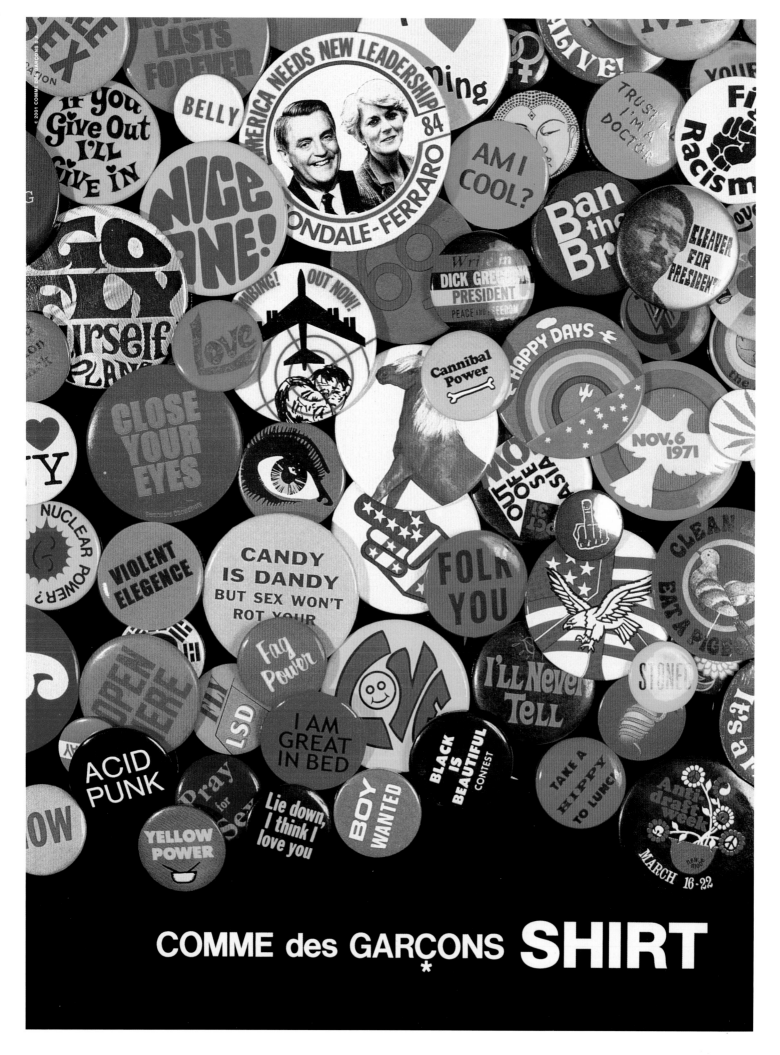

COMME des GARÇONS **SHIRT**

When Newhouse started working on the SHIRT advertising, not only were the ads themselves unlike anything else, they were put in a position, on the inside back covers of magazines, that nobody else wanted. 'I always read from the back to the front,' she says. To get a good position at the front of a magazine, you have to spend a phenomenal amount on your advertising. But suddenly, the inside back page was given new prominence. Needless to say, others followed and the rates went up.

The ads themselves are more like open spaces for a form of visual expression than tools to sell a product. Each campaign is a complete project in its own right. 'There's a lot of humour and irony in our work. She always works in collaboration and is very involved in everything that's done. We have meetings in Paris, Tokyo, occasionally London, or correspond by email between Rei and Adrian Joffe (her husband and president of Comme des Garçons). Computers make it easier to work at a distance. It is a very collaborative process.'

Opposite
Badges advertisement,
Spring 2001. Photography
by Tesh.

Below
Comix advertisement,
Autumn 2000. Artwork
by Megan Kelso.

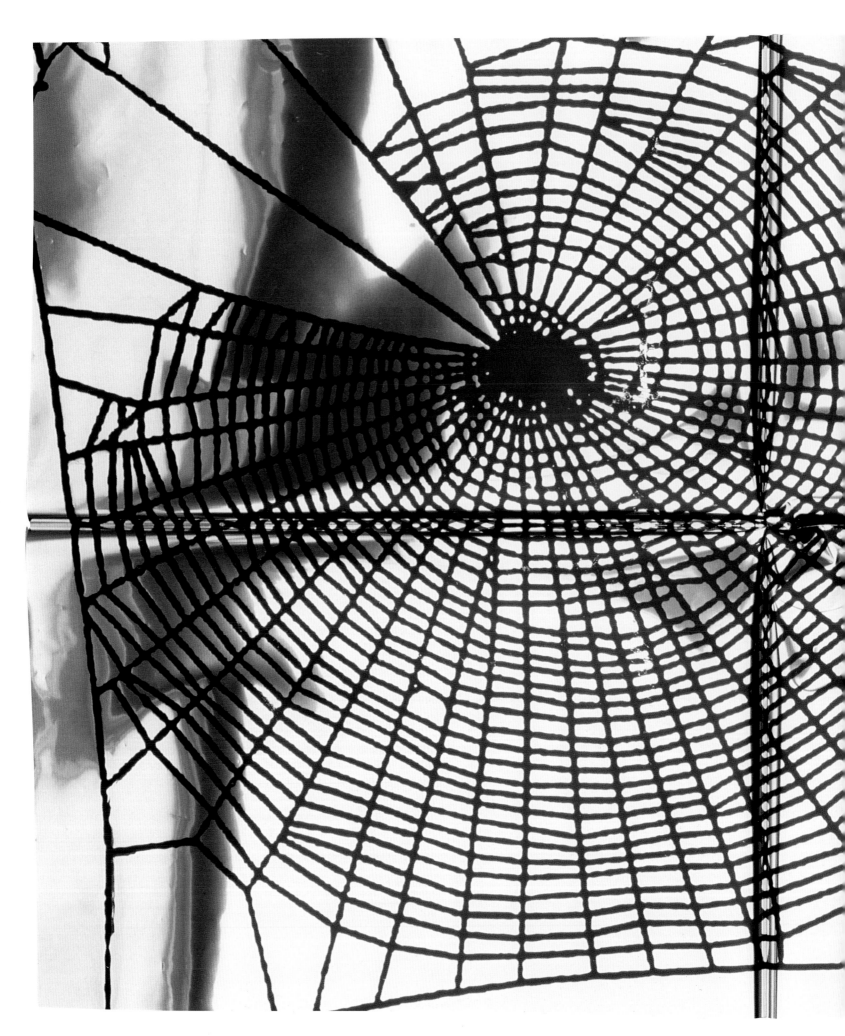

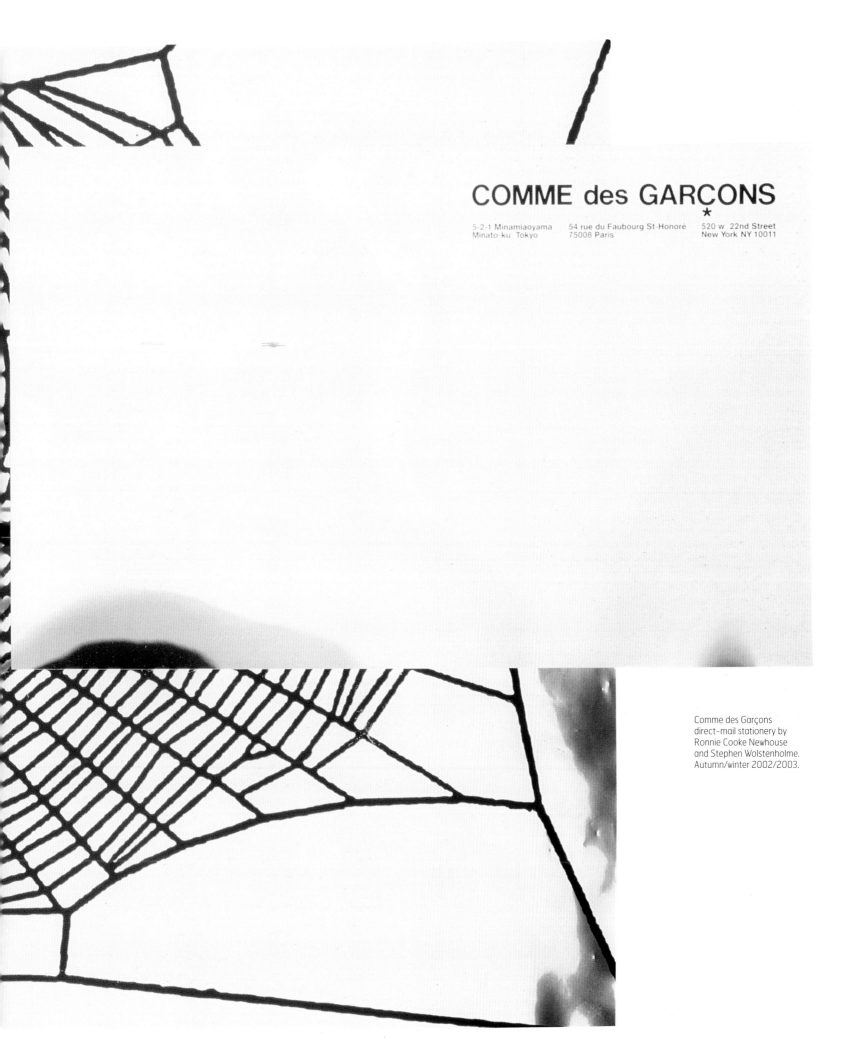

COMME des GARÇONS
*

5-2-1 Minamiaoyama 54 rue du Faubourg St-Honoré 520 w 22nd Street
Minato-ku Tokyo 75008 Paris New York NY 10011

Comme des Garçons
direct-mail stationery by
Ronnie Cooke Newhouse
and Stephen Wolstenholme.
Autumn/winter 2002/2003.

As well as the SHIRT campaigns, Newhouse works on direct mailers, or 'DMs', sent out to clients as tasters for each season's new collections, although they will rarely have a literal connection with the collection itself. These follow a particular format – a poster, or book, accompanied by a card that is slightly larger in size, and folded into a signature 'Comme' envelope, sealed with a square flap at the back. But the contents of the DMs are as erratic and unpredictable as the collections. Along with the company's annual Christmas cards, they are collectors items in their own right, but are usually thrown away as ephemera.

Left and below
Crystal white dress direct mailer, Christmas 2000, sculptures by Justen Ladda.

Opposite left
Cologne bottle, 2002. Ronnie Cooke Newhouse and Stephen Wolstenholme.

Opposite right
Graffiti direct mailer, Fall 2000, artwork by Miss.Tic.

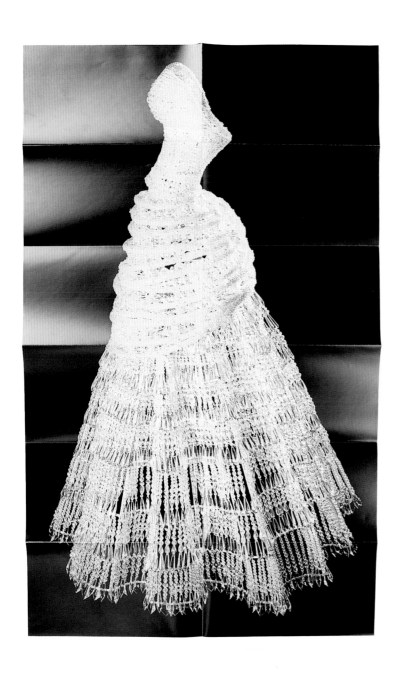

'I couldn't even guess what she's doing for her next collection,' says Newhouse. The show invitations are all produced by Rei in-house, partly because they are done very close to the deadline, and partly because every collection is shrouded in strict secrecy until it is unveiled. Kawakubo directs her in-house team of two designers in Tokyo and they work on prints for all collections, T-shirts, new logos and everything produced solely for Japan. As part of the creative team, Newhouse will also contribute ideas for the stores, has produced invitations and press packs for the stores in New York, Tokyo and Paris, and worked on graphics for the fragrances.

The latest, launched in September 2002, comes in an industrial-sized bottle printed utility-style with bold logo. 'There's freedom,' says Newhouse, but within Rei's own expansive but idiosyncratic vocabulary. The language always has to be hers. 'There's freedom to present ideas. She's very intelligent and understands things on all levels – not just the world of fashion.'

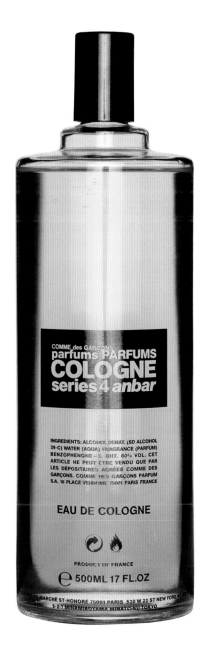

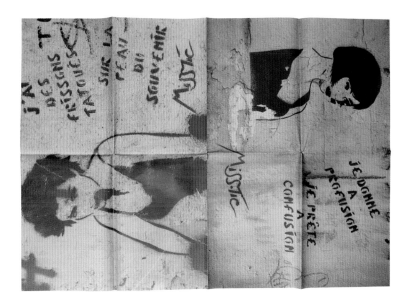

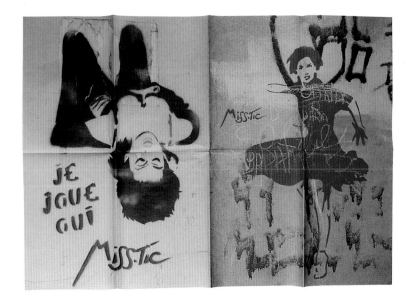

The logo is simplicity itself: two surnames linked with a tiny ampersand. But in less than two decades, Dolce & Gabbana's graphic identity has become one of the world's most familiar fashion logos. It has undergone subtle changes since 1986, but the Italian fashion house's graphic branding, be it for the main line or watches, is kept focused and consistent by its in-house graphics team, overseen by Stefano Gabbana and Domenico Dolce.

DOLCE & GABBANA
STEFANO GABBANA
DOMENICO DOLCE

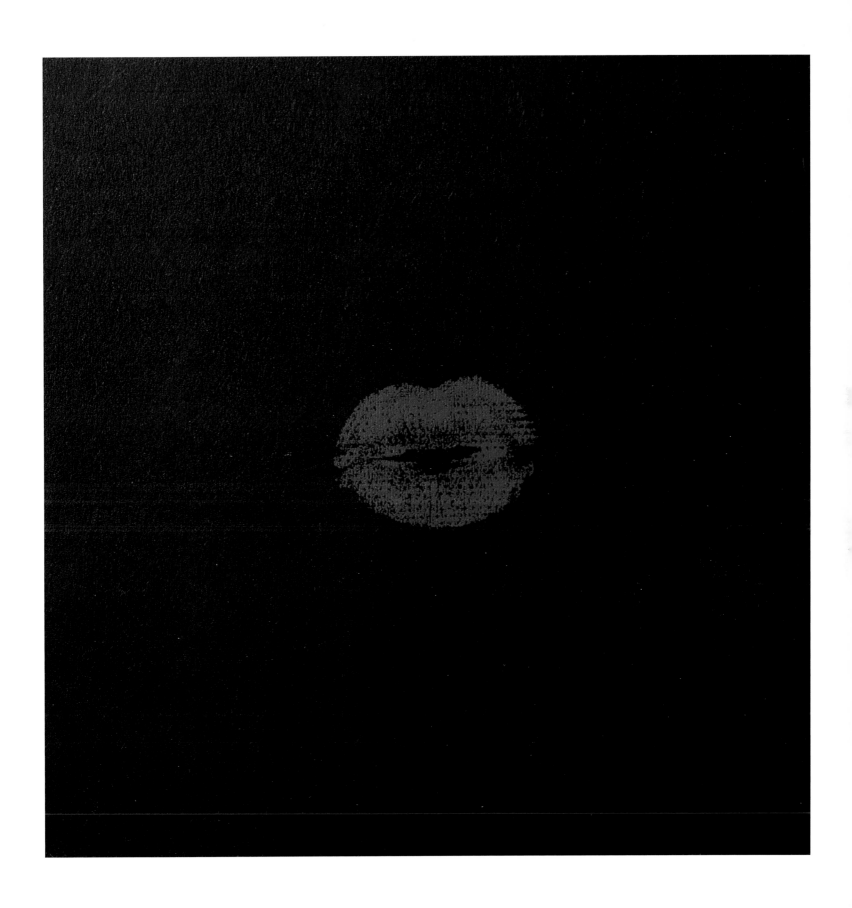

For a relatively young company (established by Stefano Gabbana and Domenico Dolce in 1984), Dolce & Gabbana has a powerful brand name and logo that are recognized around the world. The logo has indeed become so famous that the company has had to protect itself against counterfeiters with a hologram sticker to verify that its goods are in fact the real thing. The designers oversee their own in-house graphics four-person team, working with them on the graphic imagery and branding of the Italian fashion house's numerous collections, from Dolce & Gabbana and D&G to the childrenswear, watches and eyewear.

Previously, the logo – a modified Futura typeface without the edges and points – had been subtly refined by an outside agency. The house brand was already well-defined when the in-house team was put in place. Now, everything that's printed is approved by Dolce and Gabbana, including eight show invitations a year, catalogues, 'look books', packaging, labels and advertising. The team works closely with the designers, having regular meetings. Domenico might have a stronger commercial sense, but both have a very strong graphic eye. The job of graphic designer and fashion designer is really similar. The graphics can reflect the brand's many moods, be it baroque and kitsch or clean and minimal. The shop interiors and graphics are very simple. That way, the clothes can be as eclectic as they like, but the overall brand image is very focused, clean and confident.

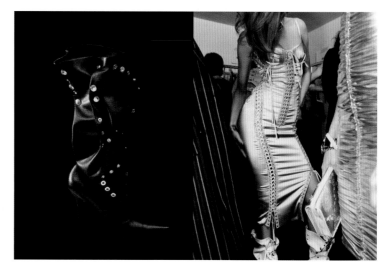

Previous page
Invitation for Dolce
& Gabbana women's
spring/summer 2001
fashion show.

Opposite
Dolce & Gabbana
spring/summer 2003
catalogue, showing
reportage images of
the show backstage,
the catwalk and still-life
product shots.

Left
Spring/summer 2003
fashion show invitation.

Below
The bright-pink envelope
contained the D&G women's
autumn/winter 2001/2002
fashion-show invitation, while
the blue envelope contained
the D&G spring/summer
2002 women's fashion-show
invitation; the green envelope
contained the D&G men's
autumn/winter 2001/2002
fashion-show invitation.

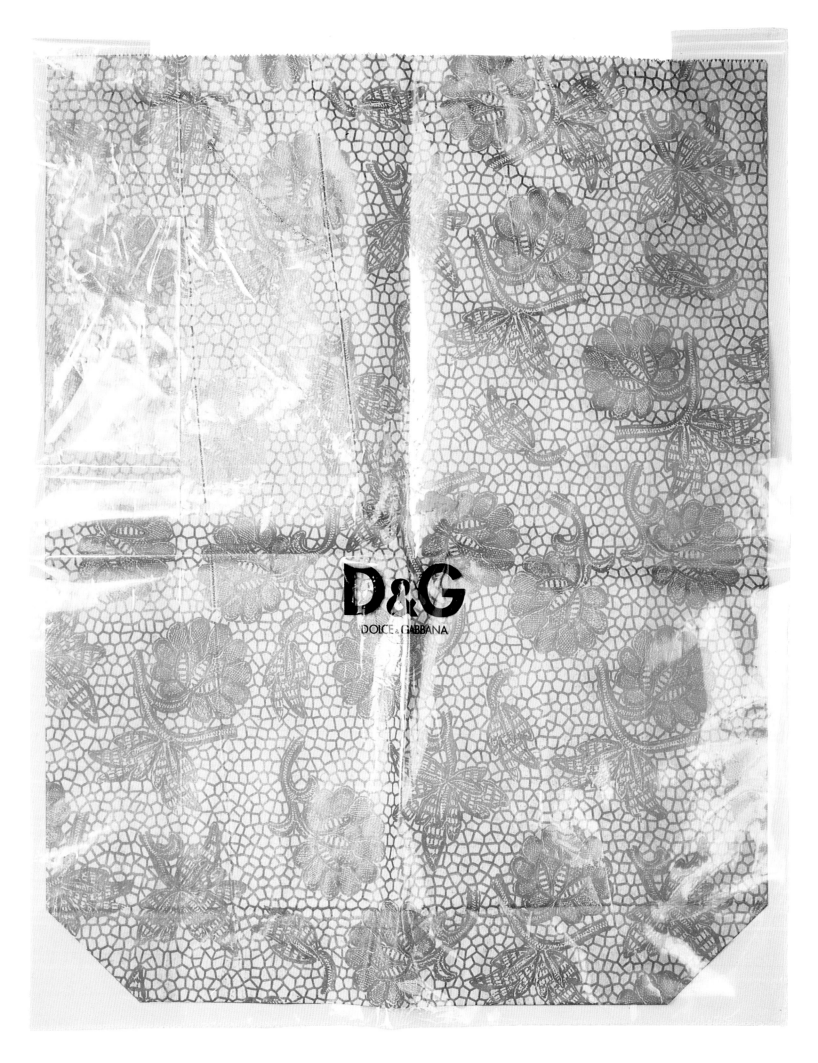

The Dolce & Gabbana identity must reflect the values of the fashion brand: at once charming, hard-edged and commercial. It is about achieving the right balance between the creativity and the fashion-strong message as well as making it commercial and appealing to a large number of consumers. The label is luxurious, rich and sophisticated. The signature is totally related to the designers' taste and mood. Just as with the collections themselves, sex is never far away from the selling of the brand. It might be as simple as a lipstick kiss mark. The brand also has a strongly recognizable palette of colours: always black – shiny and matt – alongside white and gold, or dark red, like velvet. Other key Dolce & Gabbana signatures include a leopard print and a black-and-white zebra print (the same one that used to wallpaper the dining room in their headquarters). The designers' own tastes and lifestyle are reflected in their product and packaging. They use a lot of imagery in their work, a mix of Sicilian imagery, religious iconography, masculine and feminine, sweetness and aggression, glamour and sex.

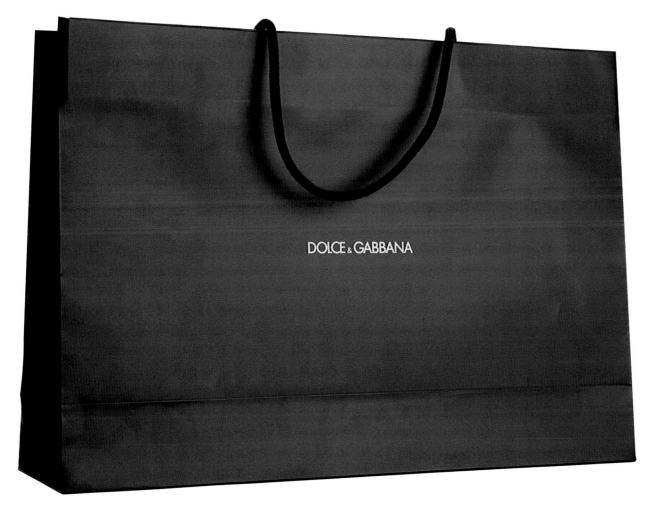

Opposite
D&G 2002 Christmas packaging with contrasting gold lace motif and transparent plastic bag.

Left
Dolce & Gabbana carrier bag, updated in spring 2003.

For the younger, more accessible D&G line, the branding is much more playful and youthful. It's not as classic as the main line, which requires a high level of consistency. The younger D&G customers are more open to change. The graphics can reflect the trends in the collection and better interpret the designers' thoughts. The brochures sent out to clients are much more pop, using bright colours, quirky Polaroid images, or picking up on a theme in the collection. For one that was ballet-inspired, they used different-coloured ribbons. For D&G Junior, where the future generation of Dolce & Gabbana wearers develop a taste for zebra print and neon colours, there are few confines.

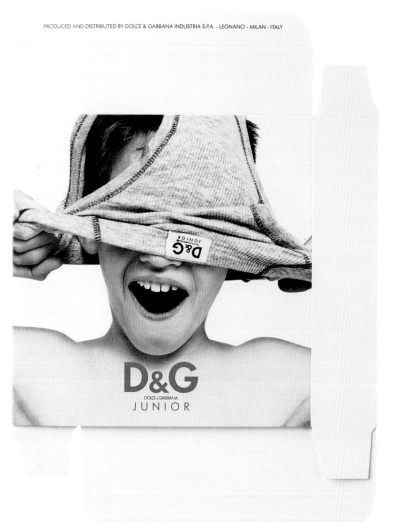

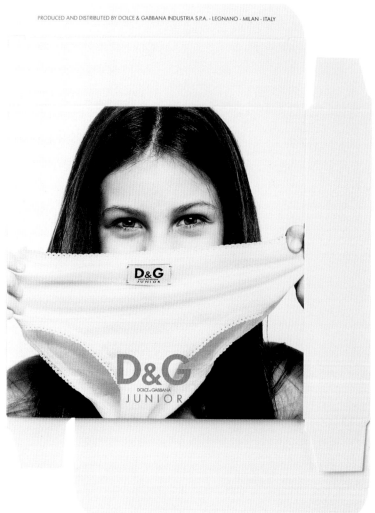

Opposite above
D&G spring/summer
2002 catalogue.

Opposite below
Packaging for the D&G
Junior underwear.

Left and below
D&G Junior spring/summer
2003 catalogue.

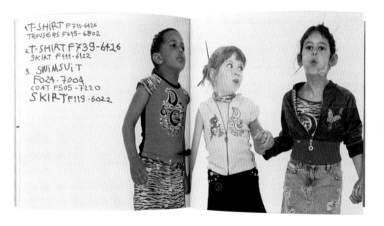
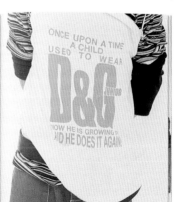

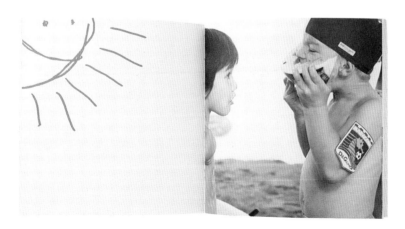

DOLCE&GABBANA® M

DOLCE&GABBANA
for Kylie

It is crucial for the graphic team to maintain a consistency with the whole image across the company. The catalogues follow the fashion and the trends, while the corporate identity itself is very strict and constant. The graphic designers' jobs vary day to day. As well as the seasonal cycles of show invitations and advertising, there are many projects that will crop up almost spontaneously. When Dolce & Gabbana hosted a party in Milan for Kylie Minogue, who they were dressing on her 2002 tour, the team had two days to turn around a whole package that included invitations, press material, VIP wrist bands and even a T-shirt. The idea for the invitation came from Domenico. Each guest was to be issued with a T-shirt and a card with guidelines on how to customize it. This would become their invitation. It was a stroke of marketing genius: 4,000 party-goers all turned up wearing their 'Dolce & Gabbana for Kylie' T-shirts, complete with a big lipstick kiss. It was a fun package that also kept within the strong confines of the brand.

This page and opposite Invitation for the June 2002 party that was held in Milan for Kylie Minogue. The invitation itself was a T-shirt that the guests were invited to customize, according to their personal creativity. The sticker with the kiss had to be ironed onto the T-shirt.

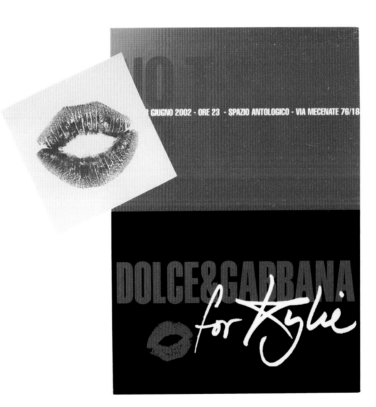

The London-based design team, Stephanie Nash and Anthony Michael, were contemporaries with John Galliano at Saint Martins School of Art in the 1980s. In 2002, they were commissioned to redesign Galliano's logo and to produce the imagery for his packaging to coincide with the opening of the designer's first store in Paris.

JOHN GALLIANO
MICHAEL NASH ASSOCIATES

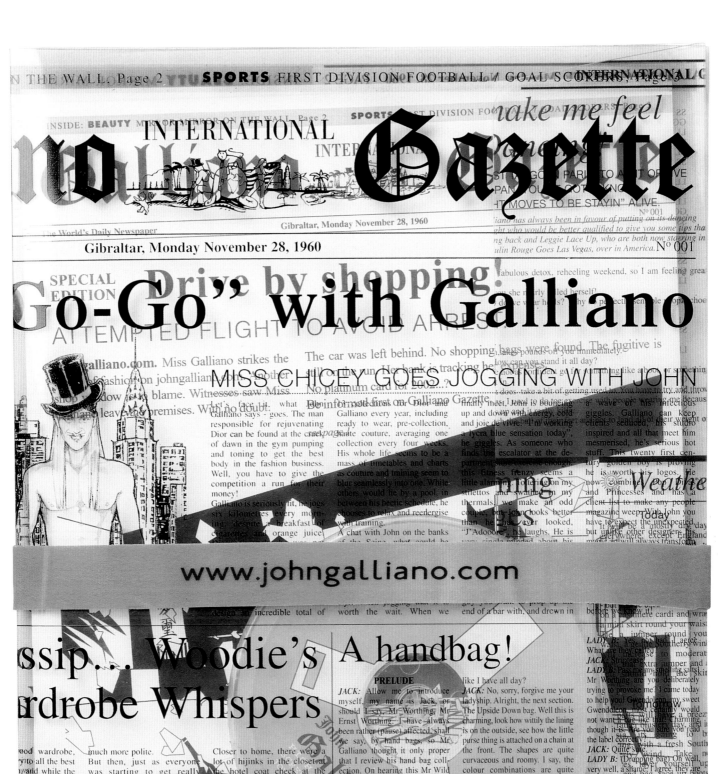

Stephanie Nash remembers a young John Galliano in the library of Saint Martins, making his logo out of a gothic Letraset typeface, and photocopying a shield to make his own label. It was the early 1980s and she and her partner, Anthony Michael, both on the graphics course, were a few years ahead of the fledgling fashion talent. They knew each other vaguely but had a mutual friend in Jasper Conran who they were already designing graphics for. Galliano graduated in 1984 with his 'Les Incroyables' collection, which made an instant impact on the fashion world. He set up his own label in London and then moved to Paris in 1994. A year later, he was appointed the successor to Hubert de Givenchy, becoming the first British designer to take the reigns at a French couture house. In 1996, he was given one of the most powerful jobs in the fashion business, as design director for Givenchy's sister company, Christian Dior.

The Letraset typeface has stood Galliano in good stead. It has stayed with him for almost twenty years. 'That is what he used until he met us,' says Anthony Michael. 'In fact, we have only just tidied it up. This typeface is still on the Letraset catalogue. We have just changed the way it works.' They got rid of the shield, and tweaked the logo by making the John smaller and the Galliano more dominant. And then they cut the whole thing in half horizontally. They did think about changing the logo completely. 'This logo really epitomized him. We tried millions of different ways of working on John Galliano but they didn't seem right', says Nash. 'It's that familiarity thing, the fact that he'd used it for so long. There is something about the gothicness that just felt right.'

JOHN GALLIANO SA 60 RUE D'AVRON 75020 PARIS TEL 01 55 25 51 51 FAX 01 55 25 51 52 54 AU CAPITAL DE 44 PARIS 374 4664 638 SIRET 374 4664 638 00013 APE 181 C 744.974 96 374 4664 638

The World's Daily Newspaper **INTERNATIONAL GALLIANO GAZETTE, Monday Novem**

Tea & Crumpets...

Despite a gruelling schedule, John Galliano takes time out to have tea and crumpets with Crepe Satinne, to talk to her about his amazing career, so far. While he serves and pours the tea, Crepe nibbles on a mini eclair, while her wonderful host fills her in on what makes him tick....
Thank you for taking the time to meet with me, you have such an amazing home, it is beautiful! Thank you! But it was my pleasure to meet you, I think that it is very important to talk to journalists and explain your thoughts and feelings. I also find it very inspiring to be constantly meeting new friends. What are the key / classic pieces in all Galliano collections? What are favourite pieces that you always include?
Bias cut, the circular cut. These are classic timeless pieces that always inspire me and remain modern. When did you know that you wanted to be a fashion designer? It has always been part of me, just waiting to get out, and like Topsy, it grew. I cannot

imagine being anything else. Who or what inspired you? Everything and nothing, it is in the air. Did you ever consider pursuing any other kind of career? Yes and No, or rather no and yes. Theatre and illustration were seductive for a while, but really its all part of the same thing, all overlapping and complimenting. I just had a passion for clothes right for the start. Can you name a couple of milestone moments in your career, please? Every collection is a milestone moment, you become so involved in every project that in the end you always look to tomorrow and remember yesterday like it was a dream. What was your proudest / most exciting moment? My last collection, but then again last year I would have said that too. I always feel proudest of what I have just done, as it is fresh, new and what I am about at the time. When you do research, what do you look for? What inspires you? Where do you go? It is impossible to say where inspiration comes from, its everywhere. Of course, once I have the beginning of something I do research quite thoroughly and seriously, but where and how I do that depends on the original

thread. I wouldn't research ROCK in the same way that I would research an 18th century boudoir, but then again, I might blend the two together, you have to be open to everything. What elements are important when designing shoes? Comfort? Image is everything and sexiness is key. What is the difference between Galliano and Dior? Well Galliano is where it all began, my first love, it is my name and will always be part of me. Galliano is my heart, and Dior is my head? What keeps you inspired and motivated? Inspired and motivated is being alive, to me its life. What would you say to your critics? I wouldn't say anything. They, like me, are entitled to their own opinions. That is what makes fashion different, strong and exciting. What to you is the most important part about a woman? Her aura, her mystic. What to you is style? Style is wearing an evening dress to McDonalds, wearing heels to play football. It is personality, confidence and seduction. How do you evolve your look each season? and your personal look, which is anticipated as much as the collections? I don't consciously think about it, its all part of who I am and that point in

time,
is no
beco
is pa
a d
their
trend
be e
cloth
icon
Laun
Who
liked
'Bla
Lasa
work
in G
your
Stree
film!
inspi
Bale
Wha
to re
time
I do
comp
shou
is y
theat
draw
emot
fridg
so h
enjoy
and v
mom

☀ Weather forecast ☾

Today
It will be a mostly dry day, everywhere, except England, although it is expected to become increasingly cloudy as the day develops. Throw on a cheeky pair of sandals and fishnets, show off your toes, no rain today (except England but you're used to it.) Throw on a cashmere cardi and wrap a mini skirt round your waist. Tie a jumper round your waist, a gentle Southerly wind will increase to moderate later, that extra jumper and a belt should hold the skirt down.

Tomorrow
All parts will have a breezy and rather blustery day, and in Russia, it's going to be freezing, with a fresh South-westerly wind. Take no chances, layer yourself up, hat, hand bag, lace up boots, scarf and gloves. Team with a

bias cut floaty thing with a plastic mac and a little sporting flash of cashmere. And those in Russia, add copious amounts of Galliano far, while you wait for the first flight out of there.

And next Tuesday
Rain will spread right across the Northern hemisphere, preceded by snow. It's going to be wet and wild all day. Arm yourself with boots and a parasol, but be sure to pick one of the lace ones, so that it doesn't turn inside out, or fly away with the wind. If you don't want a brolly, balance a hat with as many feathers and frills leaping off it as you can stand. Remember eyeliner and hair must be protected at all costs. Pick from an array of bikinis and marvellous swimwear, after all, lets be practical, you know you're going to be getting wet today.

You make me fee

FROM THE LAST TANGO IN PARIS, TO A BIT OF JIVE TALKIN' IN JAPAN, YO

The House of Galliano has always been in favour of putting on its dancing shoes, so we thought who would be better qualified to give you some tips than Siouxsie Sling Back and Leggie Lace Up, who are both now starring in The Moulin Rouge Goes Las Vegas, over in America.

GG So Girls, How have you both been?
SS Oh, well, I've just got back from a fabulous detox reheeling weekend, so I am feeling great. I feel ready for anything!
LL Just as well, last time Karen wore you she nearly killed herself!
GG OK, you're both professionals, why do we wear heels? Why do perfectly sensible people choose to balance on nails?
SS They're sexy
LL And they elongate the leg
SS They tilt you at just the right angle.
LL The higher, the better in my opinion. Takes pounds off you immediately.
GG Don't you find it uncomfortable? How can you stand it all day?

LL No pain, no gain they say! If you're not as confident, go for something like a boot, or something that'll hold your whole leg and foot in.
SS When you first start wearing heels, it does take a bit of getting used to. You have to try and throw the weight of your body into the toes. I used to do toe exercise with people wearing me because otherwise, they just scrunch the toes up and it really kills.
LL You also have to get people to stretch the ball of their feet and not to land all of their weight on the heel - that's how they break!
SS Oh I know, so painful.
GG OK, cobble stones, how do you navigate them?

LL
SS

SS

LL

GG

SS
LL

SS
SS

Forthcoming Marriages

Mr D.J Suit and Miss Flora Flutter
The engagement is announced between DJ, son of Morning Suit, of Monte Carlo, and Flora, daughter of Mme Floaty Flutter, the dancer, Paris, France.

Problem page

The Fine Art of Make Do and Mend.
The care of clothing is something that must be carefully observed - cleaning, mending and pressing is a time-consuming item in any household routine, but the secret is "a stitch in time, saves nine!" A systematic plan, and a little expert knowledge can substantially reduce the number of hours required for this task. Care of clothes is important to us at Galliano, so here we have tried to compile a list of suggestions of what to do. At Galliano, as well as at our after

SPOR

FIRST DIVISION F

Galliano Wanderers	2	0
Liverpool	1	2
Dior Divas	2	1
Peckham United	2	0
Barnet	2	1
Manchester United	3	0

𝔍𝔬𝔥𝔫
𝔊𝔞𝔩𝔩𝔦𝔞𝔫𝔬

Galliano's redefined logo was intended to coincide with the opening of his first flagship store, in Paris. Michael Nash were commissioned to work on the branding and the packaging. 'We went to see him and he said he didn't want anything from the past – all that Marie Antoinette look – and he told us he was into juxtapositions, and we went to look at the show,' says Nash. 'The biggest difficulty I had initially was differentiating the John Galliano brand from Dior. It is quite important that his own label and his own identity is quite different from Dior.' They went back to see him with thirty ideas – far more than they would usually present. 'Normally we would have only done four or five ideas but we did thirty because he is so eclectic. He's a fantastic editor, and they just pulled out a few little things and then we took that away again and from then on it didn't really change. So it's very pure. It has not been watered down in any way, shape or form. It is exactly as we presented it.'

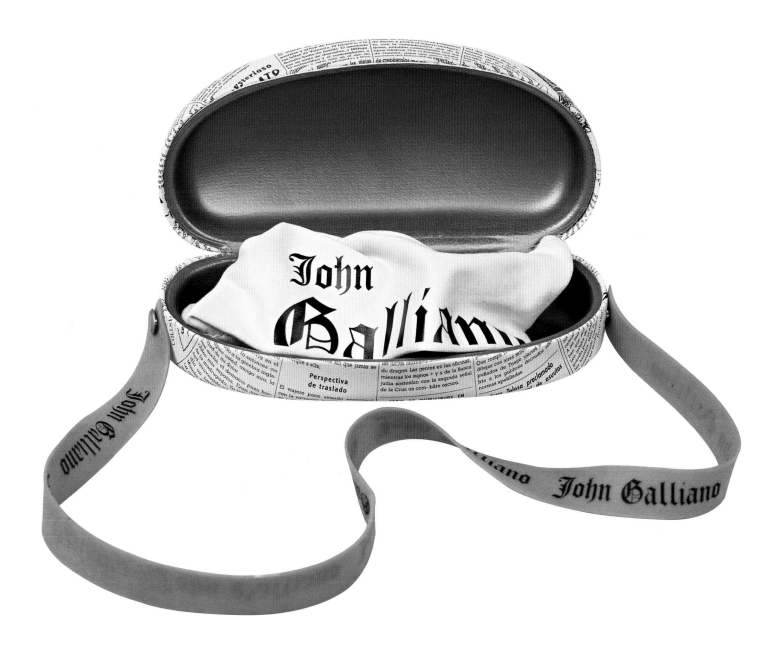

The packaging makes use of newsprint (a recurring motif in Galliano's work), paper flowers and rubber bands. The newspaper is a bespoke one, written by the Galliano team, and packed with in-house jokes and references to the designer. There's even a Dear John problem page. The labels in the clothes are all made of rubber bands with the logo printed across it. 'John found that funny, especially when it came to the lingerie – trying to print on this tiny little rubber label.' For the lingerie, there is a Perspex box – hard, white and shiny, containing the delicate underwear within, and there is white plastic mixed with a crushed velvet ribbon. 'What's interesting about John is the juxtaposition of materials and cultures, that jarring of features and technology. You just think, "Where on earth are they all coming from?", but it's the way he makes his clothes.'

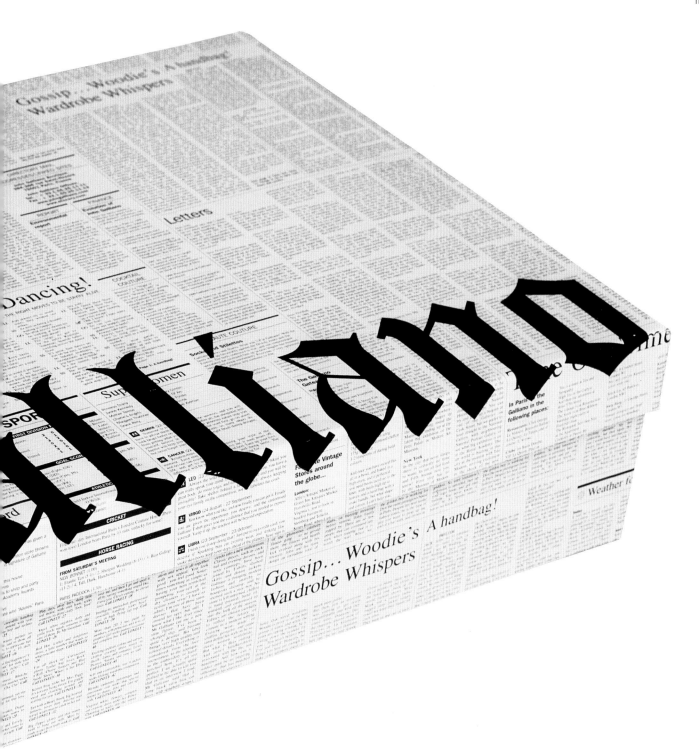

Opposite and below
The Galliano label is printed
on rubber bands, while shoe
boxes are printed with
Galliano's own personalized
newspaper.

Advertising and brand-imaging consultant Trey Laird began working with Donna Karan as in-house creative director in 1987. The original DKNY and Donna Karan logos were designed by Laird's former employer, Peter Arnell, in the mid-1980s, but Laird has worked closely with Karan ever since on the overall look of the brands, from the shopping bags to the stores themselves. He now runs his own agency in New York, Laird and Partners. His other accounts include the Gap chain.

DONNA KARAN
TREY LAIRD

The original Donna Karan collection and DKNY logos were designed by Peter Arnell in 1985 and 1987, respectively. The collection logo is sensual and elegant, while the DKNY logo has become part of the New York landscape – loud, confident and in-your-face. The collection logo was modified in the early 1990s, while the DKNY logo was 'tweaked' in the late 1990s. The man responsible for modernizing the logos was Trey Laird, who has worked with Karan since 1987, when he was employed by the New York agency, Arnell Bickford. In 1992, Donna Karan asked Laird to help her start her own in-house agency, overseeing the creative direction of everything from the stores to the advertising. 'Donna always combines everything,' says Laird. 'We were always involved in shop concepts, collateral and branding for Donna Karan and DKNY. She sees everything as connected.'

Donna Karan is one of the most cohesive, consistent brands in the business - and not by coincidence. Karan herself is incredibly focused and has a clarity of vision that permeates her whole company. 'She likes things bold and in-your-face, and she likes things to be clear. She's not one of those people who likes things overly designed. She likes things to be clear and graphic: clear communication. She likes it to be smart and concise. Not that it has to be obvious; we've always tried to be intelligent.'

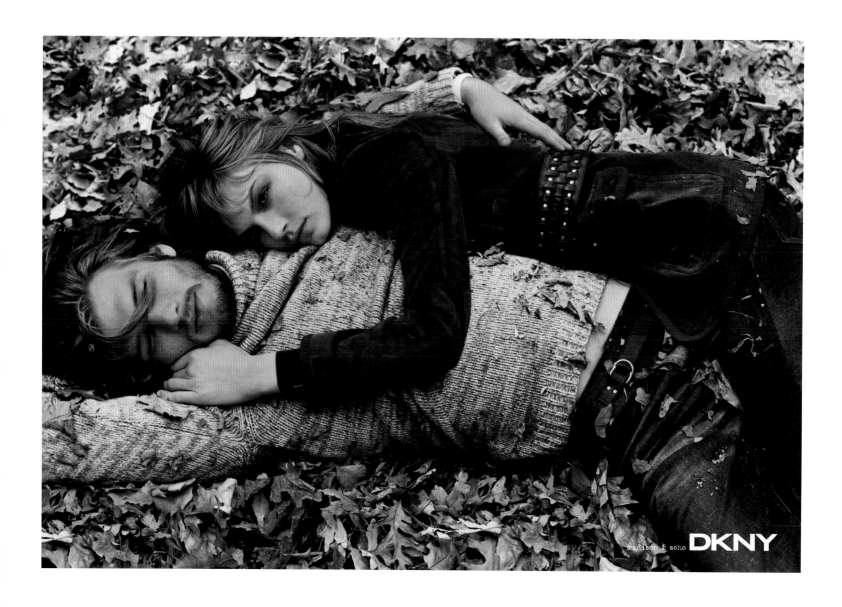

madison & soho **DKNY**

Laird did not set out to be a creative figure. He graduated with a marketing degree from the University of Texas in Austin in 1987. He began working at Arnell Bickford as a junior account executive, but it was Arnell who spotted his potential as a creative. His relationship with Donna Karan is built on trust and total understanding. 'He sees all aspects of the brand and understands that it isn't about clothes or a particular product, but about a lifestyle', says Karan. 'He knows that we need to tell a story and keep our communication consistent, be it with an ad campaign, store visuals, image books for DKNY or with our direct-mailer, *Woman to Woman*. Thanks to Trey, all these pieces work together to send a coherent message to the consumer.' In March 2002, Laird left Karan to set up his own company, but he kept her account. He wanted to pursue other projects, and won the account to refresh the Gap's image. But his relationship with Karan has remained just as close. 'I see Donna pretty much every day,' he says. 'It hasn't changed creatively.'

Previous page
The advertising for DKNY is bold, confident and very New York. The logo has become as much a part of the New York landscape as the yellow cabs themselves.

Opposite
Fall 2001 DKNY campaign.
Creative director: Trey Laird.
Photography: Mikael Jansson.

Below
Spring 2002 DKNY campaign.
Creative director: Trey Laird.
Photography: Peter Lindbergh.

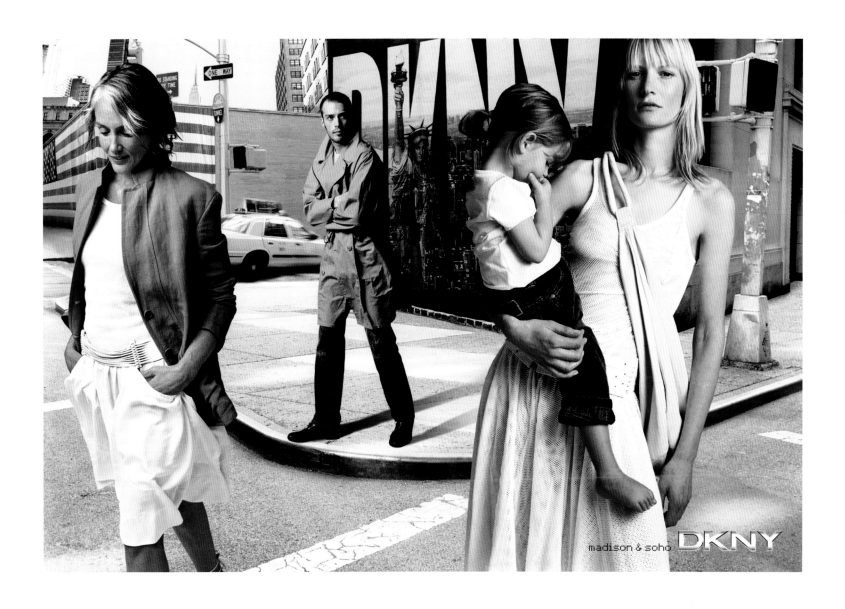

Laird's vision of what makes a brand is as clear as Karan's. 'The product is constantly changing,' he says, 'but the brand is the business. It is what you are. When you have a really strong point of view, it is like a road map and you can see what fits your journey. If you really have a clear, articulated sensibility, it helps define what the product should be. You should start with the brand. Donna's sensibility is also her brand. It's hard to have one without the other. The brand is your equity, your quality and your mark. It's what people buy into and you can't let them down. She's been very consistent and solid for a long time.'

With Donna Karan Collection, the designer's most expensive line, the black-and-gold logo reflects the lifestyle and personality of the woman herself — sensual, warm and womanly. The ethos is reflected throughout the stores and in the clothes. 'It's much more private, residential: more uptown Manhattan elegance,' says Laird. 'It's part of the whole experience of the designer and you get a sense of what the brand is.' DKNY, however, is young, energetic and always on the move. The yellow, black and white logo is as New York as the city's yellow cabs. 'It's about the hustle and bustle of the streets, moving with the city. It's part of the graphic language of the city. The spirit of DKNY is the streets of New York.' When Laird changed the logo, it was a subtle difference. 'When I started, it was big and bold. I tweaked it to keep it fresh. It's a little more elongated — still very graphic and in-your-face but a little more elegant.'

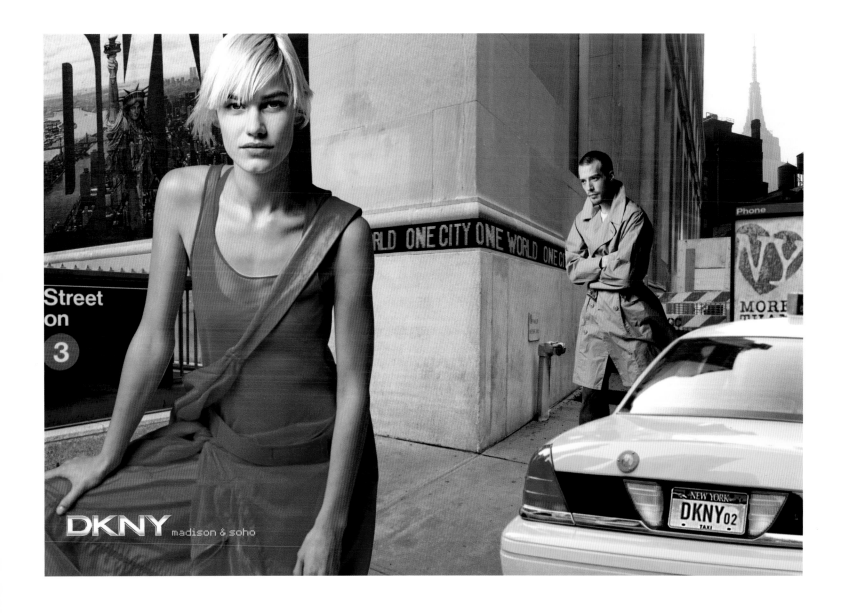

Donna is involved in everything, although she doesn't go on advertising photo shoots. 'I will talk to her about packaging. She's very interested in new materials.' When he did a new DKNY bag with a silver logo and two white translucent sides and two opaque, it was a very Donna touch to put bright-coloured tissue inside. For the Donna Karan Collection, however, the bag has a leather handle. 'It strengthens the person's experience of the brand,' says Laird. 'Donna Karan's influence in terms of the way the brand is structured has been very significant. DKNY was one of the first fashion brands to advertise on the streets. It's an icon. It's become larger than any one piece of clothing. It stands for something bigger.'

Opposite
Spring 2002 DKNY campaign.
Creative director: Trey Laird.
Photography: Peter Lindbergh.

Below
The packaging for Donna Karan and DKNY reflects the brands themselves. The former is luxurious and sensuous while DKNY is urban and youthful.

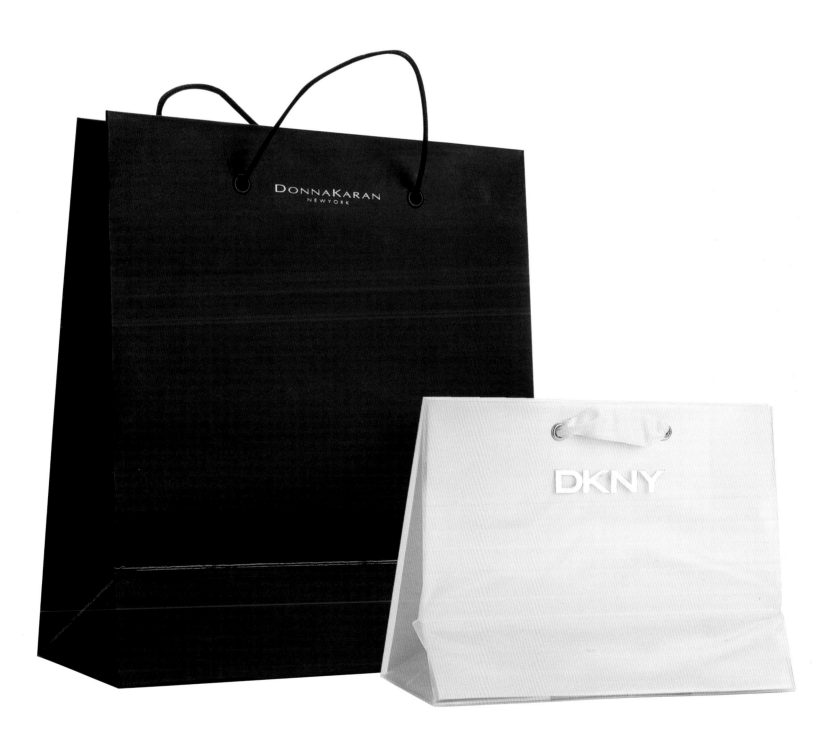

Calvin Klein's CK logo is one of the most recognizable in the fashion industry. It was originally designed by Fabien Baron to go on the leather patch on the back of jeans, but rapidly it developed a life of its own. The Calvin Klein logo became so recognizable that, in 2002, M/M (Paris) literally ripped it up and started again, redrawing it in ballpoint doodles for a two-season advertising campaign.

CALVIN KLEIN
BARON & BARON
M/M (PARIS)

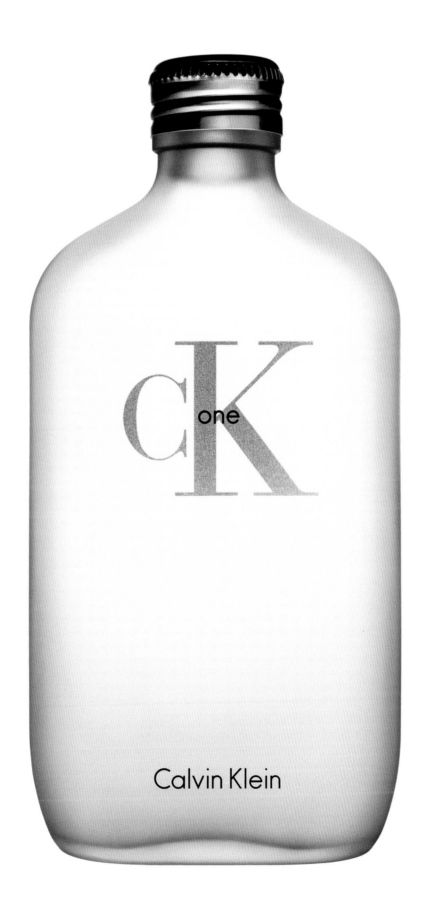

At the height of his influence in the early 1990s, Fabien Baron had worked his magic on the glossy, upmarket American magazine *Harper's Bazaar*. He was employed by the editor at the time, Liz Tilberis, to create the world's most beautiful magazine, and for many, that is just what he did. The elegant interlocking typefaces made visual feasts out of simple headlines. The magazine's typography became as important – and as influential – as the fashion. It is no surprise, then, that he should receive a call from Calvin Klein, asking him to work on the CK logo. 'It was for the back pocket on his jeans,' recalls Baron, 'a logo to go on the leather patch.'

At the time, there was just Calvin Klein and Calvin Klein Jeans and Underwear. It was Baron who suggested making a bridge line and calling it CK. 'It makes more sense than calling it Calvin Klein sportswear,' he remembers saying. 'This way you can have two businesses.' Not only could he have Calvin Klein underwear, he could have a CK line, too. 'The thing grew and grew', says Baron, who has as good an eye for marketing as he does for beautiful lettering. Out of a simple logo, originally destined for a jeans pocket, came an entire collection, a whole new business, and eventually, CK One, one of the best selling fragrances of all time.

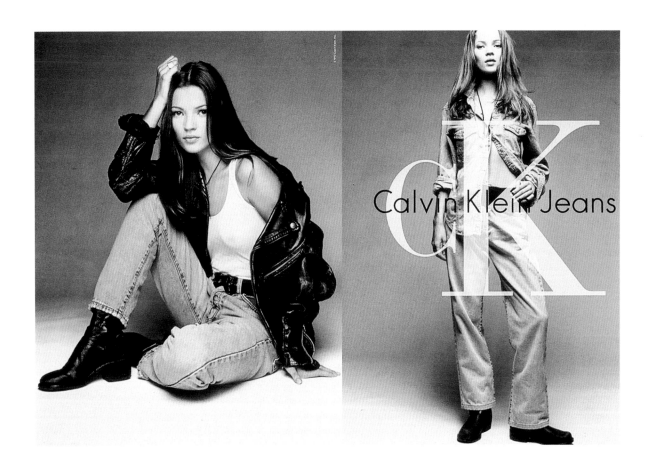

Previous page
Fabien Baron's CK One bottle has become a design classic.

Left
CK Calvin Klein Jeans advertising, autumn 1992. Photography by Patrick Demarchelier. Directed by Fabien Baron.

Opposite
Marky Mark advertises CK Calvin Klein Jeans, autumn 1993.

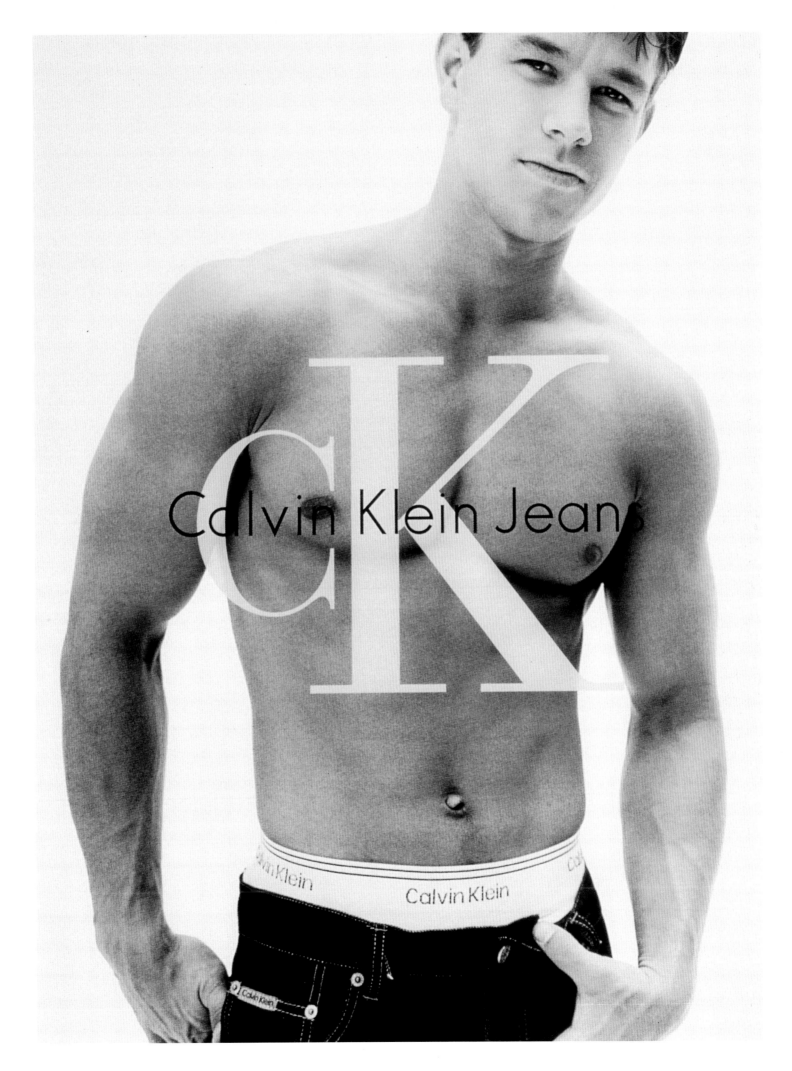

The CK logo is very much in keeping with the work Baron was doing for *Harper's Bazaar* at the time. 'The CK logo, in terms of fashion graphics, has been ripped off everywhere. How powerful those initials became. In the 1990s I was seeing it on T-shirts. Every town in America had its own CK logo. I liked seeing the copies. It became a symbol.' The recognition of those letters became universal, not just in America but across the world. It led to the Calvin Klein logo itself being redesigned to match. 'Calvin understands when things need to change,' says Baron. 'He's never nervous about changing anything. He goes for it. He takes the risk. And taking the risk paid off.' The logo, and Baron's advertising campaigns, changed people's perceptions of the brand. Kate Moss became the face of CK. Calvin Klein wanted Vanessa Paradis, but Baron saw the potential in Moss, and the designer soon agreed. Their relationship has been one of the most enduring and lucrative (in terms of both model fees and product sales) ever.

Calvin Klein's other great success story of the 1990s was also a result of Baron's graphic eye. CK One was a fragrance phenomenon when it was launched, a unisex fragrance in a bottle that looked more medicinal than cosmetic. 'There was a lot of talk about the name,' says Baron. 'I felt people wouldn't say "One", they would ask for "CK One". For the logo, he moved away from the usual Calvin Klein spelled out within the CK letters, and instead put the 'One' inside the CK. Calvin Klein ran across the bottom. 'It elevated the CK into part of the brand name.' It also worked perfectly in graphic terms. For the advertising, Baron also made a radical departure by using grungy-looking kids with unkempt hair in the images. 'It was not easy at the time', he says. A fragrance launch costs about $30–40,000 and it is not something that companies take risks with lightly. But the investment paid off. CK One made more than $200 million in its first year.

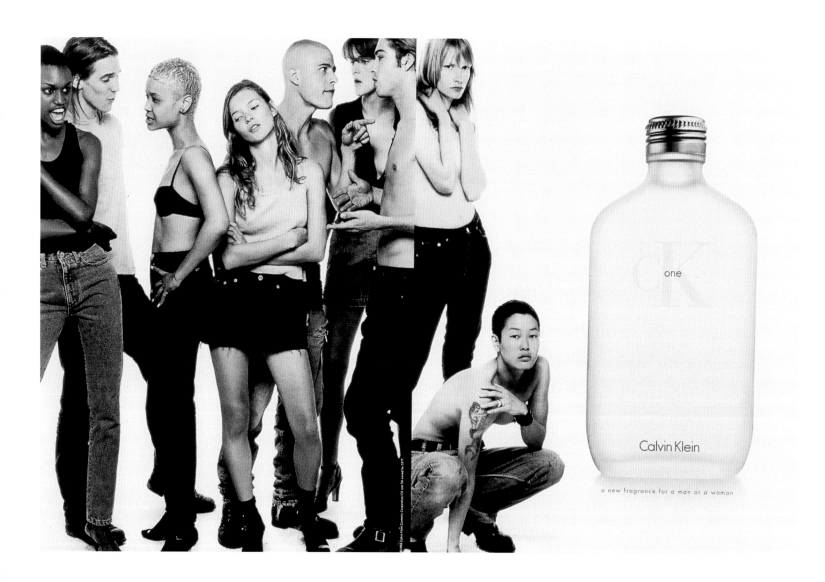

For Baron, working with Calvin Klein is one of his most creatively rewarding outlets. The two speak the same language. They are on the same wavelength, which means they work together with great synergy. 'With Calvin it becomes a little more personal,' says Baron. 'We can talk ideas. I find it the most challenging. We talk about everything: what the stores should look like, the commercial business, the fragrances — every layer. It is a really nice creative dialogue.' At one point, Calvin Klein became all-encompassing for Baron. 'I was there all the time,' he remembers. 'I was involved in everything.' With his own business to run, Baron decided that he needed to take a step back. It was a mutual decision, but their working relationship has remained a firm one. 'He has great energy and always looks to the future. He's very cool. He's a good catalyst.'

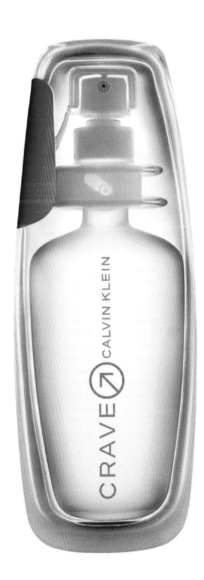

If proof were needed that Calvin Klein likes to take risks, you need only look at the advertising campaigns for spring/summer 2002. If Fabien Baron's elegantly drawn logos of the 1990s were the ultimate in chic, the new treatment of the designer's logo by Paris-based graphics team M/M (Paris) is something altogether more radical. The logo on the clothing remains the same, but for the advertisements, Michaël Amzalag and Mathias Augustyniak decided the label's image was in need of a bit of a shake-up. The designers' clients include French *Vogue*, which they art direct in an unorthodox fashion, one day a week. They are also known for their work with Björk (on her *Vespertine* album cover), Yohji Yamamoto and Balenciaga. Calvin Klein is perhaps their most mainstream client, but they have been determined not to compromise their style of work.

'We refused Calvin Klein two or three times, because we were not strong enough to impose our way of working on such a big company.' When Calvin Klein's choice of photographers, the Dutch avant-garde duo Inez van Lamsweerde and Vinoodh Matadin, insisted on working with M/M (Paris), they finally accepted. 'We had to make Calvin Klein cool again', they say. They drew the logo over the photographs, as a schoolkid might deface the page of a magazine. The ads have an immediate impact. At first glance, you wonder if somebody hasn't already got to your magazine with a biro. The doodle logo has been paired with another low-tech technique, that of taking a pair of scissors to the images. The designers cut shapes into the photographs with the result that they look as though they have been stuck into a scrapbook. It's a radical departure from Baron's slick elegance, but Amzalag and Augustyniak enjoy breaking down barriers and rubbing away the gloss.

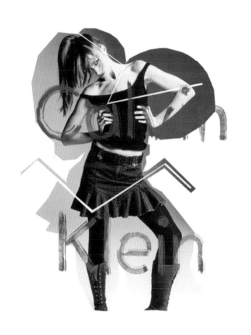
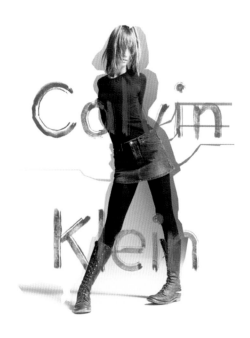
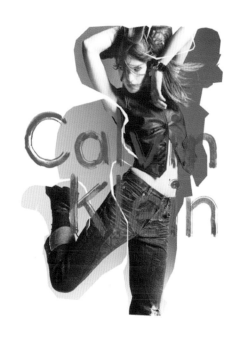
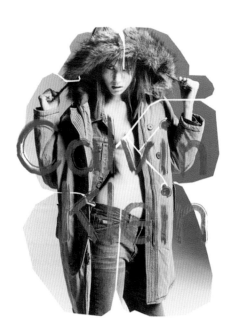
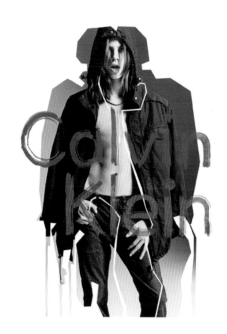
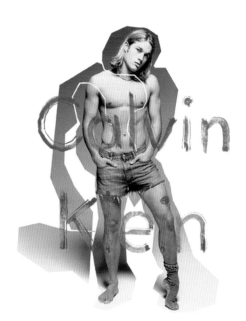

Opposite and below
Calvin Klein advertising
campaign, autumn/winter
2002/2003. This series
of ads was designed and
directed by M/M (Paris),
and was a radical departure
from the slick adverts
by Baron & Baron.
The campaign ran for two
seasons: spring/summer
2002 and autumn/winter
2002/2003. Photography
by Inez van Lamsweerde
and Vinoodh Matadin.

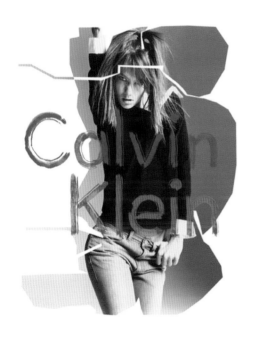

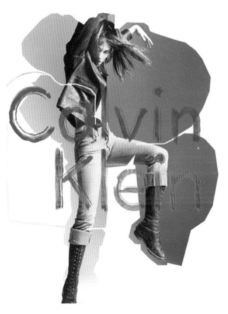

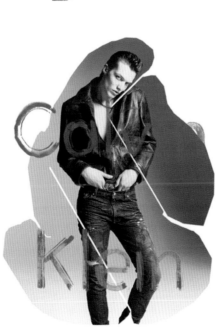

Michael Nash Associates were responsible for the influential rebranding of Harvey Nichols' Food Hall, in addition, they work with the designers Marc Jacobs, John Galliano and Alexander McQueen. They worked closely with McQueen to create a slick luxurious new brand identity.

ALEXANDER MCQUEEN
MICHAEL NASH ASSOCIATES

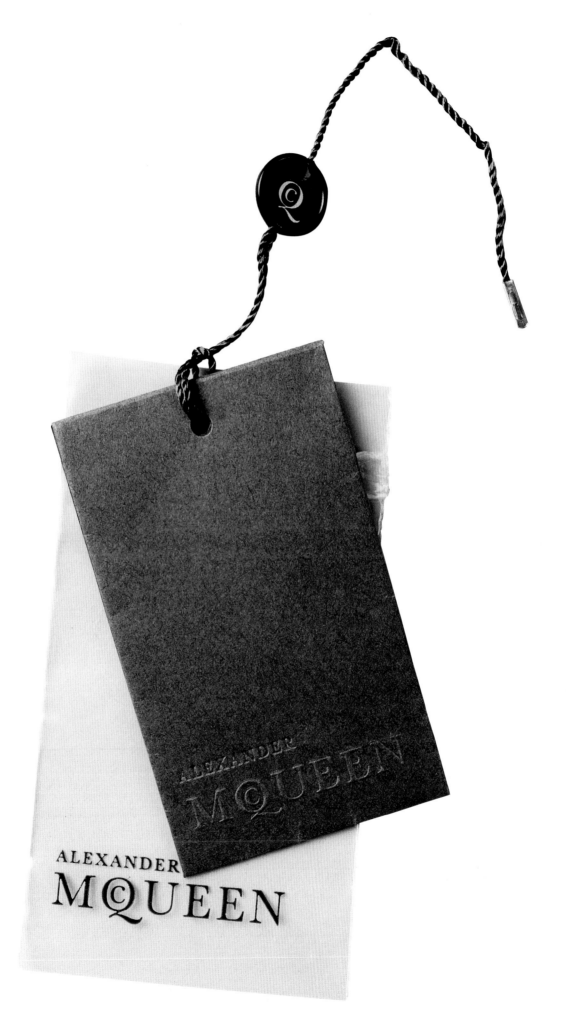

British designer Alexander McQueen has been the most influential of the new wave of designers to come out of London in the 1990s. He left Central Saint Martins College of Art & Design in 1991, and in 1996 he became one of the youngest designers to receive the British Designer of the Year award. His career has been marked by controversy – bumsters, highland rape and manacled models – and his own brand of wayward rebellion. He is not your usual fashion luvvie. Nevertheless, in 1996, he was invited into the fashion establishment by the French house of Givenchy, to take over from John Galliano as chief designer. He stayed until 2001, when Gucci invested in his own label. He is now still based in London but he shows his collections in Paris. He has his own shop in London and he opened a second in New York in the summer of 2002.

As a mark of his new maturity McQueen appointed London-based design agency, Michael Nash, to work on a new corporate identity and packaging for his shops. 'What happened with the packaging was, he asked us to put together a box of stuff and show it to him. Not design it, just pull together loads of stuff. And we got paper and bits and pieces and wire, and he really liked all the odd sort of junk that we bought. And then he decided that he wanted it to be quite grown-up. He had a logo, but he liked one half of it and he didn't like the other half. He liked the C inside the Q. We made the Alexander smaller and just did general tidying. I think he wanted it to look very grown-up and corporate.'

Previous page
Swing ticket for Alexander McQueen's clothes.

This page and opposite
Michael Nash tinkered with McQueen's logo, putting the C inside the Q. The packaging is hard and slick.

The packaging itself is surprisingly sober and cool. The carrier bags are in grey book binding fabric, with 'Alexander McQueen' simply embossed into it. Stephanie Nash says, 'The idea was that it ... was very much like you might find on a very good quality old bound book.' While McQueen's work is challenging, it is also always based on the traditions of tailoring and craftsmanship. 'He had this thing about people carrying it and not wanting to be able to read the name clearly from a long way away,' says Anthony Michael. 'It was like the opposite of what everybody else would want. If you are doing a brand then it's like, 'Can people see that bag from across the road?' He wanted the bag to be distinctive, but in a really quiet way – something which is recognizable but quiet, very understated.

You don't want a bag shouting out to you.' Alongside the quiet grey bookbinding fabric, Michael Nash gave the bag a twist with computer cable as a handle. He loved the idea that we have got a handle made up from Playstation wire and if you cut it in half it is electrical wire. He liked that technology with this really old-school binding technique. It is very restrained and very hard.'

For the tissue paper used to wrap the clothes, Michael Nash scanned a dead bird to make an abstract feather texture. The idea is very macabre, very McQueen, but quite subtly done. Michael Nash say they like to approach their work from the mindset of their client. They try to imagine what the client would do if he or she was the graphic designer. 'Alexander McQueen is very abstract. Some of his clothes are breathtaking. There are samples in showrooms that just make you think, wow, I can't even comprehend how he started to think about doing that.' To work on his packaging, it was necessary to try to get to grips with his thought process. 'He likes things that have got a slightly dark side. He is not frightened by them, he is quite happy to face them. I think he faces everything full on. You feel that when you are working with him that he confronts everything full on.'

Opposite
Michael Nash used a feather print for the tissue paper used to wrap clothes.

Right
The carrier bag makes you look twice, with its bookbinding fabric and computer cable handles.

This page and opposite
The invitations to Alexander
McQueen's Paris shows
give a taste of the collection.
The film director Tim Burton
collaborated on one invite,
providing drawings which
Michael Nash turned
into doodles in a school
exercise book.

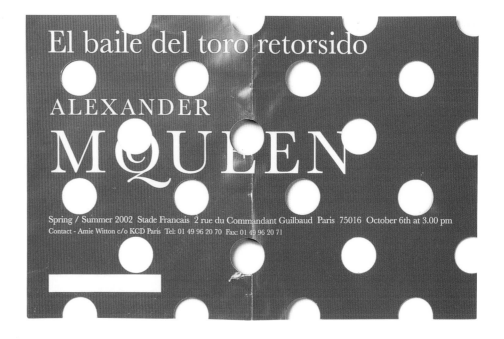

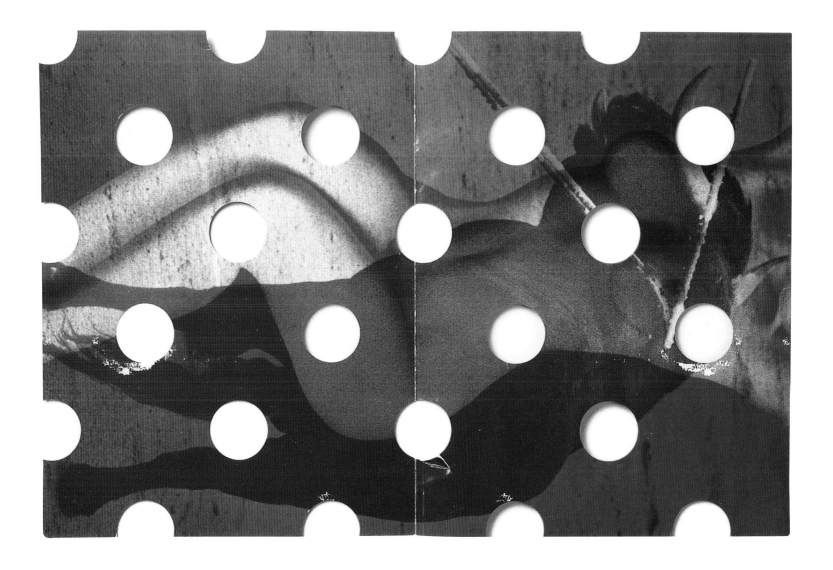

When the designers worked on the first invitation with him, the theme was Spain. 'I had to do it about 48,000 times,' laughs Nash, 'because the imagery I kept choosing was too romantic and wasn't hard enough. He doesn't reveal his personality straight away, the more you get to know him the easier it becomes to do something for him. The first one, I was picking the images and they were too nice, they needed more blood and gore.' The invitation featured a bullfight, and was stuck through with holes, as though it had been gored itself. 'For the second invitation, he simply said, 'Tim Burton has done me some drawings' and he just sort of threw these drawings at me.' After she had seen the clothes, Nash thought the collection had a schoolgirl feel to it, and decided to put the drawings into an old-fashioned school exercise book and splatter ink all over it.

With Alexander McQueen, the corporate identity has played a crucial part in his rite of passage as a designer. For him it is about getting the balance between the luxury, the corporate and the wild boy image that has been his signature throughout his career. 'We were trying to make a luxury brand,' says Michael. 'It looks very grown-up.'

London-based design collective Åbäke is made up of four designers – Patrick Lacey, Benjamin Reichen, Kajsa Ståhl and Maki Suzuki – who met at London's Royal College of Art and graduated in 2000. Since then, they have become an influential force, working on projects as diverse as album and CD covers, exhibition design for the British Council, a range of Japanese streetwear and their own cult architectural magazine, *Sexymachinery*. Their brief from Maison Martin Margiela was to create a series of visuals to explain the 'service' of 6.

MARTIN MARGIELA ⑥
ÅBÄKE WITH MAISON MARTIN MARGIELA

0 1 2 3 4 5 6 7 8 9

10 11 12 13 14 15 16

17 18 19 20 21 22 23

(0) Vêtements transformés pour femme(artisanal)

(0) (10) Vêtements transformés pour homme(artisanal)

1 La collection pour femme *

(6) Vêtements basiques pour femme

(10) Garde-robe pour homme

(13) Objets & éditions

(15) Vente par correspondance

(22) Collection de chaussures pour femme

*** Etiquette toute blanche**

Maison Martin Margiela

Previous page
An explanation of the numbering system for each of the Margiela labels.

Below left
Maison Martin Margiela uses a simple system of labelling to differentiate between the various lines: plain white labels for the main collection; or with a series of printed numbers, one of them circled to indicate the relevant collection.

Below right
Åbäke's explanation for the 6 collection, spring/summer 2003. One of a series of eight images that depict the various Maison Martin Margiela collections. This one represents the line of basic garments for women, the foundation of which is that each garment should exist in three versions. Art direction: Maison Martin Margiela. Photography: Marina Faust.

Opposite
Maison Martin Margiela uses a simple visual system to differentiate between collections. The photography and graphics are always basic and functional. (Left) Collection 10, menswear. (Right) Collection 1, white label womenswear.

Maison Martin Margiela has its own idiosyncratic methods of working. The designer himself never gives interviews and is never photographed, preferring the collections to take precedence over his own ego. The house works as a collective. In many ways, it works against the fashion system, refusing to court publicity, hosting fashion shows in obscure venues, or preferring to show a video rather than a traditional catwalk. Since Maison Martin Margiela was founded in 1988, the elusive designer has had a cult following. He is Belgian, but is based in Paris.

From the beginning, the collection has had a very distinctive identity. Unlike other fashion houses, this identity is not based on a signature, or a logo or graphic. The label for the main collection is simply a strip of white cloth, tacked onto the garment at each corner. If there is a brand identity, it is the four stitches on the outside of the garment – instantly recognizable to those in the know. There is not a logo as such, but the company uses an old-fashioned typewriter face for all of its communications, often simply stamped like something from the post office. It is anti-branding, anti-slick and anti-establishment. Invitations for the shows have a hand-made feel, often cut out in the shape of a letter, and printed with a rubber stamp. You get the impression that the company does not own a computer, just an old typewriter and access to an old-fashioned stationery shop. Packaging is simple, too. When the house opened a shop in Tokyo in 2001, the bags were just rectangles of white calico, basic and unprinted like the label. Of course, a plain white label is difficult to register as a trademark.

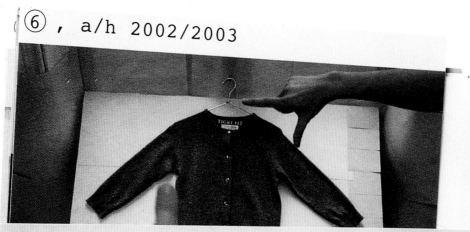

maison martin margiela

0	1	2	3	4	5	⑥	7	8	9
10	11	12	13	14	15	16			
17	18	19	20	21	22	23			

autumn/winter 2002/2003

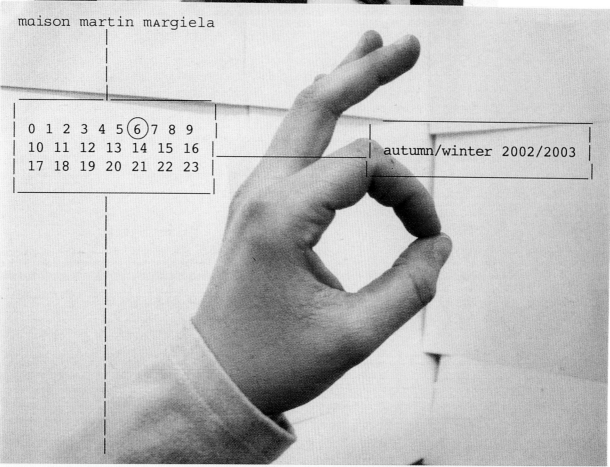

⑥, basic garments for women.
Three choices of the same garment or accessory. Six intensities of blue cross the range. Choose the garment, fit, fabric or treatment best suited to your hand.

⑥, vêtements basiques pour femme.
Trois choix pour le même vêtement ou accessoire. Six tonalités de bleu traversent la gamme. Choisissez le vêtement, la forme, le tissu ou le traitement qui vous conviennent le mieux.

⑥ 女性のためのベーシックな服。
同じ服が三通り。同じアクセサリーが三通り。六色。
アイテム、フィット感、素材．加工から選ぶ手があります。

åbäke

Margiela has collaborated with photographers, graphics houses and other image-makers in the past. For shows during fashion week, the house has worked with photographer Marcus Tomlinson, produced rough-and-ready Super-8 films, and given the collection to the British digital media company, Intro, to interpret. To differentiate one line of clothing from another, the house uses a simple numbering system. Menswear is 10; shoes are 22 and basic garments for women are 6. These labels are printed with the numbers 0–23, and the number 6 or 10 is simply circled. It is a system that needs little explanation. For the spring/summer 2002 6 collection, however, Maison Martin Margiela decided that the collection itself needed a bit of explaining to the consumer. The east-London-based graphics collective, Åbäke, went to Paris to see the fashion house to exchange ideas. They got the job.

Patrick Lacey, Benjamin Reichen, Kajsa Ståhl and Maki Suzuki are originally from France, Wales and Sweden; they set up Åbäke after graduating from the Royal College of Art in 2000. Together, they collaborate on a range of diverse projects, from Japanese streetwear to CD covers, and their own magazine, *Sexymachinery*. The British Council asked them to design a travelling exhibition of British book design in 2001. They were also asked to contribute to the Victoria & Albert Museum's Village Fête event. It is hard to pinpoint what they do and how they do it — something that would appeal to a company like Martin Margiela. Their brief was to create the conception and photography of the visuals that explain the service of 6.

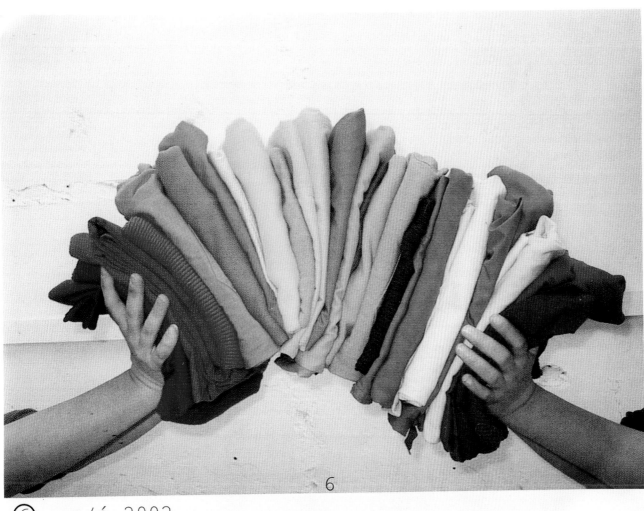

6

⑥ , p/é 2002

This page and opposite Åbäke answered the brief set by Maison Martin Margiela by producing a series of eleven stickers depicting the various services of the 6 collection. The challenge was to communicate non-verbally. Åbäke came up with idea of the human hand as a gauge. It seemed logical that the same hand also express the name of the collection. Photography: Åbäke.

maison martin mᴀrgiela

0 1 2 3 4 5 ⑥ 7 8 9
10 11 12 13 14 15 16
17 18 19 20 21 22 23

spring/summer 2003

⑥, basic garments for women.
Three choices of the same garment or accessory.
Choose the garment, fit, fabric or treatment best
suited to your hand.

⑥, vêtements basiques pour femme.
Trois choix pour le même vêtement ou accessoire.
Choisissez le vêtement, la forme, le tissu
ou le traitement qui vous conviennent le mieux.

⑥、女性のためのベーシックな服。
同じ服が三通り。同じアクセサリーが＿通り。
アイテム、フィット感、素材、加工から選ぶ手があります。

âbäke

Åbäke came up with a solution that was, according to them, very subjective in a way but also very accurate. The collection offers three choices of the same garment or accessory, varying in width, length or size. Consumers can choose the same white T-shirt in lengths of 47cm, 58cm or 80cm, or a denim dress in dark, medium or light. Åbäke utilized the Martin Margiela house style (low-tech and hands-on) and came up with a series of photographs printed on stickers which used the hand as a measuring tool. It is simple, no-frills and perfectly straightforward. The pack of eleven stickers is given away at the point of sale and also sent out to the press as both explanation and promotion. Åbäke understood the Margiela ethos totally, and worked within it. They were, however, allowed to play about a little with the Maison Martin Margiela logo, changing the font of the As. The font is slowly going to change. 'It's nice to have rules and then to break them', they say.

This page and opposite Åbäke's series of labels explaining the collections use basic elements such as hands to demonstrate different lengths and design features. The designers wanted to create a direct form of visual communication for the customer.

Wim Neels left college in 1992, a year after Paul Boudens. They met while both working for the Belgian designer Walter Van Beirendonck, and Boudens was the logical choice of graphic designer when Neels set up his own fashion label soon after. Although Neels designed his own logo, Boudens created a series of posters for him, advertising his showroom appointments twice a year.

WIM NEELS
PAUL BOUDENS

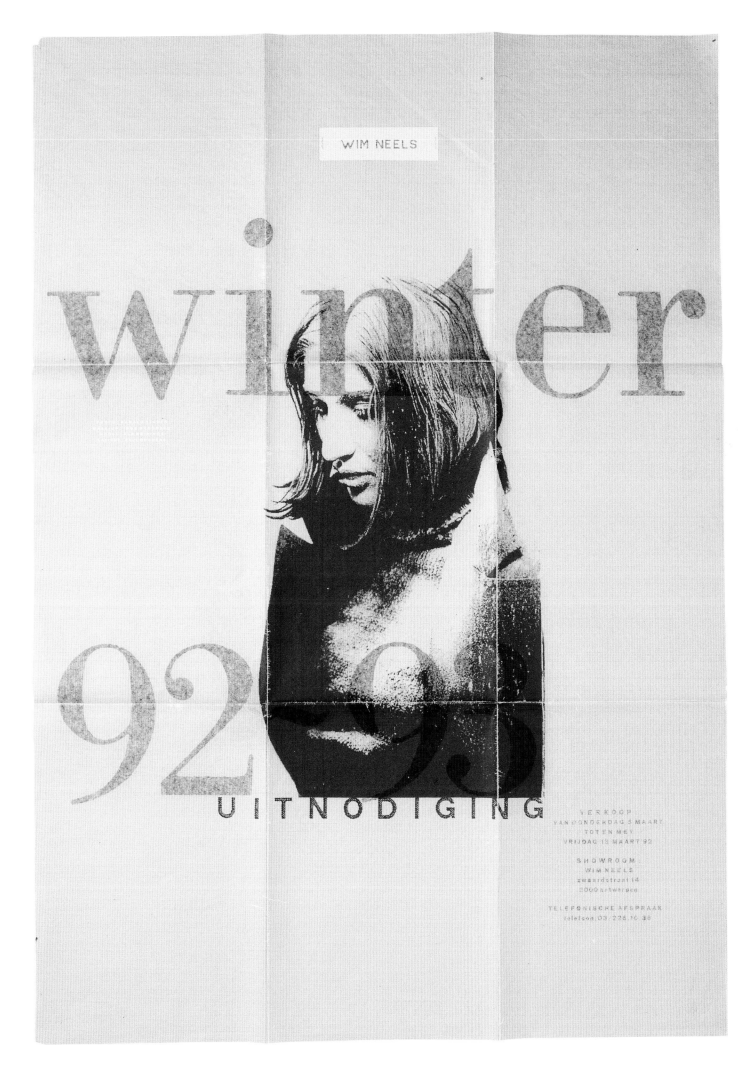

winter

92-93

UITNODIGING

VERKOOP :
VAN DONDERDAG 5 MAART
TOT EN MET
VRIJDAG 13 MAART '92

SHOWROOM :
WIM NEELS
zwaardstraat 14
2000 antwerpen

TELEFONISCHE AFSPRAAK :
telefoon:03/226.10.36

The Belgian fashion designer Wim Neels set up in business in Antwerp in 1992, after graduating from the Antwerp Royal Academy of Fine Arts. His grandparents were both tailors and his work is rooted in this tradition rather than the constant search to reinvent the wheel and create new trends every season. He has never shown his collections as part of a live catwalk show, preferring instead to invite press and buyers to a showroom to see the clothes up close.

Neels met the graphic artist, Paul Boudens, when they were both working at the studio of Walter Van Beirendonck. Everybody who passes through Van Beirendonck's studio seems to come out the other end feeling enthused and motivated. At the time, the two men were virtually living together and when Neels decided to set up his own label, Boudens was the logical choice to work on his graphics. His initial logo for the designer was very clean and classic, woven onto a plain white label in red. The logo soon changed, however, when Neels had a bolder version made up on a batch of 10,000 labels. They had to be used, and so the new logo stuck. To publicize his first collection, Neels and Boudens created a poster instead of sending out the traditional invitations. The first one was silk-screened on both sides to make it look like a front and a back. 'It's still one of my favourite pieces,' says Boudens.

Others over the years included a print on architectural-plan paper ('It ages well. In the beginning it's blue and then eventually it turns brown'); another with the slogan 'Made in Italy' because Neels was working with an Italian manufacturer; one printed onto stamp paper, and one silk-screened onto fabric (because it was lying around in Neels's studio). 'The longer we worked on the posters, the less we put on them.'

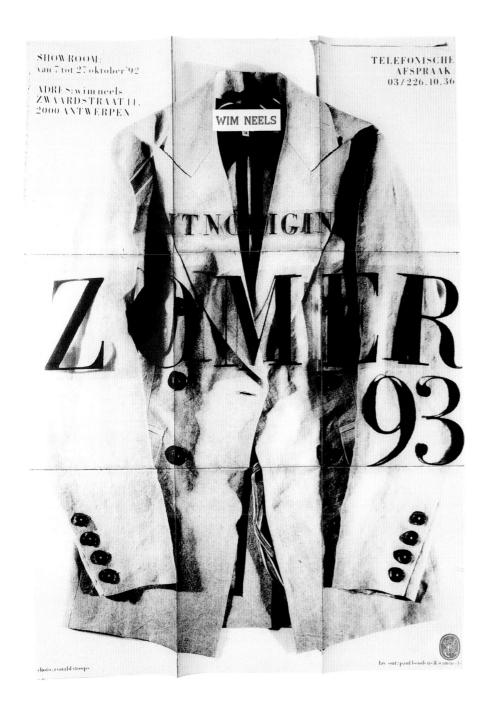

Previous page and opposite
Winter 1992–1993 invitation poster.

Left
Summer 1993 invitation poster.

Boudens's love of low-tech, basic techniques is evident in his work for Neels, where he was allowed creative freedom. One poster featured strips of sticky tape, and was posted as it was, without the need for an envelope, so that the marks and stamps from the post office became part of it; he also made use of a very bad copy machine, and used cut-and-paste techniques that were common before computers. It's a method he still uses, keeping hold of a bad printer on purpose, rubbing the work on the floor to make it dirty and then scanning it again. He tries to avoid making his work look too slick. 'I like it when people have to make a little effort to read something', he says.

Boudens also works on books, dance and theatre projects, as well as with the Fashion Institute in Antwerp. 'With fashion, there is no respect,' he says. 'After a show, they throw away the invitations. I could cry when I see that. Most of the things I make for myself. If I like them, somebody else will like them, too.'

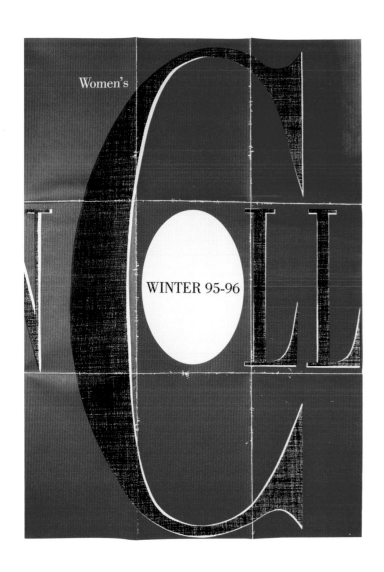

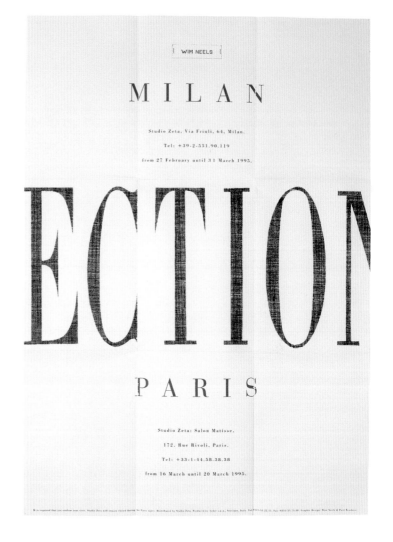

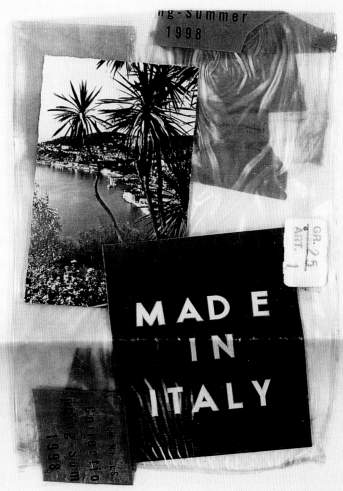

"Just in case you wanted to buy a 'Made in Italy' label" (1997)
27 x 18 cm , various plastics with personalised tape and vintage postcard

WIM NEELS Menswear Spring-Summer 1998

*Milan: **Showroom Breramode***
Via Carlo Botta 8, 20135 Milano, Italy, Tel: 0039-2-55.01.59.97 & Fax: 0039-2-55.01.59.94
From 29 June 1997 on...

Produced & distributed by **Uno Maglia SRL**, 52028 Terranuova B.NI (AR), Italy, Tel: 0039-55.91.99.497 & Fax: 0039-55.91.99.263
Produced & distributed by **Luca's Moda SRL**, 25020 Gambara (BS), Italy, Tel: 0039-30.99.56.224 & Fax: 0039-30.99.56.234
Graphic Design: Wim Neels & Paul Boudens

Antwerp-based graphic artist Paul Boudens has produced some of his most provocative and shocking images for fellow Belgian fashion designer Jurgi Persoons. Look closely at the 'royal crest' that Boudens designed as part of Persoons's logo and you will see that all is not as it seems.

JURGI PERSOONS
PAUL BOUDENS

JURGI PERSOONS
Women's Collection
Summer 98
Showroom from 13 until 21 October 1997
Galerie Bruno Delarue
12, Rue de Thorigny
75003 Paris, France
Tel: 0033-1-42.78.14.26 & Fax 0033-1-42.78.38.21
For appointments in advance please contact
Jurgi Persoons
Robert Moisstraat 30, 2018 Antwerp, Belgium
Tel: 0032-3-237.02.05 & Fax: 0032-3-238.56.30

The Belgian designer, Jurgi Persoons, graduated from the Antwerp Royal Academy of Fine Arts in 1992. Even while at college, he knew how to create a statement that would make him stand out from the crowd. His final show was all high heels, tight leather and dogs. After an unsuccessful trip to Paris to find work experience with Thierry Mugler, he returned to Antwerp and decided to set up his own label. He had nothing, but over the years he has built up quite a reputation with his eerie installations, like the one in a Paris park, where his models stood static among the trees, in giant, egg-shaped bubbles.

Persoons began working with the graphic designer, Paul Boudens, in 1996. 'You meet in Antwerp,' says Boudens, 'and start working together.' It is a small place, where people almost trip over each other. Boudens has worked with many of the Belgian designers who were so influential in the 1990s, including Dries Van Noten, Walter Van Beirendonck, A.F. Vandervorst and Olivier Theyskens. His work with Persoons began with the logo. At first glance, it is like a royal crest – you expect to see the words 'by appointment to Her Majesty', underneath it. But if you take a close look, things are not what they might seem. 'He wanted a cyberpunk with chihuahua dogs,' says Boudens. 'That's what he wanted and that's what he got – something that, from a distance, looks like a family crest. You get the same contrast in his clothes: both really chic and at the same time, destroyed.'

Persoons likes to work with stories, and that makes a good starting point for Boudens, too. For the invitation to his summer 1997 collection, the story was of a young girl who goes on her holidays to Benidorm, and gets so bored that she starts to make her own clothes in her hotel room. Boudens made the postcard from hell – a photograph of people merrily exercising on a crowded beach, with the word 'HELP' scratched across it, and a sunny logo for Persoons Tours in the corner. The invitation doubles as a poster. On the back is the information for the show, scrawled in black ink. He did the writing with his left hand. Boudens uses hand techniques a lot, even going back to good old-fashioned methods like cutting and pasting with scissors. It gives his work an emotional, urgent appeal.

Previous page
Evil Eye. Invitation poster for the summer 1998 collection. For Persoons's first invite, Boudens used a heavily made up eye – it was Persoon's own, bloodshot after walking into a tree.

Opposite and below
Help! Persoons Tours. Invitation to the showing of the summer 1997 collection. The collection was about a girl who was stuck on a holiday from hell in a hotel in Benidorm. Boudens scrawled an SOS on a post card image of the resort.

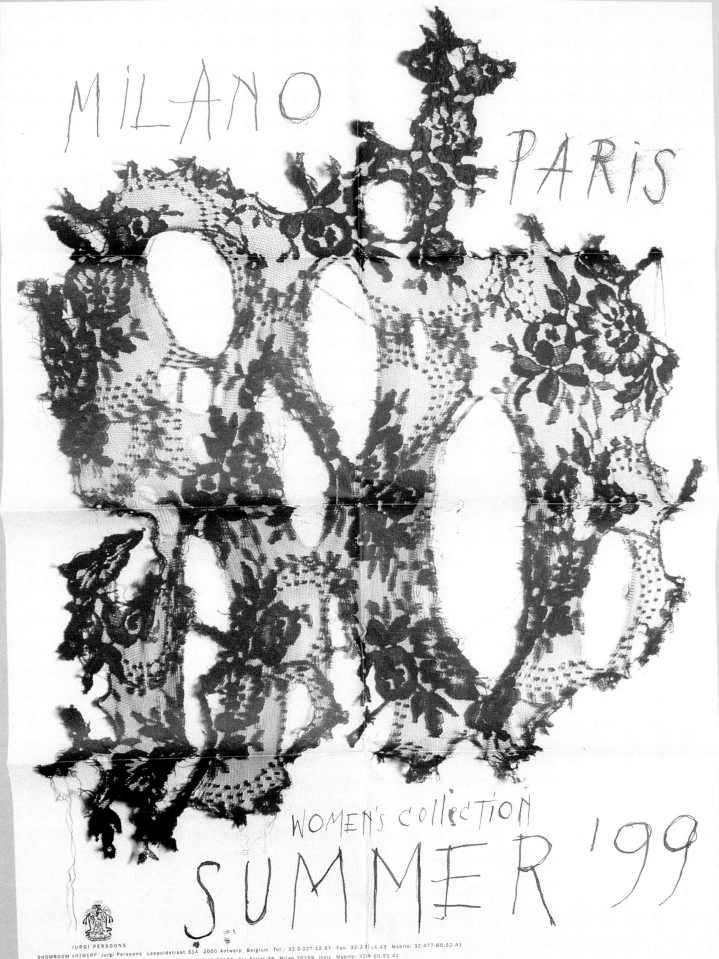

MILANO PARIS

WOMEN'S COLLECTION
SUMMER '99

JURGI PERSOONS
SHOWROOM ANTWERP Jurgi Persoons Leopoldstraat 31A 2000 Antwerp Belgium Tel.: 32-3-227.12.67 Fax: 32-3-2 14.43 Mobile: 32-477-60.52.41
SHOWROOM MILAN From 4 until 9 October 1998 VIAFARINI SPACE Via Farini 35 Milan 20159 Italy Mobile: 32-4-60.52.41
SHOWROOM PARIS From 12 until 20 October 1998 GALERIE BRUNO DELARUE 12 rue de Thorigny 75003 Paris Face Tel.: 33-1-42.78.14.26 Fax: 33-1-42.78.38.21
For appointments in advance please contact Graça Fisher or Cyril Tayac at our Antwerp Office 1.: 32-3-227.12.67 or Mobile: 32-477-60.52.41
Graphic Design: Paul Boudens & Jurgi Persoons Photography: Ronald Stoops Printed by Imschoot Ghent

CRUSHED LACE PRODUCTIONS & PERSOONSFILMS PRESENT A BVBA JURGI PRODUCTION 'I KNOW WHAT YOU'LL WEAR NEXT SUMMER'-THE MOVIE STARRING JURGI PERSOONS WOMEN'S COLLECTION SUMMER 1999
PREMIERE ON SUNDAY 11 OCTOBER 1998 FROM 9.30 PM UNTIL 11.30 PM AT CINEMA LE TRIANON 80, BOULEVARD ROCHECHOUART 75018 PARIS, FRANCE METRO: ANVERS
SHOWROOM FROM 13 UNTIL 20 OCTOBER 1998 AT GALERIE BRUNO DELARUE 12, RUE DE THORIGNY 75003 PARIS, FRANCE TEL.: 33-1-42.78.14.26 FAX: 33-1-42.78.38.21
FOR MORE INFORMATION PLEASE CONTACT PRESS AGENT FREDERIQUE LORCA TEL & FAX: 33-1-53.17.06.37
DIRECTED BY: PHILIPPE VAN DAMME DIRECTOR OF PHOTOGRAPH: RONALD STOOPS MAKE-UP ARTIST: INGE GROGNARD HAIR: PER LEI STUDIO GRAPHIC DESIGN: PAUL BOUDENS PRODUCED BY BVBA JURGI, PERSOONSFILMS & CRUSHED LACE PRODUCTIONS

 CONCORDIA CRUSHED Lace PRODUCTIONS® PERSOONSFILMS® JURGI PERSOONS

For the following summer, Boudens designed a poster with a larger-than-life photograph of one of Persoons's eyes, bloodshot after an accident (walking into a tree in the woods). It is smudged with black kohl, and the type and crest play a much smaller role. After that, there was a blood theme that stuck for a season, with an invitation made to look like a wedding announcement, on beautiful thick cream card, with the cyberpunk crest looking very proper and grand in gold. The blood splatters across the inside of the invitation, just when you are least expecting it. 'I called a nurse and she took blood from my arm and I used it to splash from a pencil and then rushed the result to the scanner. It's brownish when it dries. We were young and aggressive then', says Boudens. For summer 1999, Persoons made a film instead of a show, and Boudens made him a film poster. 'I know what you'll wear next summer' was scratched in red ink, like the title of a pulp horror movie.

Boudens likes to push his work beyond the actual layout and graphics. He likes to create his own imagery and artwork too. His work is always very different, depending on who he is designing for, but there is always something raw, something real, that is his trademark. 'Maybe I have a split personality,' he says. 'I'm not really interested in what the designers do. I never see the clothes.' Although he will have an idea about colours and theme, he treats the invitations as separate entities altogether. For the final invitation he made for Persoons for spring/ summer 2002, he knew the collection had lots of pleats in it, so he used a *plissé* technique for the type, classical, curly italics in black with stripes taken out in pale blue. 'I wanted it to look like the type fell off', he says.

Previous page
I Know What You'll Wear Next Summer. Invitation poster for video-presentation, 1999. Boudens created a spoof film poster for Jurgi Persoons's video presentation of his collection for spring/summer 1999.

Below and right
Blood Wedding. Invitation for the winter 1998–1999 collection. Boudens scanned splatters of his own blood – carefully and clinically taken by a trained nurse, for a sinister invitation carefully disguised as an invitation to a posh wedding.

Opposite
Needlework. Invitation poster for the winter 1999–2000 collection. Boudens created his own *trompe l'oeil* pin art for this poster-sized invitation.

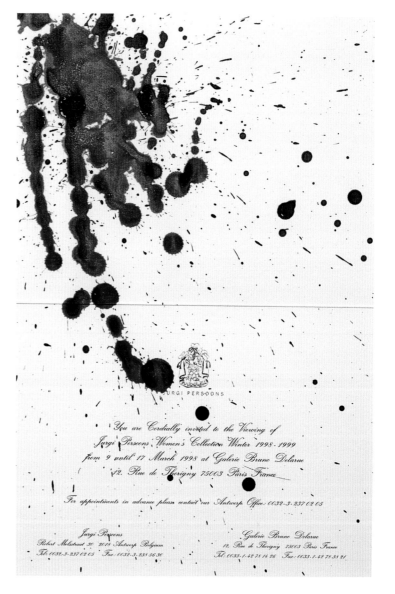

JURGI PERSOONS
WOMEN'S COLLECTION
WINTER
1999–2000
FROM 8 UNTIL 16 MARCH
AT GALERIE BRUNO DELARUE
12, RUE DE THORIGNY
75003 PARIS
TEL: 33-1-42 78 38 21 +
FAX: 33-1-42 78 14 26
FOR ALL APPOINTMENTS PLEASE
CONTACT OUR ANTWERP OFFICE
TEL: 32-3-227 12 67
+ FAX: 32-3-227 14 43

JURGI PERSOONS WOMEN'S COLLECTION WINTER 1999-2000 PRESENTATION SUNDAY 7 MARCH 1999 10 P.M. 16 QUAI D'AUSTERLITZ 75013 PARIS FRANCE DRIVE-THROUGH OPTIONS: 1. FREE TAXI-SHUTTLES AT 9 ESPACE CAROLE DE BONA (AFTER SHOW OF FRED SATHAL)-PLACE DES PETITS PERES 75002 PARIS 2. EASY ACCESS FOR CARS 3. PEDESTRIANS: METRO GARE D'AUSTERLITZ SHOWROOM FROM 8 UNTIL 16 OCTOBER 1999 AT GALERIE BRUNO DELARUE 12 RUE DE THORIGNY 75003 PARIS FRANCE TEL: 33-1-42.78.14.26 & FAX: 33-1-42.78.38.21 ANTWERP OFFICE: TEL. 32-3-227.12.67 FAX. 32-3-227.14.43 PRESS AGENT FREDERIQUE LORCA TEL. & FAX. 33-1-53.17.05.37 GRAPHIC DESIGN: PAUL BOUDENS PREPRESS: FOTOGRAVURE GOEDFROIT ANTWERP

The Jil Sander logo has remained unchanged since it was designed by Peter Schmidt in the 1970s. In the early 1990s, Peter Saville and Nick Knight were employed by Marc Ascoli who was Sander's art director for twelve years. He recently commissioned M/M (Paris) and the brand developed a strong new personality.

JIL SANDER
MARC ASCOLI
PETER SAVILLE
MILAN VUKMIROVIC

When Jil Sander walked out on her own label six months after it was bought by Prada in 1999, Milan Vukmirovic, one of the partners behind the innovative Paris store, Colette, was appointed as creative director. For loyal followers of Jil Sander's modern minimalist fashion, it was the end of an era. For Vukmirovic and Prada, it was the beginning of a new one. 'Today, you can't consider minimalism like it was ten to fifteen years ago. We wanted to bring a more human feel: less cold,' says Vukmirovic. Whatever else was to change, however, it was agreed that the logo, designed in the 1970s by Hamburg-based graphics supremo Peter Schmidt, would stay. 'When a house has already been in existence for twenty-five years or more, it is important when it gets bought by another group, to keep the logo and identity of the label. For some companies, the logo is the first thing to be changed, but for us it was the opposite; the logo was part of the identity of the brand.'

The Jil Sander logo has stood the test of time. 'It's very pure,' says Vukmirovic. 'Time doesn't have an effect on it. The logo has to express the philosophy of the brand. It is simple, pure, with quite big letters which can express a certain security – you know the product will be well-made, good-quality. It's quite reassuring. It's important to have a logo that is recognizable.' For him, the most effective form of advertising is the carrier bag. 'It's even more important than the ads in the magazines,' he says. 'People carry the bag because they want to show that they have bought something of quality from Gucci, Prada, of Jil Sander.' It all adds to the frisson of buying a luxury item. While the logo itself has remained untampered with, Vukmirovic has, however, changed the carrier bag, from black with a slightly beige logo, to matt black with a shiny black logo. 'The logo is shiny but discreet, for people who want a private, discreet luxury.' He felt that there are so many logos out there on the street, he didn't want Jil Sander to be cheapened by having to compete. Instead of shouting, it whispers.

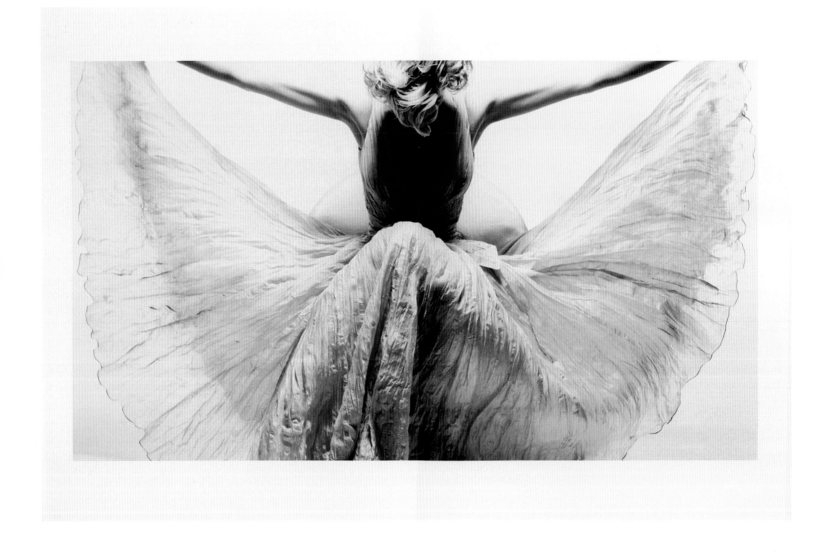

Vukmirovic has a background in retail and buying. He has a strong commercial eye. For him, the graphics of a brand are as important as the clothing or the store design. They all have to come from the same place. 'I almost treat it as I treat the clothes.' For Vukmirovic, the graphic aspect of the brand has been an opportunity for expression further than the clothing itself allows. Previously, the Jil Sander show invitation followed the same rigorous formula, season after season. It was a plain white card. 'They were always the same – very simple,' says Vukmirovic. 'This reflected the extreme minimalism of Ms Sander.' He has done the complete opposite, using the invitations as a canvas for images and colour, ideas that change season after season. 'I don't want to have a limit with our graphics. I like the idea that people will want to put it on their wall and keep it. When you look back in ten years' time, you will see there is a lot of creativity that went into each invite.' Similarly, with the stores, although the basic architectural framework remains the same, the company has now introduced light boxes in the windows, showcasing different photographs, which change regularly like gallery exhibits. The graphics are all directed by Vukmirovic, in collaboration with Milan based designer Susanna Cucco.

Previous page
Jil Sander's minimal packaging.

Opposite
Jil Sander advertising campaign, spring/summer 1992. Photography: Nick Knight. Model: Tatjana Patitz. Art direction: Marc Ascoli. Design: Peter Saville, Pentagram.

Below
Jil Sander advertising campaign autumn/winter 2002/2003. Photography: Richard Avedon. Model: Emma Balfour. Art direction: Milan Vukmirovic and Matthias Vriens.

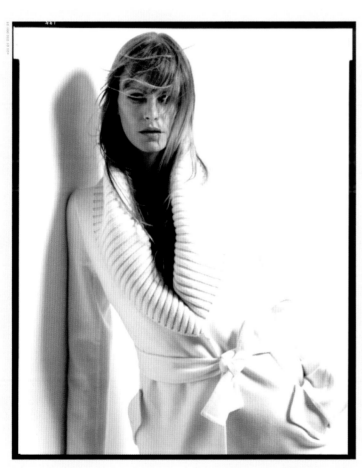

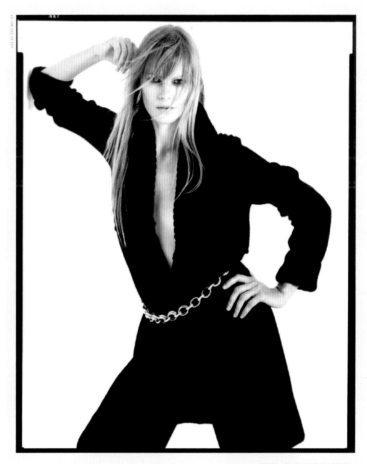

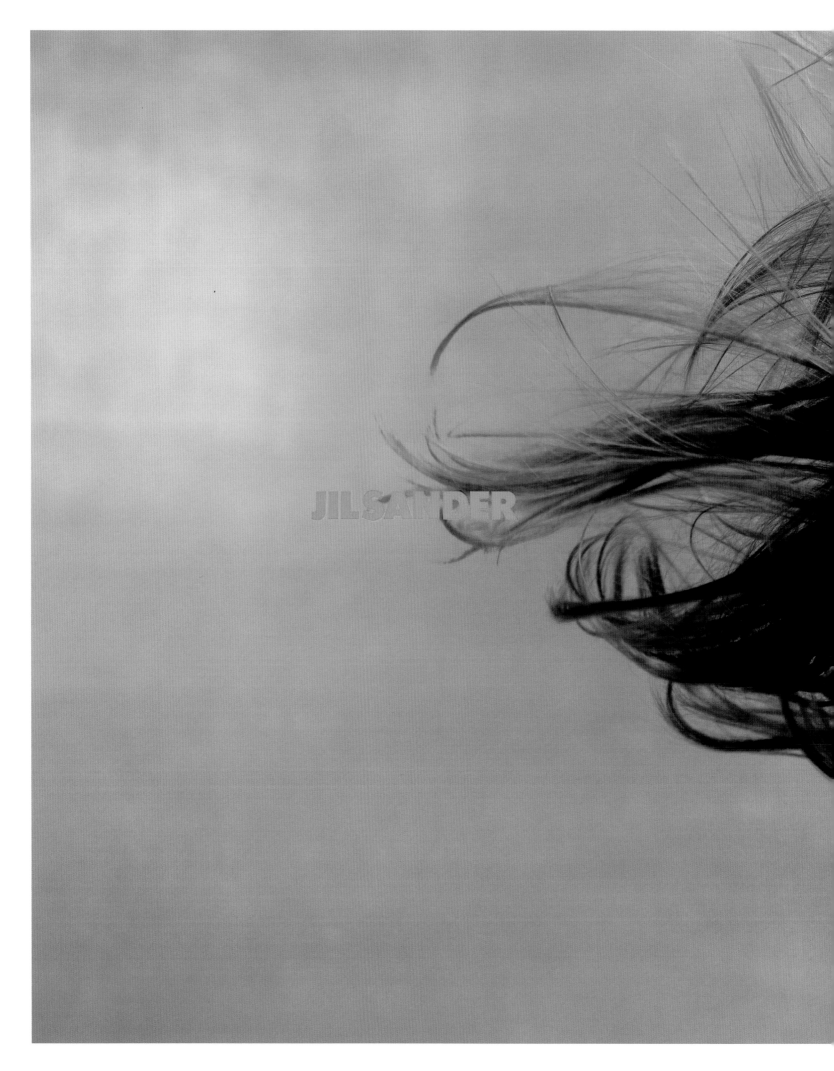

JIL SANDER

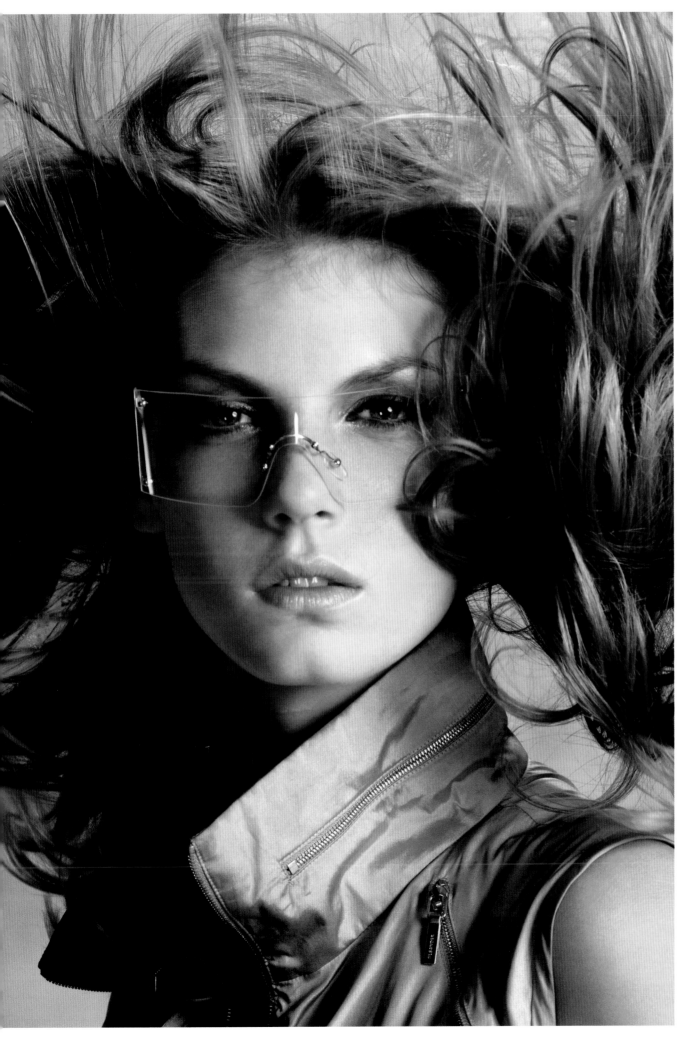

Left
Jil Sander advertising
campaign, spring/summer
2003. Photography:
Richard Avedon. Model:
Angela Lindvall. Art direction:
Milan Vukmirovic and
Matthias Vriens.

Jil Sander has a long tradition of strong graphic design. The logo itself is a bold, graphic statement. In the early 1990s, Sander employed Marc Ascoli, fresh from Yohji Yamamoto, to work on the creative direction. He, in turn, commissioned Nick Knight and Peter Saville to work on the ad campaigns. 'Like the Three Musketeers, we reconvened for Jil', says Saville. It was during those four or five seasons that the profile of Jil Sander as a directional fashion force really took off. 'I think Jil invested the resources and devoted the sense of self to achieving it,' says Saville. 'But Marc completely reinvented it. The high point was a photo of Tatjana Patitz, by Nick, and it's just, "Wow, is that Jil Sander?"' When British *Vogue* recreated the image for a cover, it was proof that Jil Sander had arrived. For Saville, it was 'mission accomplished'.

With Sander, Saville's role was less involved than with Yohji Yamamoto. 'Yes, there's always something to edit,' says Saville. 'There's always a conversation about what will be best for the advertising; there's always some picture that has to be in because the garment is important; and there's always the discussion about which is the iconic image. We would all have an opinion. And then it had to be presented and it was a matter of putting it on the page in the right way. It's invisible, and my approach to fashion graphics at that time was that it should be invisible. It's fashion, and already we have to see it through the medium of photography. You don't really then have to go through the medium of graphics – and I kind of felt that my input should be invisible.' Presentation for Saville was about simplicity, not looking as though it was trying too hard. 'I don't want to fight my way through ten layers of knick-knacks and bits and pieces. You don't actually need it. If it's a great dress

JIL SANDER

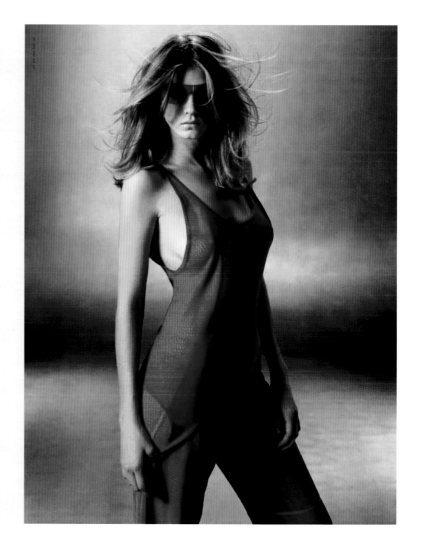

and a great photograph, that's it. You really don't need six different ribbons and four different types of paper. You don't need it, and it's just an awful lot of form over content and it's not chic – it's not chic at all. It's desperate. I've seen a lot of work during the Nineties where there are more graphics going on the page than fashion. You've got to fight your way through the graphics to see the picture. When somebody manages to get, spiritually and emotionally, the feel of something, that's the thing, you know. But you don't see it; it just feels right. The right paper for an invitation, the rough cut down the side of a catalogue or something which just touches the spirit. That has got to be light and subliminal, because that's what it's about. It's about fashion and it's about clothes. It's not about graphics.' In 2003, Jil Sander returned to the helm of her country, thankful that her logo had not been changed.

Opposite
Jil Sander advertising campaign, spring/summer 2003. Photography: Richard Avedon. Model: Angela Lindvall. Art direction: Milan Vukmirovic and Matthias Vriens.

Below
Invitations to celebrate the opening of the Jil Sander store in London, February 2002. Design: Milan Vukmirovic and Susanna Cucco.

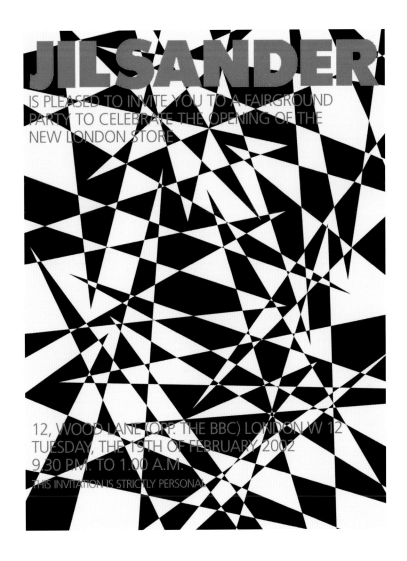
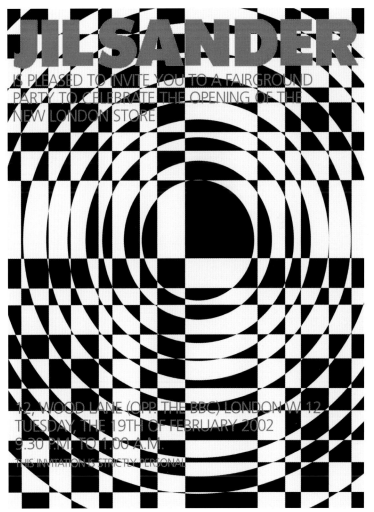

Alan Aboud began his relationship with Paul Smith in 1989 when he was still a graphics student at Saint Martins School of Art. After graduating, he and his college friend, Sandro Sodano, formed Aboud Sodano. They have worked with Paul Smith almost continuously ever since. Aboud art directs while Sodano concentrates on photography.

PAUL SMITH
ABOUD SODANO

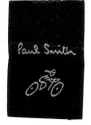

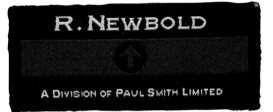

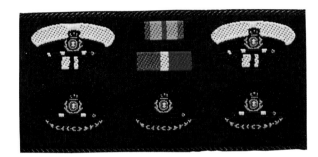
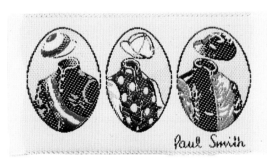

Alan Aboud began his relationship with Paul Smith in 1989, when he was still a student at Saint Martins School of Art in London's Covent Garden, next door to Paul Smith's offices. 'They were looking for a freelancer at the time. The head buyer came to the show and shortlisted about ten of us', he remembers. Aboud got the job. The same year, he and his college friend, Sandro Sodano, went into business together and formed Aboud Sodano. Paul Smith was their first client, and he has remained a client ever since. At the time, there was just the main line collection and the jeans line. Aboud started working two to three days a week. 'I've grown with them', he says. 'It's quite a unique partnership. In a way I'm part of the furniture. I'm the art director, but I'm also the client.'

'We only used real people – i.e. "non models" – for the first two to three years', he says. 'It was quite a daring thing to do at the time. We instigated it. One of our failings is that we've moved on from good ideas too quickly.' Strategic ad placement gives the illusion that the ad spend is more than it is. The relationship between Aboud and Smith is key to the longevity of their partnership. It took him several years before he gained Smith's trust completely, but over the years he has grown to understand both Smith himself and the way he runs the company. Paul Smith is still independently owned and the designer has resisted pressure to sell to bigger conglomerates. He is very hands-on. It is typical that he chooses to remain working with Aboud rather than with a big agency. 'He'll choose absolutely the wrong person to work with', says Aboud who never intended to work in fashion. But somehow it works.

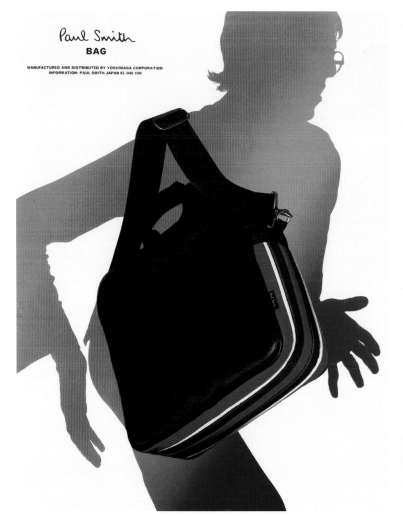

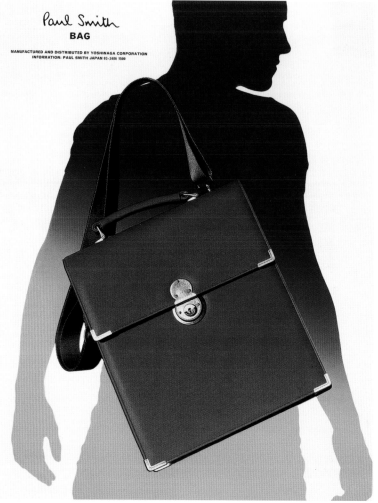

At college Aboud was always more interested in typography. Sandro Sodano concentrated on photography and has shot many of the campaigns with Aboud over the years. 'Sandro and I have a very loose business partnership,' says Aboud, 'whereby we both do individual projects with respective photographers and art directors, and then come together on other projects.' He will use Sodano if he is right for the job, but will equally use another photographer if he is better equipped for a particular shoot.

Previous page
Paul Smith labels
1986–2003. Art direction
Alan Aboud.

Opposite and below
Paul Smith bag campaign
spring/summer 1997.
Design and art direction
Alan Aboud, photography
Sandro Sodano.

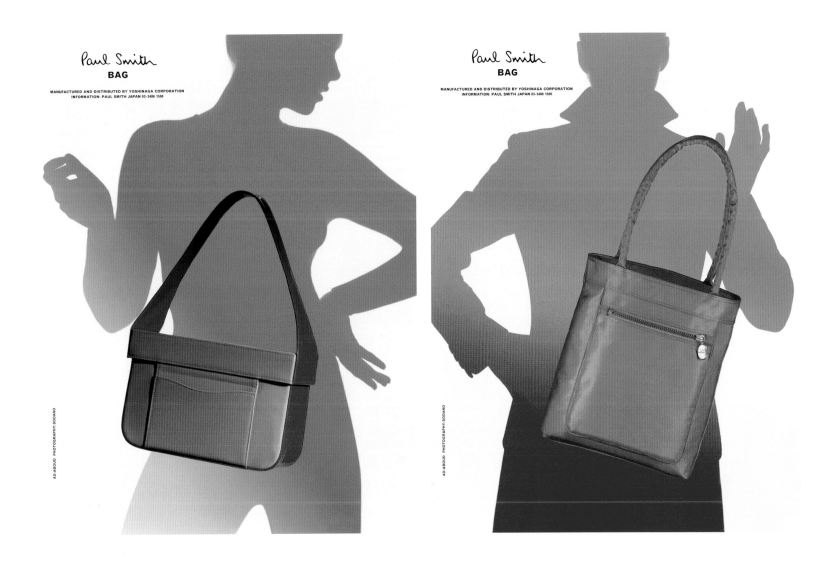

Below
Paul Smith Fragrance 2000.
Design Sophie Hicks,
Alan Aboud, Maxine Law.

Opposite
Paul Smith Christmas
brochure 1992.
Design and art direction
Alan Aboud, photography
Sandro Sodano.

'You really need to know how the company works. People think Paul is like a child and that he likes a laugh. But he's more childlike than childish. People can get it so wrong with him. In reality he's very knowledgeable about photography, design and art. He's a very complex character. I'm lucky that I've grown to know him well.' They meet every couple of weeks to discuss everything from the carrier bags to the advertising – anything to do with the image of the company. The meetings between Smith, Aboud, the creative director, Häkan Rosenius, and womenswear designer, Sandra Hill, are informal. It is very different to the way Aboud works with other companies like H&M and Levis, which is more structured and purely business.

'He holds off from cashing in', says Aboud of Smith. And in return, Aboud – as an idealist more than a capitalist – has relative creative freedom within the Paul Smith universe that he has helped define. 'You have to be more resourceful with a limited budget. One single H&M campaign (which changes every three weeks) would be the equivalent of a whole season at Paul Smith. These days, his job involves finding ways to integrate the many strands of the Paul Smith empire – the main line, PS, watches, bags, shoes, jeans and fragrance. 'We do stuff on a whim and a hunch', says Aboud. And it works: it is not design by committee or led by market research.

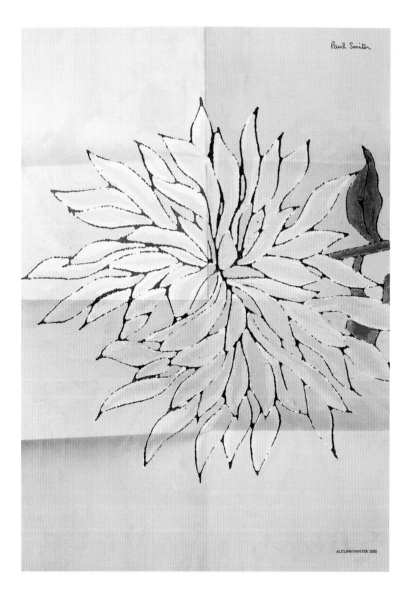

When Aboud began working at Paul Smith, the signature logo was already in place. 'We redrew the logo, and refined it slightly', says Aboud. Before that, it was simply a photocopy that was faxed around. It was not properly defined. Surprisingly enough, it is not the designer's actual signature. 'It was a friend of his in Nottingham in the 1970s who drew Paul Smith for him – probably on the back of a cigarette packet or something', says Aboud. Over the years it has become Smith's own signature. His logo has become his hand writing rather than the other way round. 'In the beginning we wanted to change it just for the sake of it. But if you've got a recognizable signature and it ain't broken, don't fix it. It's quite a tricky logo. It can look dreadful in terms of scale. It looks good small but on a large scale it is difficult to control.'

Opposite
(Top row, left to right)
Paul Smith Men
Spring/Summer 2001.
Art direction Alan Aboud,
design Maxine Law.

Paul Smith Women
Spring/Summer 2001.
Art direction Alan Aboud,
design Maxine Law.

Paul Smith Women
Autumn/Winter 2002.
Art direction Alan Aboud,
design Mark Thomson.

Paul Smith Men
Spring/Summer 2003.
Art direction Alan Aboud,
design Maxine Law.

Opposite
(Bottom row, left to right)
Paul Smith Men
Autumn/Winter 2000.
Art direction Alan Aboud,
design Maxine Law.

Paul Smith Men
Autumn/Winter 2002.
Art direction Alan Aboud,
design Mark Thomson.

Below
Paul Smith Women
Spring/Summer 2002.
Art direction Alan Aboud,
design Maxine Law.

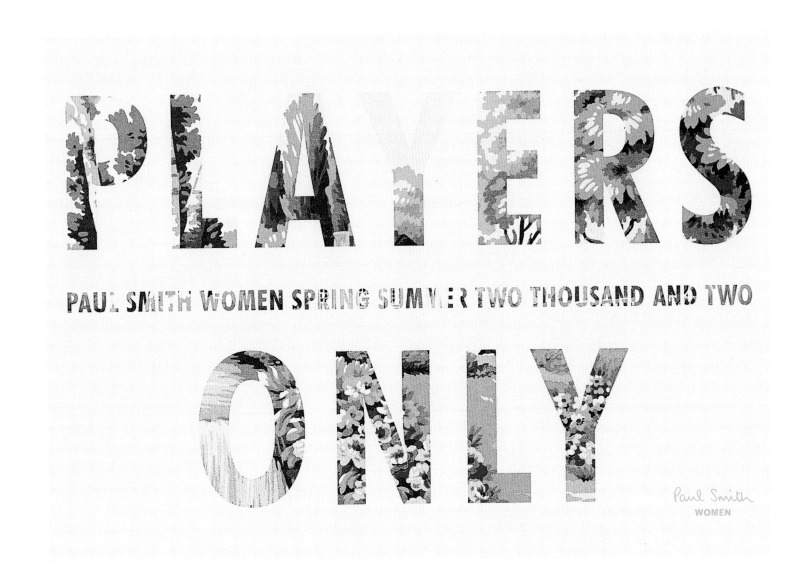

PLAYERS
PAUL SMITH WOMEN SPRING SUMMER TWO THOUSAND AND TWO
ONLY

Paul Smith
WOMEN

Perhaps the single most memorable thing that Aboud has done with the Paul Smith branding has been to introduce the signature multicoloured stripes. They first appeared on show invites for 1996 and then on bags in 1998. He wanted to change the carrier bag design because he felt that it was dull and not reflective of the vibrant Paul Smith collections. So he transformed it from grey with a black logo to a carnival of stripes. 'We took inspiration from a textile print in the archive', he says. 'It was based on a Bridget Riley style painting. I loved it. Everything we had before was grey, which was a bizarre anomaly for a designer who was so known for his use of colour. Since then, everyone's got them. It's incredible. They're everywhere.'

The original straight stripe pattern, and its sister swirly stripe for women, has not only been used on the clothing itself, but by other fashion houses, department stores, Channel 4 and Swatch. 'The final straw is the Euro flag,' says Aboud. The Dutch architect, Rem Koolhaas, has produced a stripy flag that *Creative Review* magazine connected to Aboud's bag for Paul Smith rather than the united colours of Europe. 'Its great that it's recognizable as ours, but not so great that it's copied and you don't make anything out of what you've done', says Aboud. The company decided to stick with it and weather the storm.

Right
Paul Smith women's
stripe bag 1999.
Art direction Alan Aboud,
design Maxine Law.

Opposite
Paul Smith Eau Extreme
fragrance bottles 2002.
Art direction Alan Aboud,
design Maxine Law.

R. Newbold

'Newbold is the most design literate of all the lines', says Aboud. As such, it is the one he can have most fun with. It began with a factory in Derby that Smith used to manufacture shirts. Smith bought the factory when it went out of business, and worked through its archives of road sweepers' overalls and police shirts. 'R. Newbold is a real factory and a real person,' says Aboud. 'We've built up the image of Newbold primarily for Japan – for a 16- to 17-year-old market. Because the market is so young and transient, it constantly reinvents itself. It was a gift of a project as a designer', says Aboud. The R. Newbold book was produced using photographs of what was already there. 'It was stuck in a timewarp, packed with a wealth of inspiration and source material. It's the most graphic of all Paul Smith lines and probably the most modern. We didn't have to adhere to fashion or trends. There were three or four logos because the target age group wanted something different every season. The graphics worked through into the clothes – in the form of arrows in circles, logo ticker tape and other graphic logos. It relied a lot on graphics. The boundaries blurred between us and the fashion designers.

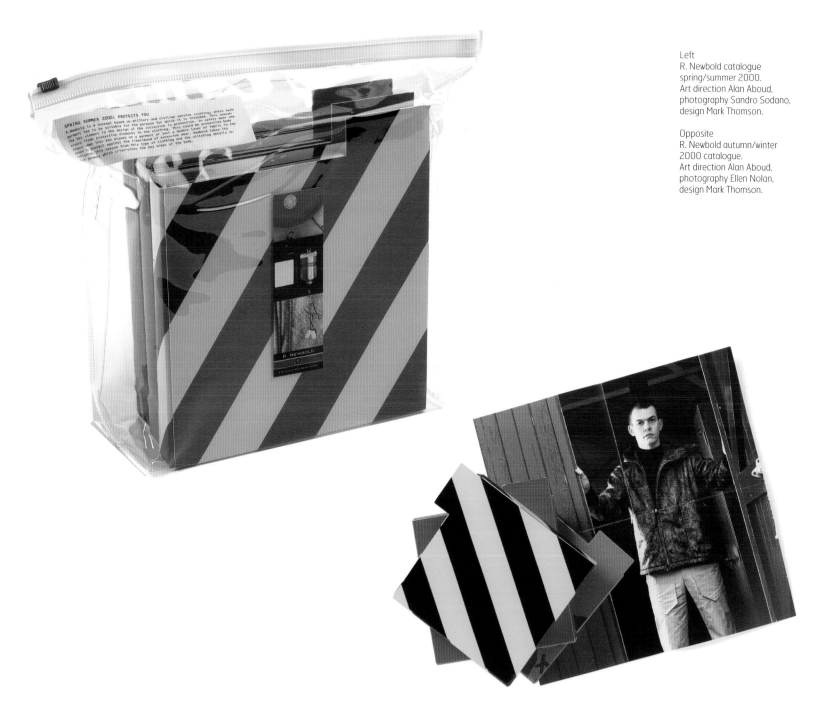

Left
R. Newbold catalogue
spring/summer 2000.
Art direction Alan Aboud,
photography Sandro Sodano,
design Mark Thomson.

Opposite
R. Newbold autumn/winter
2000 catalogue.
Art direction Alan Aboud,
photography Ellen Nolan,
design Mark Thomson.

Each season, Aboud produces a look book for Japan, which also has to convey information about the collection for the consumer. For autumn/winter 2000, the collection was all about travel and couriers – land, sea and air. So he produced a UPS-style envelope and printed onto waybills. It was a nominee for a D&AD award. 'The design awareness it creates is disproportionate to the amount of money that is spent on it', he says. For another collection inspired by bad weather and storms, Aboud printed the brochure on water resistant paper. Graphically it was very arresting.

Red Ear
Paul Smith introduced the Red Ear collection for autumn/winter 1997/1998. It's a line of Japanese denim that came out of his jeans collection. It has become very successful, eclipsing the R. Newbold workwear collection in the UK. The logo is a pair of rabbit ears. 'Paul came up with the logo', says Aboud. It's a symbol of good luck in Japan and rabbits are also the designer's lucky emblem. The logo was semi-existent from an old Japanese image. It's never been promoted but has developed under its own steam.

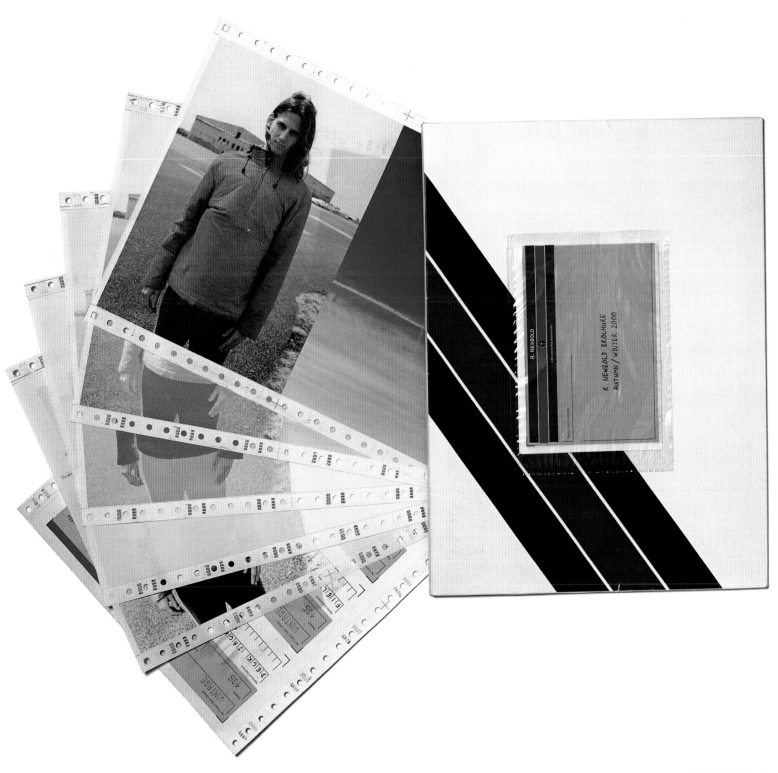

The comic caricatures created by Dean Landry (aka Chooch) for the New York designer Anna Sui, give her brand added personality. The self-taught graphic artist has a background in rock posters, and has been working with Sui since 1996, providing her with imagery, illustrations and logos for special projects. His work reflects her own fun, quirky style.

ANNA SUI
DEAN LANDRY

New York-based designer Anna Sui takes an irreverent view of fashion. Her collections draw on all sorts of diverse influences, from thrift-store finds to MTV. She is very much a 'downtown' designer, with a store in New York's SoHo, and a youthful, 'pop' approach to both her fashion and her successful cosmetics and fragrance ranges. Her label has a strong collection of visual reference points. She has a fascination with swirly Art Nouveau style, mixed with a touch of rock goth and 1970s' psychedelic typefaces.

Since 1996, Sui has had her very own caricature character, designed for her by the graphic artist, Dean Landry, who works under the name Chooch. His other clients include *Cosmopolitan*, *Nickelodeon*, *Teen People*, *TNT*, *The History Channel* and *The Late Show with David Letterman*, but his true love – and his common ground with Sui – is music. He has his own rock band, Nine Story Fall, and he began his career in graphics designing posters for bands. He is self-taught, but has drawn for as long as he can remember. 'I play music and design stuff for bands, and Anna saw my stuff and liked it. She's a big fan of rock posters. I think she had a connection with me because of that. She's very easy to work with – they are usually very varied projects.'

The original Anna Sui logo was already established, but Landry says he has created many additional ones since then – for T-shirts, or to accompany an illustration, or for the website. Unlike many major American designers, Sui is not so wedded to the idea of the corporate uniformity of a label. Her model is altogether looser. 'There are varied styles, always,' says Landry. 'They have the one main logo they use, but they use other ones as well. She's easy like that. She always wants a different flavour each season.'

Previous page and this spread
A selection of Dean Landry's
graphic logos for Anna Sui.
The designer is happy to
switch from 1970s' hippy
to 1980s' goth. Landry uses
the language of rock music
in his work, something with
which Sui herself identifies.

Chooch

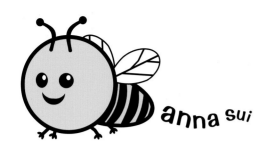

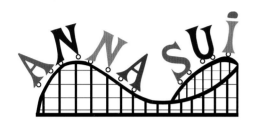

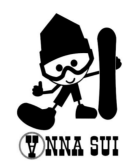

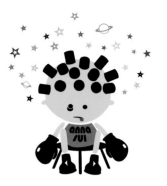

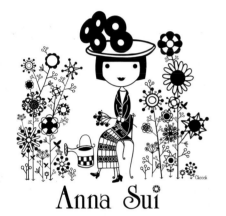

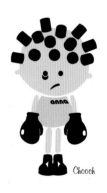

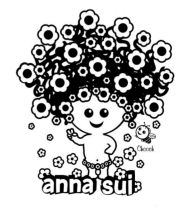

Since beginning to work with Sui, Landry's graphics and illustrations have become a permanent fixture within the language of the label. He created all the drawings for her complex and colourful interactive website, designing an environment for his Sui character based on that of her store. 'I took Polaroids of it and recreated it in drawings,' he says. It's all very comic-book chic, with a hint of retro 1950s. 'For spring/summer 2003, I worked on themes using poppies and flowers and some very campy golfing characters. They're always cute and really happy.'

'She's very hands-on. We meet up each season and talk about what we'll do. She does a lot of walking round flea markets for inspiration. You're always looking for something, seeing things to inspire you. As soon as she knows the direction of the collection, we'll get together and discuss what we're going to do.' As well as designing graphics for the packaging of the cosmetics, the website, and the characters and logos within them, Landry's work crosses over into the actual clothes themselves, too. His illustrations translate not just onto T-shirts but into prints for fabrics.

Opposite
A series of humorous, cartoon-style logos, used throughout Anna Sui's work and giving the designer an assortment of personalities and identities, ranging from geisha girl to Chinese Elvis.

Above
A page from Sui's website, www.annasui.com, illustrated by Landry, using many of Sui's logos and symbols.

Paul Boudens got his first break with Walter Van Beirendonck, who employed him straight from college in 1990. Boudens acts as a conduit for Van Beirendonck's bright and bold graphic ideas, although the relationship works both ways: Boudens has thought up many a slogan for the designer's T-shirts. Over the years, they have collaborated on the ultra-graphic W< brand, and most recently on Van Beirendonck's own label and his provocative streetwear collection, Aestheticterrorists.

WALTER VAN BEIRENDONCK
PAUL BOUDENS

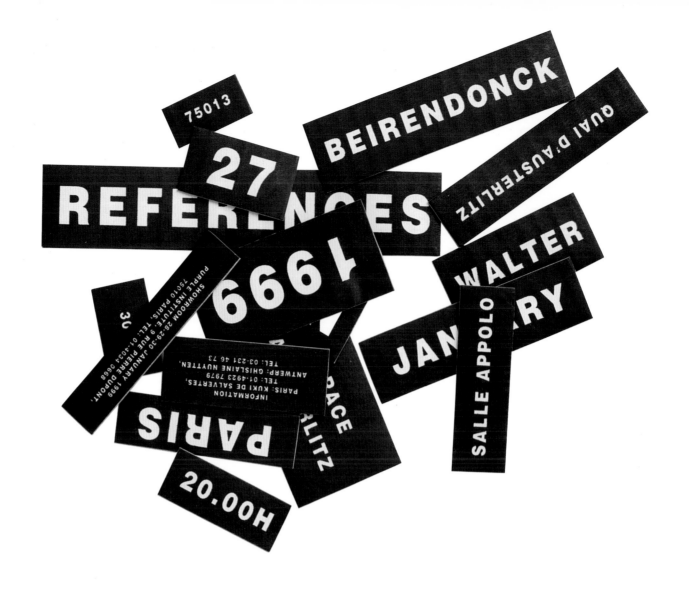

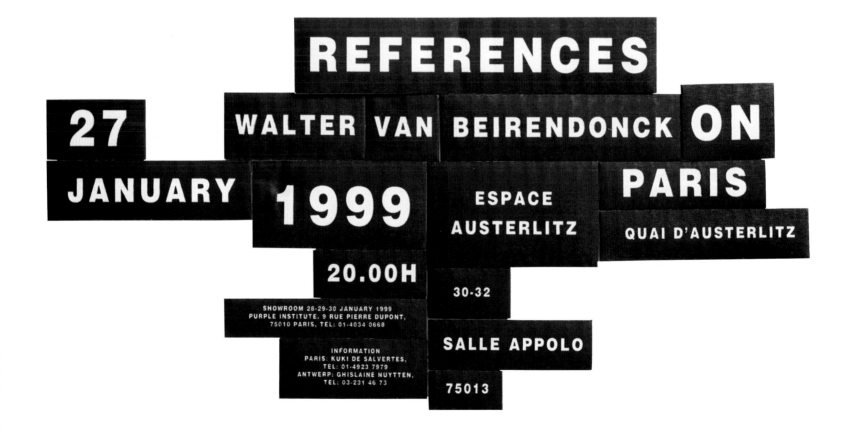

Walter Van Beirendonck first became known as one of the Antwerp Six, the group of Belgian designers, including Dries Van Noten and Ann Demeulemeester, who first showed at the London Designer Show in 1986. He designed for almost ten years under his own name, before developing his W< brand for Mustang Jeans in 1993. Since 1999, he has been working under his own name again as well as his label, Aestheticterrorists. Since 1990, he has collaborated with the graphic artist, Paul Boudens.

'When I was at school, he asked me to work for him', says Boudens. Previously, Walter had been working with the graphic designer Anne Kurris, and Boudens was introduced to Van Beirendonck through her. He took a desk space at Walter's office and was free to work for other people while he was there, as well as working full-time for the designer. 'From the first projects I did together with Paul (a newspaper invitation called "Fashion is dead") I liked his way of working and his flexibility to react to my ideas and add a value I appreciated', says Van Beirendonck. His work has always been as much about graphics as fashion. 'Walter's stuff is not really mine,' says Boudens. 'He always knows really well what he wants.' He'll have a drawing, or he'll fax an idea to Boudens, who now has his own studio. 'In the beginning, I had the same taste as Walter. I know perfectly what he wants.' Perhaps as a result of their time together, Boudens says he is not afraid of colour.

Previous page
Swing tag for Walter
Van Beirendonck's
Aestheticterrorists collection.

Opposite
Jigsaw puzzle show invite
for Walter Van Beirendonck,
1999, designed by Walter
in collaboration with
Madeleine Warmenbol
and Paul Boudens.

Below
Walter Van Beirendonck's
early show invitations
were printed on cheap
corrugated cardboard.

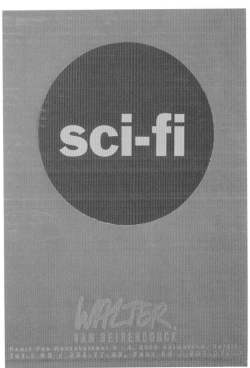

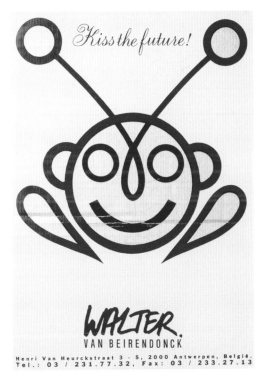

This page and opposite Walter Van Beirendonck's early show invitations all followed the same format, with bright colours and bold patterns. Sometimes Boudens simply used a word to sum up the collection; other times, he and Walter invented cartoon characters, reflecting the playful nature of the clothes.

believe

walter van beirendonck & wild and lethal trash!

Walter's work is often about communicating a message – a word or a slogan. 'I believe that fashion designers should try to change boundaries and make statements,' says the designer. 'Slogans and messages (sometimes even secret messages) have been all over my work from the beginning. Of course, Paul helped (he is good with sayings, too) to optimize and translate it graphically.' His collections have titles like 'Let's Tell a Fairytale' (summer 1987); 'Shoot the Moon, Shoot the Sun, Be a Star' (winter 1988–1999); 'Fashion is Dead!' (summer 1990). His most recent project, Aestheticterrorists, uses slogans like 'Cherish Creativity' and 'Ban Fashionazis'. He continues to print his show invitations on basic corrugated cardboard. For his No References collection, the invitation was a cardboard puzzle. Most things go through Walter's brain and end up on Boudens's drawing board. 'As we started to work together such a long time ago, it is really a trust collaboration,' says Walter. 'I know that I can sleep on both ears when he takes responsibility for a project. The influence that Paul has on my ideas depends on the projects.

For the collections, prints and invitations, I am quite precise about how it should be. For real layout, printed projects it is a real collaboration.' 'I had the luck that I could work at Walter's after I graduated,' says Boudens. 'I just rolled into fashion. I didn't plan it.' As a result of their long-term collaboration, Paul Boudens is often associated with Walter Van Beirendonck, but Boudens points out that he is a conduit for Walter's own vision. He still enjoys working with him, but has his own voice too. He has designed two books for the designer: *Believe* and *Mutilate*, a ring-bound notebook, complete with cut-outs and examples of work and imagery from over the years – something Walter refers to as his 'mental notebook'. 'When they say my work is fashionable, I explode,' says Boudens. 'They don't take me seriously.' With Walter Van Beirendonck, however, he has created a body of work that includes two books, and has stood the test of time to become a vocabulary all of its own.

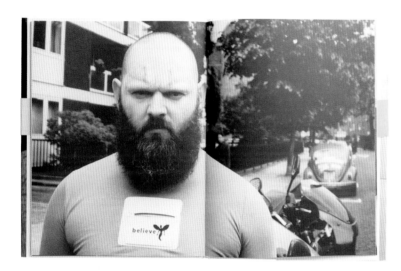

This page and opposite Van Beirendonck and Boudens have worked together on two books. The design of the books follows the fashion designer's own aesthetic.

The designer is pictured here, above the label for his latest collection, the provocative Aestheticterrorists T-shirt line. Both the man and his taste for graphics are big and bold.

Mevis & Van Deursen is based in Amsterdam. Armand Mevis and Linda Van Deursen have worked together since 1989. They work with the publisher Artimo on most of its projects, and Viktor & Rolf is their only client from the fashion world. Just as Mevis & Van Deursen is not a typical graphic design firm, Viktor & Rolf also enjoys challenging the boundaries between fashion, art and commerce.

VIKTOR & ROLF
MEVIS & VAN DEURSEN

The Dutch design duo Viktor & Rolf have emerged as one of the most influential forces in contemporary fashion. Their early shows were staged during Paris *haute couture* week – fashion more as concept than viable commercial product. They even went as far as to launch their own limited-edition perfume, which was more about the idea of a fragrance, complete with its own packaging and advertising, but with nothing more than water in the bottle. In 2000, the designers launched their first ready-to-wear collection, and they now show their clothes during the Paris *prêt-à-porter* week, and manufacture and produce their collections for sale across the world. They even have a fragrance planned – a real one this time – to be produced in 2005 by L'Oréal.

Until the launch of their ready-to-wear collection, Viktor Snoering and Rolf Horsting did not have a conventional label as such. Their clothes were made in extremely limited numbers (one-offs) and they did not have the need for a logo on a label as other designers do. Going into production, however, they were forced to take their corporate image more seriously, and they employed Mevis & Van Deursen, whose studio was located in the same neighbourhood as theirs in Amsterdam, to make a logo for them. They had already collaborated on show invitations and a book celebrating Viktor & Rolf's first five years, which Mevis & Van Deursen designed for the publisher Artimo. The design agency was set up in 1989, by Linda Van Deursen and Armand Mevis, who met at the Rietveld Academy in Amsterdam. Both studied graphic design, but were more drawn to fine art than commercial art. Since setting up a studio together, they have worked with cultural institutions, artists' catalogues and book publishers. 'Mostly we work for non-commercial clients', says Linda Van Deursen. Viktor & Rolf is their only fashion client.

'They didn't have a real logo,' says Van Deursen, 'just their name typeset in Arial. Very straightforward and simple.' They kept the designers' original 'logo' but changed the type. They also made a short, compact version of the logo and a 'seal' of the logo. 'It's quite easy to work with them since they know what they want. We don't always have the same graphical preferences, but that also makes it more interesting for us. Most of the time, we simply start by talking about it together: what the show is about and how the invitation can reflect that. They accept our solutions as long as they are based on a strong and understandable idea.

COLLECTION PRÊT-À-PORTER AUTOMNE-HIVER 2000-2001

VIKTOR ★ ROLF

VOUS DONNENT RENDEZ-VOUS

LE 29 FÉVRIER 2000 DE 10H00 À 19H00
14, RUE DU MAIL - 75002 PARIS
PRIÈRE DE PRENDRE RENDEZ-VOUS EN TÉLÉPHONANT
AU 2E BUREAU - SYLVIE GRUMBACH-NICOLAS DELARUE
TEL 01 42339305 - FAX 01 40264353

Pitti Immagine Uomo
presents

VIKTOR & ROLF
"Monsieur"

Worldwide premiere
F/W 2003 2004

Thursday 9th January 2003 8.30 pm
Stazione Leopolda, viale F.lli Rosselli 5
Florence, Italy

Dinner party to follow

Press Office

Viktor & Rolf:
Karla Otto T 0039 02 655 69 81 F 0039 02 290 145 10
PR Consulting T 001 212 228 81 81 F 001 212 228 87 87

Pitti Immagine: T 0039 055 3693 245 F 0039 055 3693 200

For spring/summer 2003, the collection was all about flowers, reflecting the preparation for the launch of their perfume. 'They were really interested in smells and took the fragrance of thousands of Bulgarian roses as their starting point. The show was to be loose, free, wild, flower power. They wanted the invitation to be loose and free also.' With 700 invitations to produce in a limited amount of time, that was to be an artificial freedom. Van Deursen came up with the idea of holding a workshop at the Rietveld Academy (which involved eighty of her students), and another one in Zürich, organized by friends, which involved a group of young Swiss designers.

Opposite and below
Viktor & Rolf menswear
show invitation autumn/winter
2003/2004.

Overleaf
For spring/summer 2003,
Mevis & Van Deursen
commissioned students
from the Rietveld Academy
in Amsterdam to produce
a series of individual, custom-
made invitations. Each one
featured the designers'
'wax' seal.

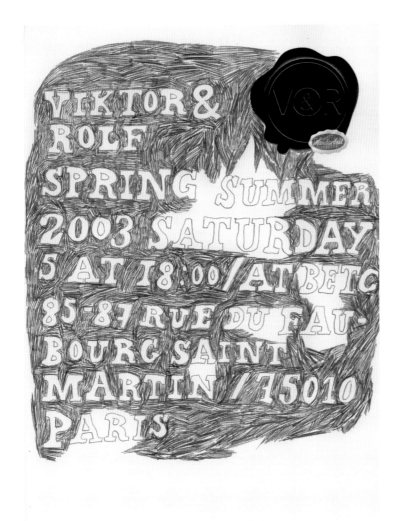

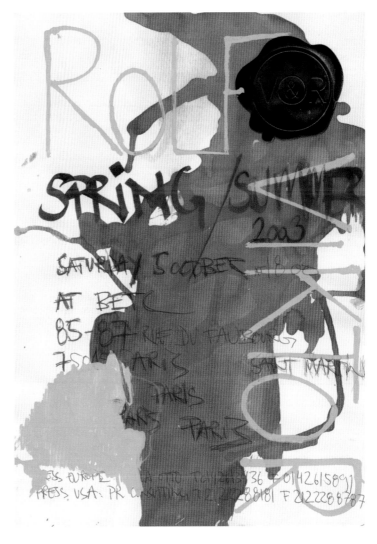

Viktor & Rolf introduced the workshop. All the participants received a sample of the roses, and their letterhead, which has now become the basis for the invites. They received 700 individually produced invitations. 'They were all very different,' says Van Deursen. 'Some are really horrible, some are really beautiful. I have no idea if the recipients appreciated them.' Most likely, they didn't give them another thought, and wouldn't have realized that they were all different. Other invitations for the designers have included one for the Black Hole collection, which was a sheet of black paper with the type cut out, and an idea for a half-shredded invitation for a collection inspired by Fred Astaire and tap-dancing musicals.

As fashion designers, Viktor & Rolf create clothes that will make a strong image, rather than simply a functional piece of clothing. They have a long-term collaboration with the avant-garde fashion/art photographers Inez van Lamsweerde and Vinoodh Matadin. Mevis & Van Deursen share a lot of common ground with Viktor & Rolf. Both work in applied arts fields, but have a closer affinity with fine art. 'Every job has a commercial side to it and Viktor & Rolf are probably our most obvious commercial client, but, because of how they approach fashion, they are also very challenging to work for', says Van Deursen.

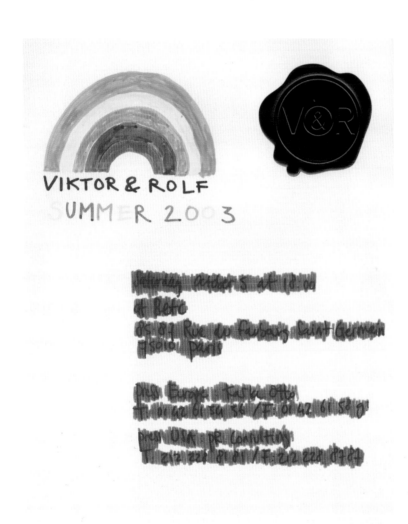

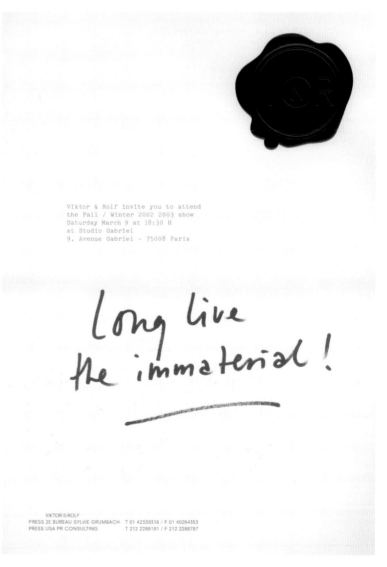

British designer Vivienne Westwood has long reached a stage in her business where her logo will sell a simple twinset. The Westwood orb is both historical and futuristic – a mixture of traditional English heritage and flying saucer. Westwood uses symbols throughout her collections, from the Stonehenge logo for the Man range to the pirate Anglomania logo. Her in-house graphics team interprets her ideas and references.

VIVIENNE WESTWOOD
IN-HOUSE DESIGN

The Vivienne Westwood brand is built entirely around the personality and charisma of its designer. When she started out in business in the pre-punk years with Malcolm McLaren, the idea of branding and marketing was a dim and distant notion. In 1981, when Westwood set up on her own, however, she did so with a very strong brand identity which has remained with her ever since. The logo itself might as well be her signature. A few years ago, there were plans to change the design to her handwriting, but it seemed unnecessary. Over the years, her autograph has come to resemble her logo anyway. The gold and the pink are a typically Westwood combination: the baby pink is feminine, vulnerable and delicate, while the gold is the colour of royalty, couture and luxury. And in fashion circles, Vivienne Westwood is as close to royalty as it is possible to be.

Previous page
Vivienne Westwood's distinctive packaging uses her signature and the orb symbol.

Below
Vivienne Westwood's signature orb logo (left), was redrawn by the designer's friend, artist Tracey Emin (right).

Opposite
Red Label show invitation, New York, autumn/winter 1999/2000.

Vivienne Westwood

RED
LABEL

Everything is done in-house, from the licenses to the graphic design. Westwood works closely with multimedia designer Jo Campos and a team of ten designers, who translate her ideas – often very specific – into show invitations, labels and packaging. She is usually quite specific about how she wants things to look. The graphics and the fashion are absolutely linked; the graphics feed off the fashion. Over the years, Westwood has built up her own vocabulary of symbols, which all mean something to her loyal customers. The most famous is the orb. In the Westwood lexicon, the orb symbolizes the world. It is also, of course, part of the traditional British heritage, held by the Queen during the ceremonial opening of Parliament. The orb represents tradition and the past, while the orbital ring of Saturn represents the future. The orb logo is a stamp of approval, used on knitwear, as well as accessories, the fragrance and handbags. Tracey Emin, a Westwood fan and collaborator, reinterpreted the orb in 2000. She has knocked it off its grand pedestal and redrawn it in her own way, as a loose scribble. Some of her artwork was also used for show invitations. The orb is much copied in Korea and Kuwait, where Westwood products are a prime target for counterfeiters.

Right
Gold label invitation,
'Anglomania', autumn/winter
1993/1994.

Below left
'Man' collection show
invitation, autumn/winter
1998/1999.

Below right, top
'Man' collection show
invitation, spring/summer
1999.

Below right, bottom
'Man' collection show
invitation, autumn/winter
2002/2003.

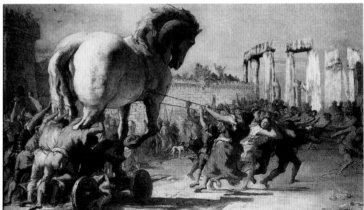

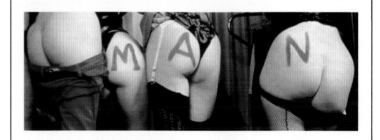

Vivienne Westwood
MAN Collection Autumn / Winter 2002-03
Palazzo Serbelloni
Circolo della Stampa
Corso Venezia, 16 Milano 20122

Other symbols include Pan, the young faun. He is half-devil, half-angel and his hooves have been incorporated into shop fittings in Westwood stores. Then there is the frame – an ornate, traditional gilt frame which represents the link between the present and the past. The frame is the gateway into the world of Westwood, like *Alice Through the Looking Glass*. The two other labels in the Westwood stable are Man and Anglomania. Reflecting the historical inspiration in her clothes, the Man label has a caveman look about it, with lettering emulating the stone blocks at Stonehenge. It is humorous and cartoon-like. For the Anglomania street and jeanswear collection, Westwood plundered her own archives, taking the swashbuckling Captain Hook logo from the original Pirate collection. The Anglomania collection is designed to subvert the idea of the street and sportswear lines of Tommy Hilfiger and Calvin Klein.

The logos and symbols are all carried through into the packaging, fragrance and accessories. The orb becomes the packaging for a watch, or the stopper on the Boudoir perfume bottle, designed to look like an antique, hand-blown perfume flacon. Although still an independent and relatively small company, Vivienne Westwood has unconsciously managed to create a graphic identity that is focused, instantly recognizable and consistent throughout the collections. It is not about brand equity in the same way as the big American and Italian corporate fashion houses. For Westwood, it is important that the brand is always about creativity, first and foremost.

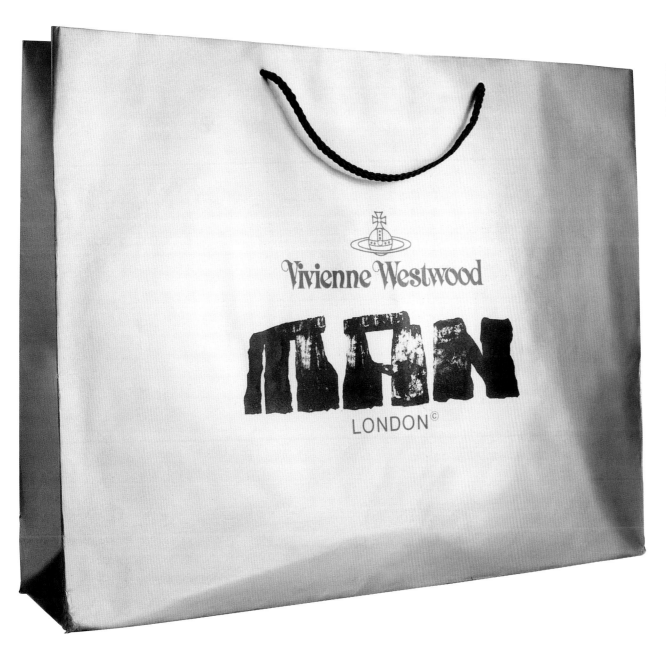

Left
Man carrier bag. The logo uses a rough-hewn type-face, designed to look like Stonehenge.

The Dutch photographer/collage duo, Carmen Freudenthal and Elle Verhagen, provide an interesting perspective on Bernhard Willhelm's collections each season, interpreting the clothes in their own way with a good dose of surreal humour thrown into the mix. Their 'look books' offer more than a visual reference guide to the collection; they add to the collection's sense of personality.

BERNHARD WILLHELM
IN-HOUSE DESIGN WITH CARMEN FREUDENTHAL & ELLE VERHAGEN

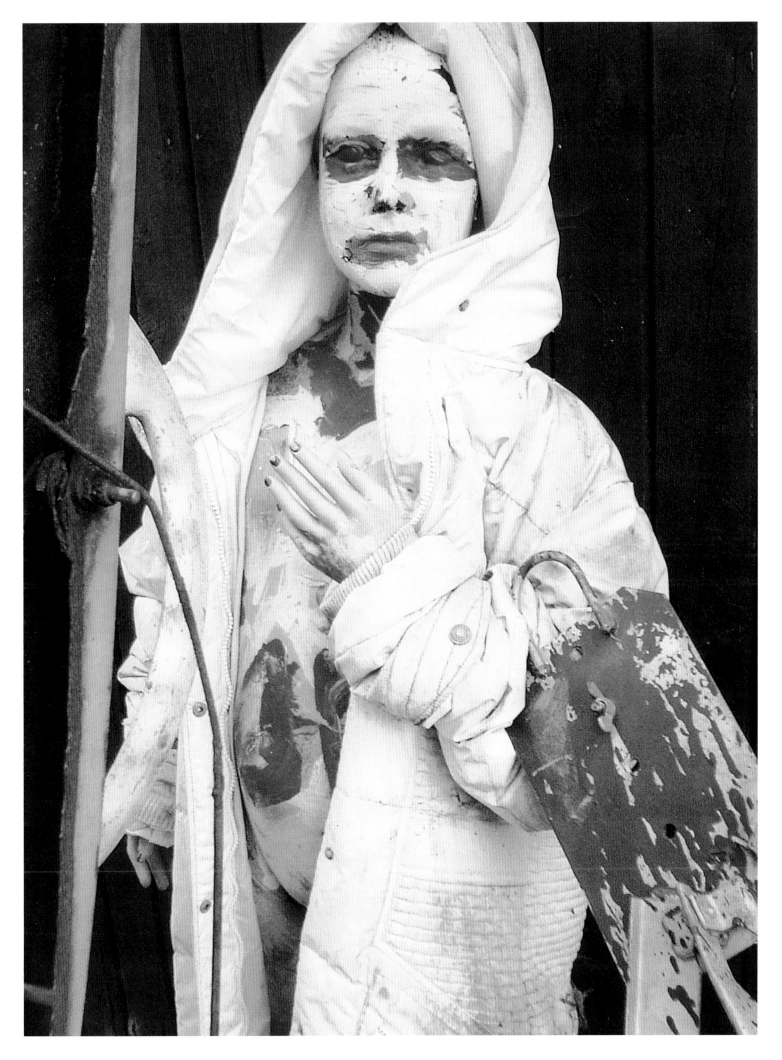

Bernhard Willhelm
nnnnnn
show autumn, winter 02/03
Sunday 10th March at 21.00h

Le petit Palais

Avenue Winston Churchill
75008 Paris

Bernhard

Bernhard Willhelm

show autumn / winter 02/03

Sunday 10th to 10th March at 21.00h

Le petit Palais

Le petit Palais

Le petit Palais

invitation

invitation invitation

invitation

 invitation

invitation

invitation
show autumn / winter

 winter

autumn autumn winter Autumn / winter

 autumn autumn

The German designer Bernhard Willhelm graduated from the Royal Academy of Fine Arts in Antwerp in July 1998, with a collection called 'Le Petit Chapeau Rouge'. Before graduating, he worked with Vivienne Westwood and Alexander McQueen in London and Walter Van Beirendonck (also his tutor from college) in Antwerp. He is now based in Paris, and designs collections for men and women that have the same strong signature he developed at college. From the outset, he gave a naive, childlike quality to his work and his brand. He gets his inspiration from nursery rhymes and children's stories, often twisting them and distorting them into something darker and more sinister. His label is a simple, black-cloth hand with three rows of stitching for the fingers, their threads left hanging, and a button stitched into the middle. 'My favourite toy when I was young was a monkey from Steiff', he explains. He used the monkey's hand and the Steiff button with his logo written simply on it. His headed paper and company logos are also decidedly uncorporate, with hand-drawn, childlike motifs, making his business look refreshingly more charming than corporate.

Previous page
Lookbook, autumn/winter 2002/2003 by Carmen Freudenthal and Elle Verhagen.

Opposite
Invitation for autumn/winter 2002/2003 show, by freelance designer, Sabine Sehringer.

Left and below
A cross-stitched label with Willhelm's initials is typical of the designer who likes to mix traditional crafts into his work; his stationery (designed by Sabine Sehringer) is unconventional, with cartoon-like drawings ensuring that nothing is taken too seriously.

The graphics and communications for his collections are done in-house by his design team. The designer's stationery was created by the freelance graphic artist, Sabine Sehringer. Willhelm doesn't believe in strict briefs, preferring to work on a concept together and make something out of it. Willhelm also has a long-standing relationship with the Dutch photographer/collage team, Carmen Freudenthal and Elle Verhagen. He has worked with them for five seasons, allowing them to interpret his clothes in elaborate 'look books' that are sent to press and industry insiders. The first book was called the *Cook Book* and featured gingham tablecloths and cut-outs of food alongside the clothes. The illustrators share a sense of humour with the designer. 'We usually have a couple of meetings with Bernhard before we start work on the look books,' says Carmen.

'We don't usually see the clothes, but he tells us themes, prints and fabrics, and we develop a concept out of that. We make an interpretation. It's more of a conversation than a brief.' For the collection for spring/summer 2003, the themes were sport, romance and odd juxtapositions of ideas that don't go together. Each look book has got more complex than the last. 'The layout is freer, and more wild with strong colours.' They work with a copywriter who supplies a text, but the layouts and graphics are all part of their artwork.

bernhard willhelm autumn/winter 2002/2003, lookbook by FreudenthalVerhagen

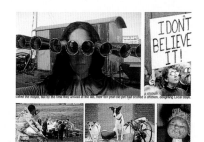

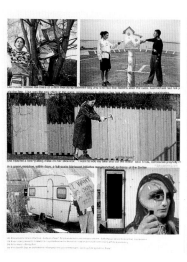

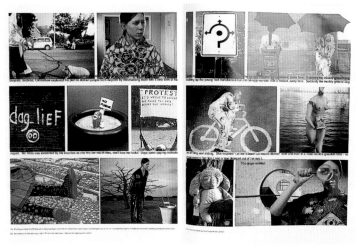

Freudenthal and Verhagen both attended the Gerrit Rietveld Academy in Amsterdam. Freudenthal studied photography and Verhagen studied fashion design; the two have collaborated since 1989, shortly after graduating. They have contributed to publications such as *Visionaire* and *i-D*, and have also collaborated with the conceptual accessories company, Bless. Their work for Willhelm raises his look books to something altogether more involved and elaborate than mere tools for fashion editors to select clothes from. They use their own blend of photography and collage to create environments for the clothes so that they come to life on the pages. The results are often surreal and humorous, a reflection of Willhelm's own collections and inspirations.

Opposite and below
The autumn/winter
2002/2003 look book
by Carmen Freudenthal
and Elle Verhagen.

When creative director Marc Ascoli hired a young Nick Knight and Peter Saville to work on the Japanese fashion house's publicity brochures, the result was ground-breaking. Between them, they produced some of the most influential fashion advertising and communication work of the 1980s. When M/M (Paris) took over in the 1990s, they saw their work as an evolution of what had gone before and continued to commission and art-direct innovative photographers, including Craig McDean, Inez van Lamsweerde and Vinoodh Matadin.

YOHJI YAMAMOTO
MARC ASCOLI
PETER SAVILLE
M/M (PARIS)

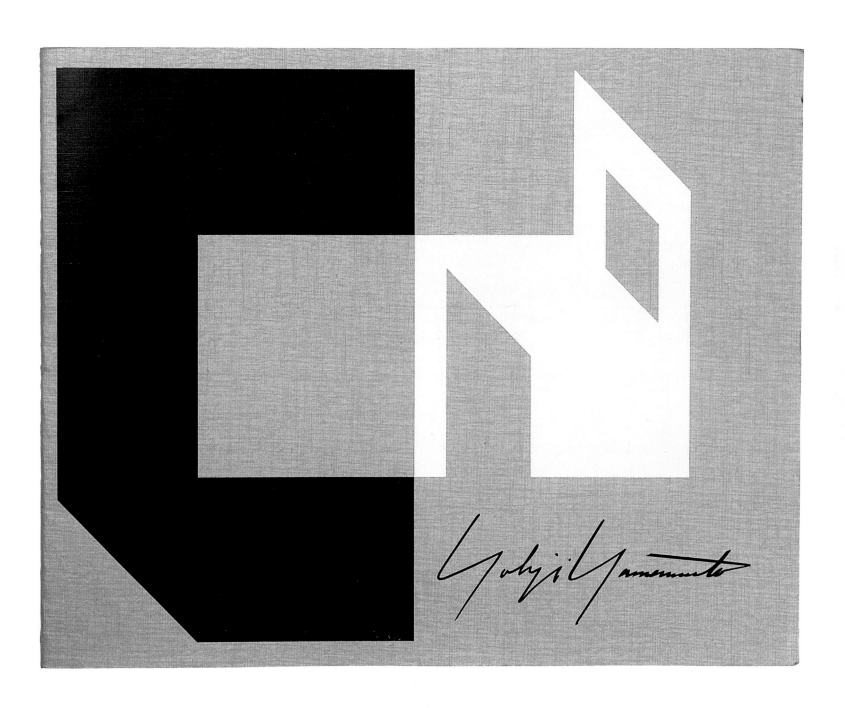

In the mid-1980s, Marc Ascoli, Yohji Yamamoto's director of communication, commissioned an up-and-coming photographer, Nick Knight, to work on some images for a new catalogue. Knight asked who would be working on the graphics, and suggested Peter Saville, a designer he had worked with occasionally, who had already made a name for himself with his bold, industrial graphics for the Hacienda nightclub in Manchester and his album covers for the band New Order.

Saville sent some examples his work – mainly his covers for New Order. 'Marc was very interested in a cover I had just done in 1985, called "Low Life", and he said "It's very like what I do with Nick Knight", and I said "Yes, I know". It really bothered him that I'd just done something six months earlier in the same spirit as he'd taken to be terribly progressive for Yohji.' Saville had been inspired by a book on Yves Klein – 'the monochrome blues and the gold leaf and the white rose, and I thought "Now I understand Yves Klein." You have to be in the right mood. I went and bought a drawer full of black polo-necks. The New Order cover that year expressed that. It was the same sort of values. I told Marc why: time to strip everything down, I'd had enough of it all. And then he said, "So if I take you for Yohji, you do the same thing, no?" I said no, because that was last season. He said, "OK, you've got the job."'

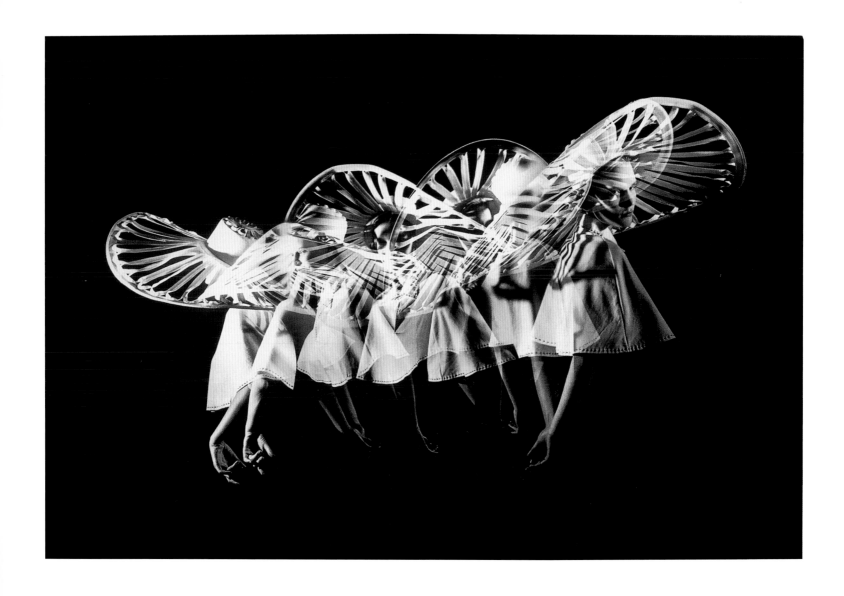

'He was the first person to understand the work I'd been doing within music: to understand it in terms of fashion,' says Saville. 'Marc saw very quickly how it had been fashion-linked. My learned skill was what we could do with the graphics and his learned skill was what he could do with the fashion.' And Saville understood the pace of fashion, the constant need for something new and directional. The Ascoli/Knight/Saville team did five years together, creating brochures each season that suggested a mood rather than simply sold a product. It was an extremely fruitful period, producing some of the images that Knight is still best-known for today: Suzy Bick smoking; Naomi Campbell in silhouette, wearing a red coat or with a bright-red net bustle jutting out behind her.

Previous page
Brochure for autumn/
winter 1998/1999.
Art direction and design
by M/M (Paris).

Opposite
The brochures produced
by designer Peter Saville
and photographer Nick
Knight in the 1980s are
now highly collectable.

Below
The series of silhouettes,
including Naomi Campbell
with the red coat, were
pure, clean graphic images.
Photographs by Nick Knight,
art directed by Peter Saville.

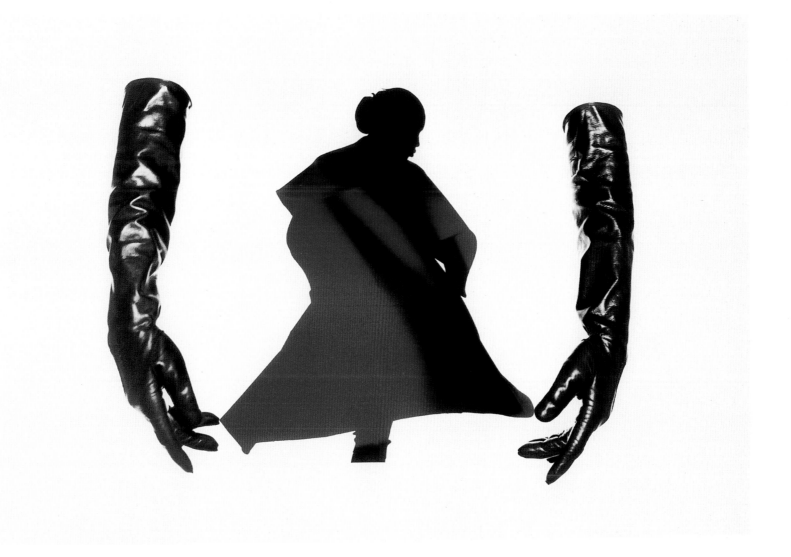

After he was hired, there was a notable shift in how everything looked. 'I just brought some discipline to the editing and sequencing of the catalogue and to the scale and the finishing,' explains Saville. 'I specified them how I wanted to specify them. It was wonderful. Yohji's office never compromised me with anything. We'd print 1,000 to 2,000 copies. If Yohji said we'd do it, then we'd do it.' For Saville, it was a dream. A few years after the relationship was over, he was asked to work on the logo type for a new collection, Y's. The Yohji logo itself is a version of the designer's own signature.

'Yohji doesn't seem to want to live in the fashion world,' says Saville. 'It is much more that he does the work, and afterwards, he wants to go and play pool or play his guitar. He doesn't want to be networking. He wouldn't want to talk about the show after it had happened. He would say, "No, I'm tired and I want to go back to Tokyo." He would leave the room and with a smile, just say, "Surprise me." It's kind of like I've done my bit, you've seen it, now I want to know what you feel. I don't want to tell you what you feel; show me what you feel.'

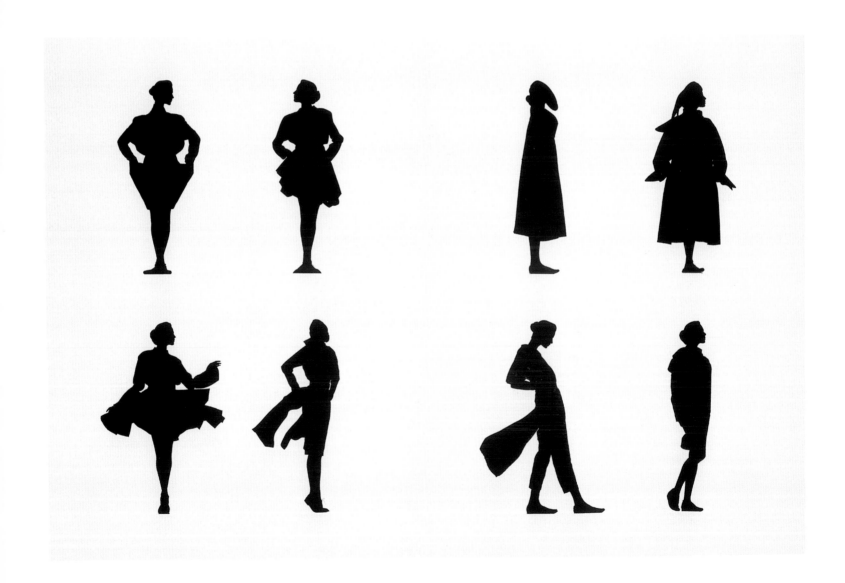

Opposite
The series of black and white silhouettes created strikingly stark graphic layouts. Photographs by Nick Knight, art directed by Peter Saville.

Left and below
Between them, Marc Ascoli, Nick Knight and Peter Saville produced some of the most innovative and influential images in fashion history for Yohji Yamamoto. Saville's layouts never overwhelmed the photography.

When M/M (Paris) took over the Yohji contract in 1994, the brief remained the same: to create a brochure each season that communicated the mood of the collection. They saw the story continuing to unfold and took up where Saville left off. 'Each season was an episode of the story', they say. They commissioned each photographer – Craig McDean, Paolo Roversi, David Sims, Inez van Lamsweerde and Vinoodh Matadin – to work on three seasons so there would be some continuity. 'Every six months, in a way, we were creating an episode of a big story.' With each photographer, the third season would usually be the most accomplished and most developed. Their relationship with Yohji Yamamoto himself was very loose.

'When he knows he needs an image, he just lets go, which made the image stronger than, say, Comme des Garçons, where Rei Kawakubo is really controlling everything. But it's different. Her whole brand is an image. It's different than Yohji where he makes clothes and needs some people to advertise those clothes. In a way, the fashion images produced for Yohji are more influential, more complex. They have a longer life span than a commercial image – they are more like logotypes.'

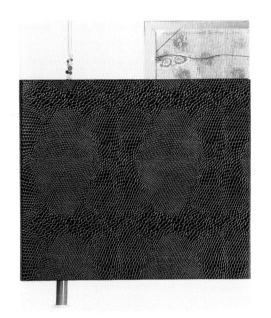

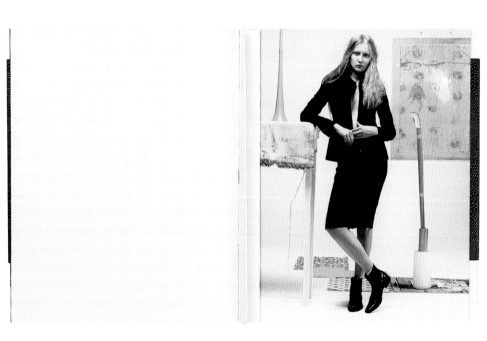

This page and opposite
In 1994, M/M (Paris) began
working with Yohji Yamamoto.
They started where Peter
Saville and Nick Knight had
left off, creating close working
relationships with photographers.
For spring/summer 1999/2000,
they worked with Craig McDean
on this brochure designed
to open like a concertina.

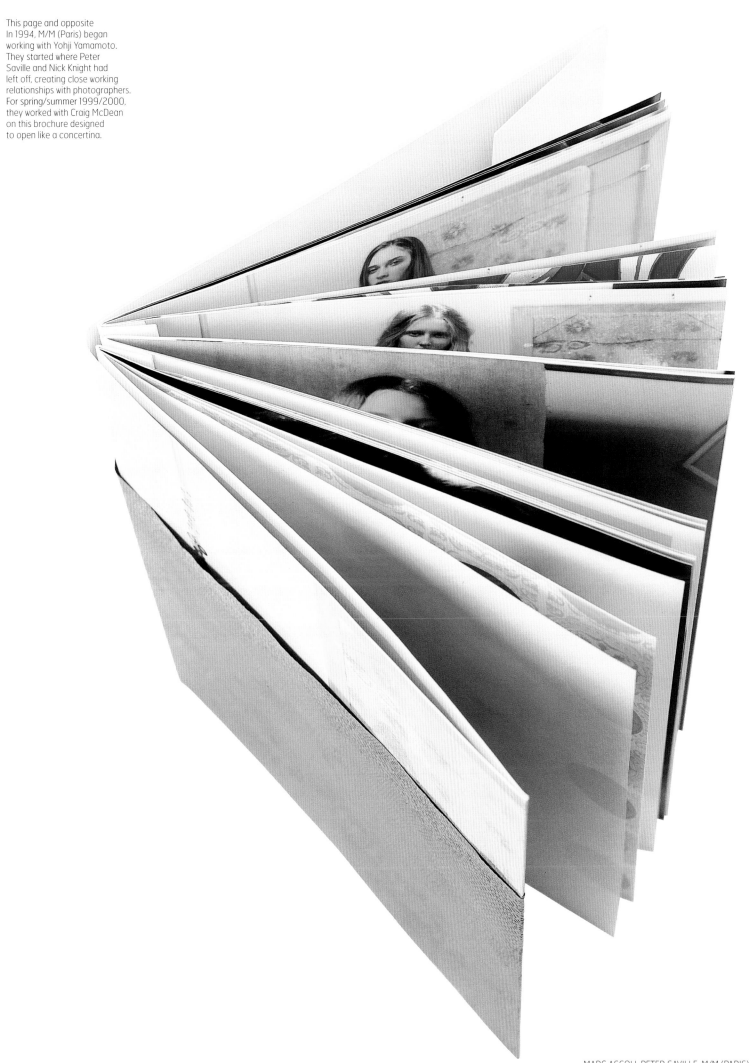

Over five years, they created three hundred images for Yamamoto, culminating in their work being brought together for a book, *Fast Forward*, published to celebrate Yamamoto's twenty years in business. It was a lot of images, each one a strong statement in its own right. 'A powerful fashion image is really like a mirror in relation to what's produced by the brand,' says Michaël Amzalag of M/M (Paris). 'Sometimes you have to distort it; sometimes you can't just show what was produced in the show; sometimes you have to show something next to it, you have to think of the next season ahead.'

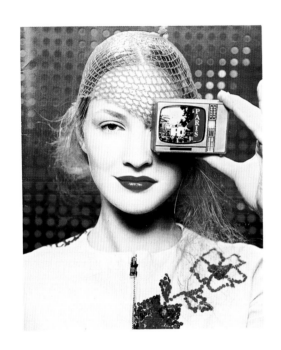

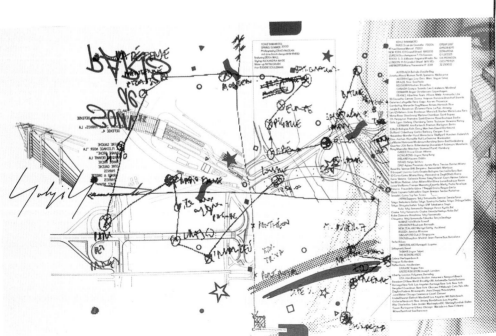

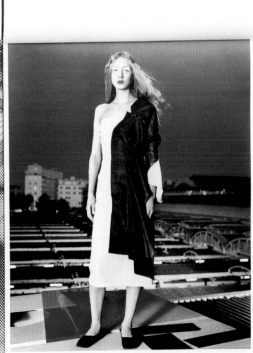

Opposite
Publicity brochure
for spring/summer
2000. Photographs
by Craig McDean
and art direction and
design by M/M (Paris).

Below
Brochure for autumn/
winter 1998/1999.
Photographs by Inez
van Lamsweerde and
Vinoodh Matadin; art
direction and design
by M/M (Paris).

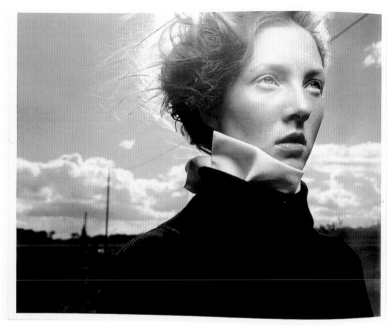

This page and opposite
Brochure for autumn/winter
1999/2000. Photographs
by Craig McDean and
art direction and design
by M/M (Paris).

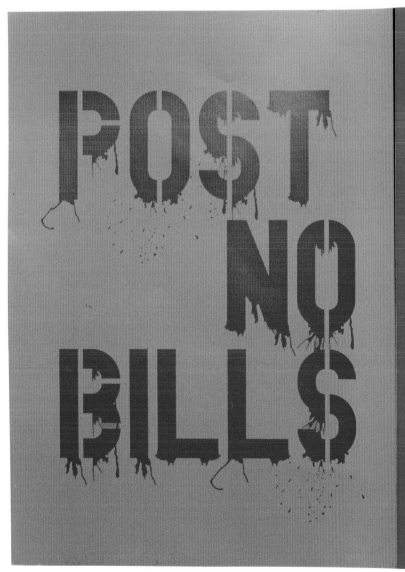

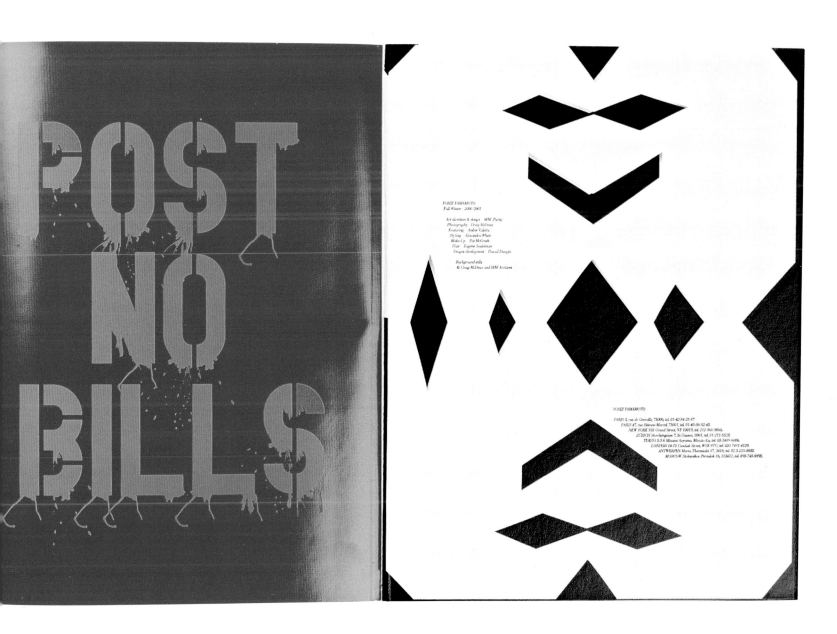

POST NO BILLS

YOHJI YAMAMOTO
Fall-Winter 2000-2001

Art direction & design M/M (Paris)
Photography Craig McDean
Featuring Amber Valletta
Styling Alexandra White
Make-Up Pat McGrath
Hair Eugene Souleiman
Image development Pascal Dangin

Background stills
© Craig McDean and M/M Archives

YOHJI YAMAMOTO
PARIS 3, rue de Grenelle, 75006, tel 01-42-84-28-87
PARIS 47, rue Etienne Marcel, 75001, tel 01-45-08-82-45
NEW YORK 103 Grand Street, NY 10013, tel 212-966-9066,
ZURICH Storchengasse 7, In Gassen, 8001, tel 01-211-5823
TOKYO 5-3-6 Minami Aoyama, Minato-Ku, tel 03-3409-6006
LONDON 14-15 Conduit Street, W1R 9TG, tel 020-7491-4129
ANTWERPEN Maria Theresialei 17, 2018, tel 32-3-225-0032
MOSCOW Stoleshnikov Pereulok 16, 113001, tel 095-745-8958.

The London-based fashion brand You Must Create (YMC) was founded in 1995, and has since developed a loyal and international following. Its creators, Fraser Moss and Jimmy Collins, developed their own logo through trial and error. Their graphic training came from looking at record sleeves and corporate logos such as Shell and Coca-Cola. They wanted their logo to have the same impact.

YOU MUST CREATE
FRASER MOSS
JIMMY COLLINS

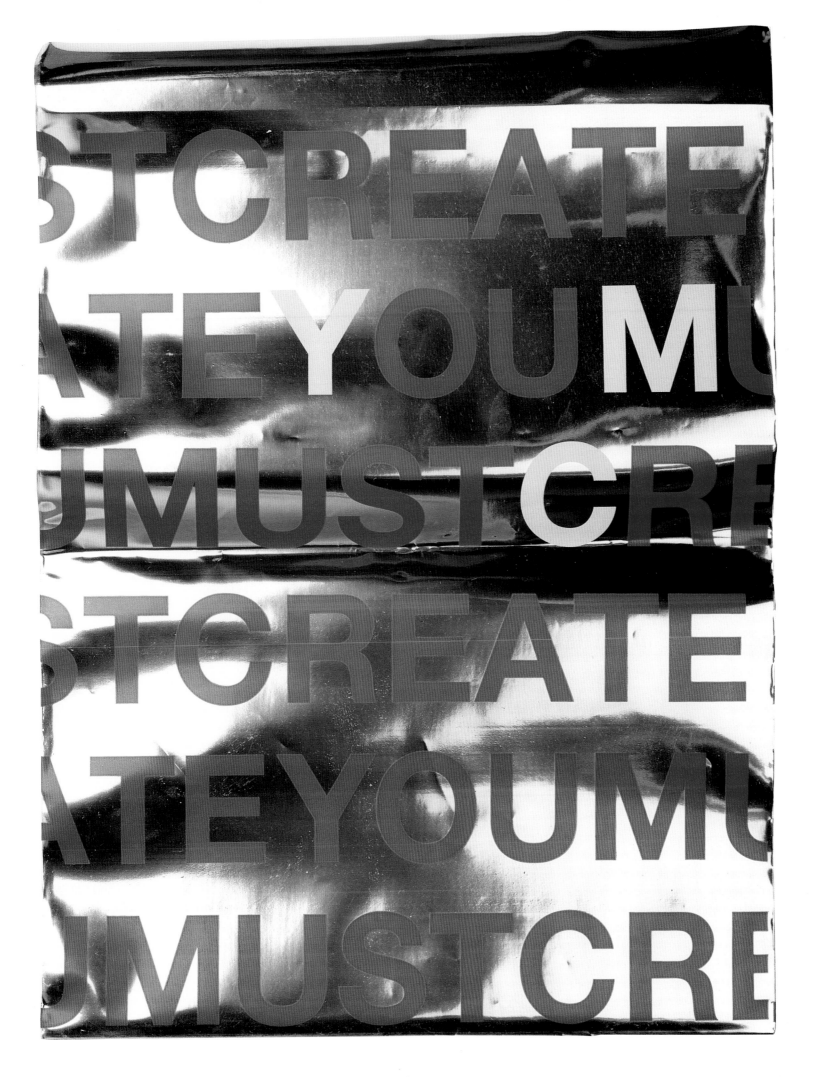

When Fraser Moss and his partner, Jimmy Collins, set up their business in London in 1995, they took inspiration from Raymond Loewy. His logos for corporations like Shell, Exxon and Nabisco were so familiar, they were almost invisible. 'We took a quote from a lecture he gave to some design students in America, when he said, "You must create your own design style"', says Moss. And they shortened their slogan to YMC. Their own logo happened almost accidentally.

In 1999, they signed a licensing deal in Japan with Renown Look, and discovered that in Japan, YMC also stood for Yamaha Motorcycle Corporation. Their logo therefore had to change and they decided to spell it out in full. It became You Must Create. It retained its simplicity, this time drawn in the Arial typeface, in contrasting shades of dark and light blue. Every few seasons it changes colour. It has been blue and red, and then red and purple. As a small company, You Must Create does not have a budget to pay a design agency, or to splash out on marketing research for a new identity. Everything is done in-house. The labels change when they need a new batch printing and the colours usually match the new collection. It's as simple as that. Despite their efforts to sell their clothing rather than their label, You Must Create has inevitably become a strong graphic identity.

Previous page
The You Must Create logo printed on the foil used for packaging clothes.

Right
Swing tags first used for the spring/summer 2000 collection. Designed by Fraser Moss. YMC decided to update the tag for the millenium.

Opposite
YMC introduced this pink box for their spring/summer 2001 collection. Designed by Fraser Moss.

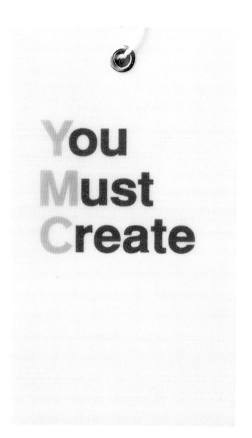

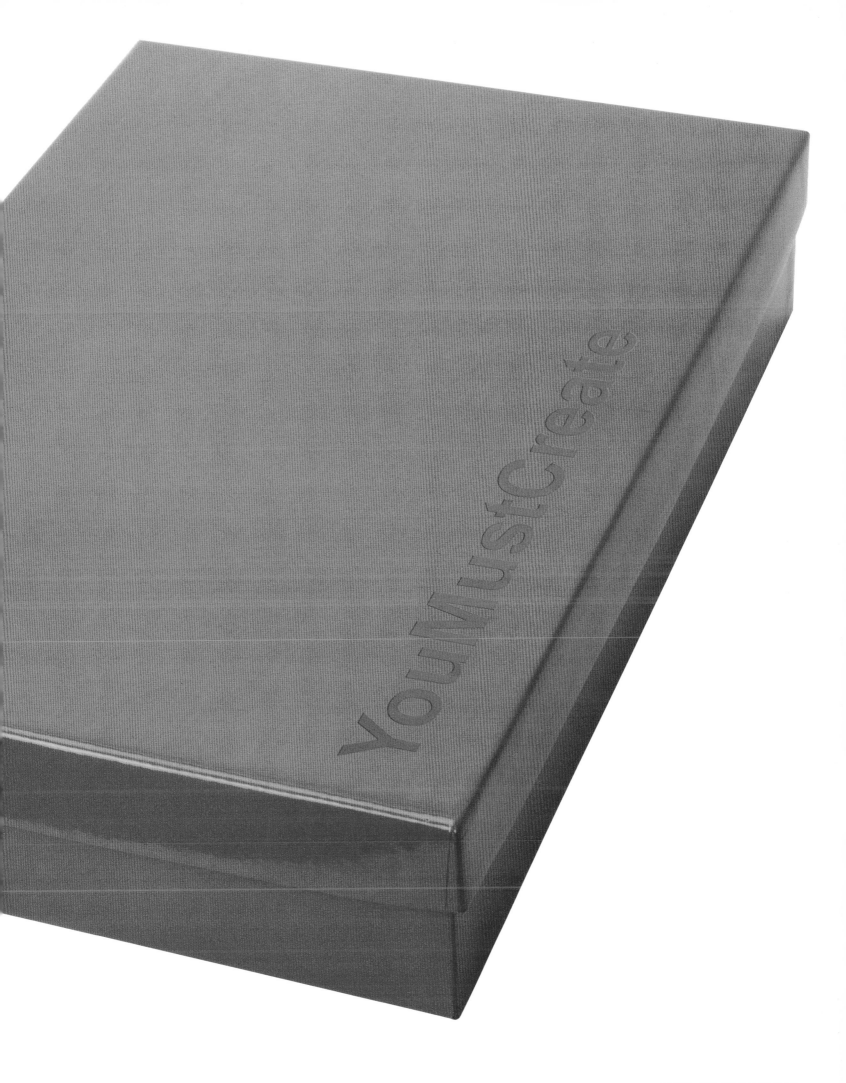

Right
Chocolate You Must Create
bag. Designed by Jody Moss
for the shopping bags at the
YMC shop. The colours are
changed to complement
each season's collection.
This chocolate colourway
was for spring/summer 2001.

Opposite above
Spring/summer 1997
collection. Photography:
Phil Poynter. Stylist: Katy
England.

Opposite below
Spring/summer 2001
collection. Photography:
Paul Wetherell. Stylist:
Lynette Garland.